NEUROSCIENCE | P. 205

DNA | P. 95

PHYSICS | P. 23

DARWIN | P. 111

C. Darwin 1837

WHAT THE MIND MAKES | P. 219

NATURAL HISTORY | P. 157

HUMANITY | P. 189

Science Ink

SCIENCE INK

*Tattoos
of the Science
Obsessed*

Carl Zimmer

*Foreword by
Mary Roach*

STERLING
New York

To everyone marked by science, both within and without

STERLING
New York

An Imprint of Sterling Publishing
387 Park Avenue South
New York, NY 10016

ISBN 978-1-4027-8360-9 (hardcover)
ISBN 978-1-4027-8935-1 (ebook)

Prepared and produced by
Scott & Nix, Inc.
150 West 28th Street, Ste. 1103
New York, NY 10001
www.scottandnix.com

A portion of the proceeds from *Science Ink* will be donated to
DonorsChoose to support science classroom projects.
To learn more, visit www.donorschoose.org.

Distributed in Canada by Sterling Publishing
c/o Canadian Manda Group, 165 Dufferin Street
Toronto, Ontario, Canada M6K 3H6
Distributed in the United Kingdom by GMC Distribution Services
Castle Place, 166 High Street, Lewes,
East Sussex, England BN7 1XU
Distributed in Australia by Capricorn Link (Australia) Pty. Ltd.
P.O. Box 704, Windsor, NSW 2756, Australia

For information about custom editions, special sales,
and premium and corporate purchases, please contact Sterling Special Sales
at 800-805-5489 or specialsales@sterlingpublishing.com.

Manufactured in China

4 6 8 10 9 7 5 3

www.sterlingpublishing.com

Contents

Foreword

UNTIL I SAT down with this book, my favorite tattoo belonged to a type designer named Jim Parkinson. "Born to Letter," it says, above a menacing black skull smoking a joint. I liked the surprise of it, the sly humor. You don't expect large, showy tattoos on lettering professionals. And you don't expect them on scientists. Or I didn't. But this is silly. Of course scientists have tattoos. Scientists, as much as bikers or gang members, have the requisite motivator for a trip to the tattoo parlor: a passion that defines them. If you like the Mets, you buy a baseball cap. If you love the Mets—or chloroplasts or Billy Bob Thornton—you get a tattoo. The word love appears many times in this book, applied variously to pure mathematics, experimental physics, and marine fossils. That tattoo artists today receive more requests for DNA helices than they do for "Mom" (and I am guessing here) can only be good.

Tattoos mark their wearers as members of a tribe. In the language and symbols of the tribe, the tattoo communicates that which is meaningful: I prefer Harleys; I have killed three men; I know a lot about fonts. Scientists have the best symbols of all. I can't parse the exact statement Cassie Backus is making with the symbols for a noise circuit (p. 226), but it looks extremely cool there between her shoulder blades. Ditto the glottal stop symbol on linguist Luzius Thöny's pinky (p. 200) and the Schrödinger wave function equation on Brittany Hughes's back (p. 35). The symbols of science set the tattoo-wearer apart from the rest of us at the same time they draw us in with their mystery and beauty.

I have never seen Carl Zimmer without his clothes, but I am told he has no tattoos. As a science writer, he belongs to no tribe. He is the interloper, the interpreter, a dozen United Nation headsets going at once. To write this book, Zimmer had to learn all the languages, decode all the symbols. This is no coffee-table tattoo book—to absorb it is to acquire instant science literacy. Zimmer explains the tattoos in brief, clear, eloquent essays. You try doing this with the Fourier Transform, the Dirac Equation, and the Lazarus Taxon. (Does everything in science have to sound like a Robert Ludlum novel?)

Many years ago Carl Zimmer was my editor at *Discover* magazine. Each assignment meant acquainting myself with a subject I knew nothing about: bird migration, say, or the biomechanics of locomotion.

In each one, there came a point where I had got in over my head. "Mary, can you try this paragraph again," Carl would write in the margin. "It doesn't make sense." Then he'd suggest a 400-page book by a prominent expert in the field. I never read the books, because it was easier to beg Carl to write the passage himself. It was always the smartest, smoothest part of the piece. If I could choose a tattoo for Carl Zimmer, it would be something random, a parsnip or a lunchbox or Maria Conchita Alonso's bosom. Just so I could hear him say, "Mary, this doesn't make sense" one more time.

P.S. Here is the tattoo I would get, if I ever got one.

Fig. 1. The underpant worn by the rat.

This drawing comes from a European urology paper entitled "Effects of Different Types of Textiles on Sexual Activity," by the late Ahmed Shafik, an Egyptian researcher. I stumbled onto it when I was working on my book *Bonk: The Curious Coupling of Science and Sex*. I immediately, giddily fired off an email to Cairo, knowing that I had to meet this man and include him in the book. No image better represents what is for me the irresistible lure of what I do for a living.

—Mary Roach, 2011

Introduction

SANDEEP ROBERT DATTA puts up an intimidating front. On his website at Harvard Medical School, where he is an assistant professor, he poses in front of a wall of flasks and scales, his arms folded and his mouth drawn into a scowl. "The central hypothesis of our laboratory," his site informs us, "is that the neural circuits that trigger fixed action pattern behaviors in response to ethologically-relevant odors (such as those from food, predators and mates) are both anatomically and genetically stereotyped; we plan to leverage the invariance of this specific type of neural circuit to understand how odor inputs are coupled to behavioral output centers in higher brain, which in turn will reveal principles used by genes to specify behaviors."

I happen to be friends with Professor Datta, and I can vouch that there is a less daunting side to this neurobiologist. For starters, he prefers to be called Bob. Bob and I have stood for hours together at a club in Hoboken, as the band Yo La Tengo has killed off some of our ear cells with their power chords. He and his wife Eliza have twin boys, Jasper and Theo, whom they take to Chuck E. Cheese to celebrate birthdays. In the summer of 2007, the Datta clan came to a pool party for the birthday of my nephew Blake, and the esteemed neurobiologist splashed around in the water for hours with his boys. It was then that I noticed something on Bob's arm. He had a tattoo.

The tattoo, I could see, was that most famous molecule, the twisting ladder of DNA. There was a logic to the choice, since Bob studies the DNA of fruit flies, observing how mutations to certain genes alter how their nerves develop and how they behave. When I complimented Bob on his ink, he let me know that the DNA in the picture was not just *any* DNA. It had a message.

DNA stores information for making proteins in its rung-like units called bases. There are four different bases: adenine (A), cytosine (C), guanine (G), and thymine (T). It takes three consecutive bases to encode a single amino acid, the building block of protein. There are twenty different kinds of amino acids in humans, each abbreviated with a letter. The letter E, for example, stands for glutamate.

Bob explained to me that his tattoo spelled out the initials of his wife, Eliza Emond Edelsberg. He took advantage of the fact that E is the abbreviation for one of the building blocks of proteins, called glutamate.

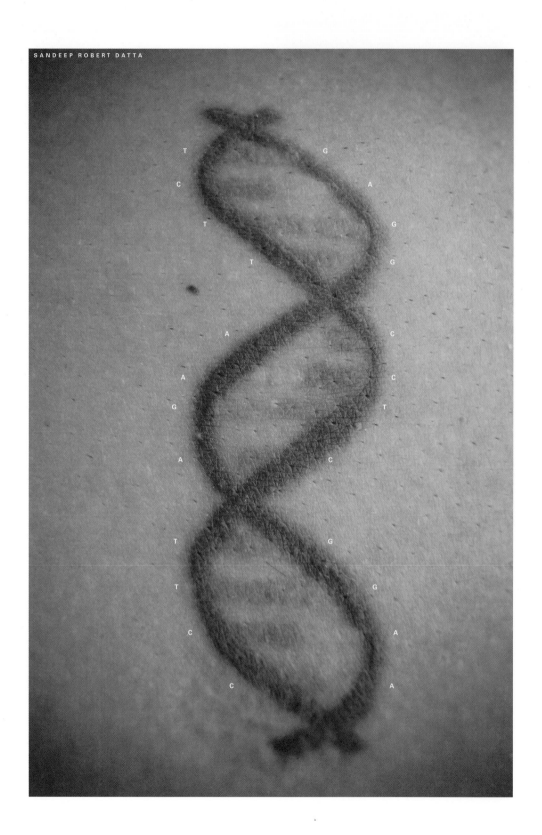

SANDEEP ROBERT DATTA

T
C
T
T
T
A
A
G
A
T
T
C
C

G
A
G
G
G
C
C
T
C
G
G
A
A

(Why not G, you may ask? Because another building block, glycine, got first dibs.)

Our bodies make twenty different protein building blocks, called amino acids. We store the amino-acid sequence for each protein in our DNA. The information is encoded in the rung-like sections of DNA, called nucleotides. Encoding twenty different amino acids is a tricky operation, because we only have four different nucleotides. Our cells manage this stunt by representing each amino acid with three nucleotides in a row—a codon. They encode glutamate either as guanine-adenine-guanine, or guanine-guanine-adenine (GAG or GGA for short.)

Bob decided he wanted to represent EEE as GAG-GGA-GAG. But that would only get Bob a piece of DNA that was one and a half turns long. To get to a more aesthetically pleasing two turns, he'd get an extra E for good measure: GAG-GGA-GAG-GGA.

Once he had a sequence picked out, Bob decided that he did not want to use letters to mark each base in his tattoo, so he came up with his own color scheme. Green would stand for G, amber for A. And since the bases on one strand of DNA bind to corresponding bases on its partner (A to T, and G to C), Bob needed colors for C and T as well. He chose blue for C (cyan), and—in something of a stretch—red for T (tomato).

"Pretty cool," he said to me.

It was, I granted him, a pure expression of geek love. And it occurred to me that Bob was not the first scientist I had encountered sporting ink. I make a living writing about science, and so I spent a fair amount of time with scientists lurking in laboratories, on research vessels, or out in bogs. I recalled a visit to the University of Chicago, where I had met with a developmental biologist

named Marcus Davis. Davis was working as a post-doctoral researcher there, learning the genetic instructions for fins stored in the DNA of fishes. Like a number of other biologists, he wants to understand how new structures evolve—how, for example, a fish fin became our own hands and feet. It was a warm day in Chicago when I visited, and Davis was wearing short sleeves. Running up one arm was the picture of an ancient fish, *Eusthenopteron*, with fleshy lobes for fins, straddling the transition that would take our ancestors out of the water and onto dry land.

I wondered if I had been missing something interesting about the scientists I spent so much time with, or if I was just mistaking two tattoos for a trend. So I posted the question on my blog, "The Loom." I immediately received a comment from a scientist who said that he knew an old geneticist with a DNA tattoo as well.

Then a physicist wrote in. "A former student got a tattoo of a cartoon atom on the back of one of his legs," he recalled. "He told me that the first day after he got it, he went to rugby practice, and was showing it to someone when one of the seniors on the team (also a physics major) walked by. The senior looked at it, said 'Oh, please. The Bohr model?' and walked off."

The next message I received had a picture attached to it. Two psychology graduate students decided to express their love by getting his-and-hers Necker cubes, a classic optical illusion. More messages came in the days that followed, with tattoos of equations, fossils, and galaxies. I posted the pictures as fast as I could, but more kept coming in. Some of the tattoos were gorgeous; some were old and grungy. And most of them came with stories—such as the one about a neuron on

a woman's foot. It was the kind of neuron destroyed by Lou Gehrig's disease. Her father had died of the disease, and his death had forged her career as a neuroscientist.

Without intending it, I became a curator of tattoos, a scholar of science ink. I found myself giving people advice about how best to photograph a tattoo. Rule one: don't take a picture right after you get the tattoo. Shiny, puffy skin does not please the eye. Tattoo enthusiast magazines called to interview me. All in all, it was a strange experience; I have no tattoos of my own and no intention of getting any. But the open question I posed brought a river of new pleasures.

Some people have watched this growing obsession of mine and scoffed. They see tattoos as nothing but mistakes of youth, fated to sag, or to be scorched off with a laser beam. But the truth is that tattoos are etched deep in our species. In 1991, two hikers climbing the Austrian Alps discovered the freeze-dried body of a 5300-year-old hunter, who came to be known as Ötzi. His skin was exquisitely preserved, including a series of hatch-marks on his back and a cross pattern on his knee. In 2009, a team of Austrian researchers determined that the tattoos had been made with ashes from a fireplace, which someone had sprinkled into small incisions in Ötzi's skin.

Tattoos are preserved on other mummies from ancient civilizations, from the Scythians of Central Asia to the Chiribaya of Peru. If, through some miracle of preservation, archaeologists find older human skin, I could easily imagine their finding even older tattoos. After all, two hallmarks of *Homo sapiens* are decoration and self-identification. Seventy thousand years ago, our ancestors were boring holes in shells, probably to string together as necklaces.

They were grinding ochre for body paint. By thirty thousand years ago, they were creating magnificent paintings on the walls of caves. Surely those early humans might have turned their own bodies into cave walls, to display the animals that they worshipped, or to mark their membership in a tribe.

For thousands of years after Ötzi died in the Alps, Europeans continued to mark themselves. The Picts of Britain were covered in blue-tinted artwork. In the tenth century, the Arab writer Ibn Faḍlān wrote that among the Rus (the people of the Ukraine), "every man is tattooed from finger nails to neck with dark green (or green or blue-black) trees."

Tattoos disappeared from Europe as time passed, but they returned with a vengeance in the eighteenth century, when European explorers rediscovered them in other parts of the world. The word *tattoo* first entered the English language when Captain James Cook and his crew sailed through Polynesia in 1769. European sailors learned the local art of the tattoo and brought it back home.

Today, tattoos in Western cultures are at once popular yet furtive. In New Zealand, a high-class Maori warrior would traditionally wear a full-face tattoo, a proud vortex of lines swirling from ear to eye to chin. In London or Los Angeles, a tattoo is more likely to be hidden away, at the base of the back or on a shoulder. Even the most enthusiastic tattoo lover may cut his tattoos short so they won't peek out of a business suit. Likewise, most scientists keep their tattoos to themselves. Some say they'll wait until they get tenure before rolling up their sleeves at work.

But science tattoos are often obscure not just in location but in their very nature. Not many people will recognize the symbol for a

glottal stop inked on a linguist's pinky finger. At the sight of an equation, few people will call out, "Nice Euler's Identity!"

Many scientists are also teachers, but these tattoos are not dermal pedagogy. Scientists get tattoos in order to mark themselves with an aspect of the world that has marked them deeply within. It is not simply the thing in the tattoo itself that matters. *Archaeopteryx* is, in itself, just an old bird.

But it is part of the transition dinosaurs made from the Earth to the sky; it is an example of how new forms evolve from old, of how we are so lucky to live in an era where we can recognize fossils not as harmonic formations taken on by rocks themselves, but the flattened and preserved impressions of creatures that lived millions of years ago. These tattoos are a tribal marking: they display a membership with the universe itself.

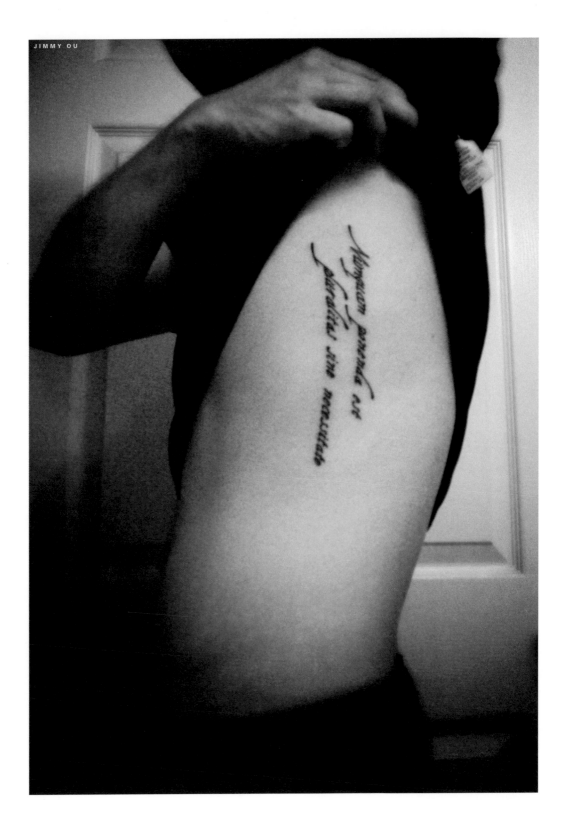

Occam's Razor

AT THE HEART of all science is a desire for elegance. There are many ways to explain the world, some hideous with bloated clumsiness, some beautiful in their sleek brevity. Medieval scholars were the first to champion simplicity in all things—mathematics, philosophy, logic, science, and theology—but this desire came to be associated most closely to William of Occam, a fourteenth century monk. William of Occam argued that the best explanation was the simplest, and centuries later this view of science came to be known as Occam's Razor.

"This," writes Jimmy Ou, "is a picture of my recent ink in commemoration of getting my Ph.D. in molecular pharmacology: Occam's Razor in its original Latin text—*Numquam ponenda est pluralitas sine necessitate*—roughly translated, 'plurality should never be posited without necessity.' I've always subscribed to this fundamental tenet behind the scientific method not only in my passion for science, but also in my beliefs in philosophy and religion."

Occam's Razor slices away needless assumptions, bells, whistles, and epicycles. In mathematics, its blade is especially sharp. You measure the temperature of a pot of heating water once a minute and search for an equation to explain the change in temperature (y) over time (x). You find that the eqation $y = 9.867 + 1.424\,x$ plots a line that shoots close by the points on your graph. For a better fit, you then try something fancier. You discover that $y = 9.783 + 1.466x - 0.004\,x^2$ traces a gentle curve that also flies close by the points. But despite its extra term, the new equation gets no closer than the first one. Faced with such a choice, Occam's Razor declares, you should choose the shorter equation. The extra clutter adds no important insight; instead, it offers more clutter in which errors can lurk.

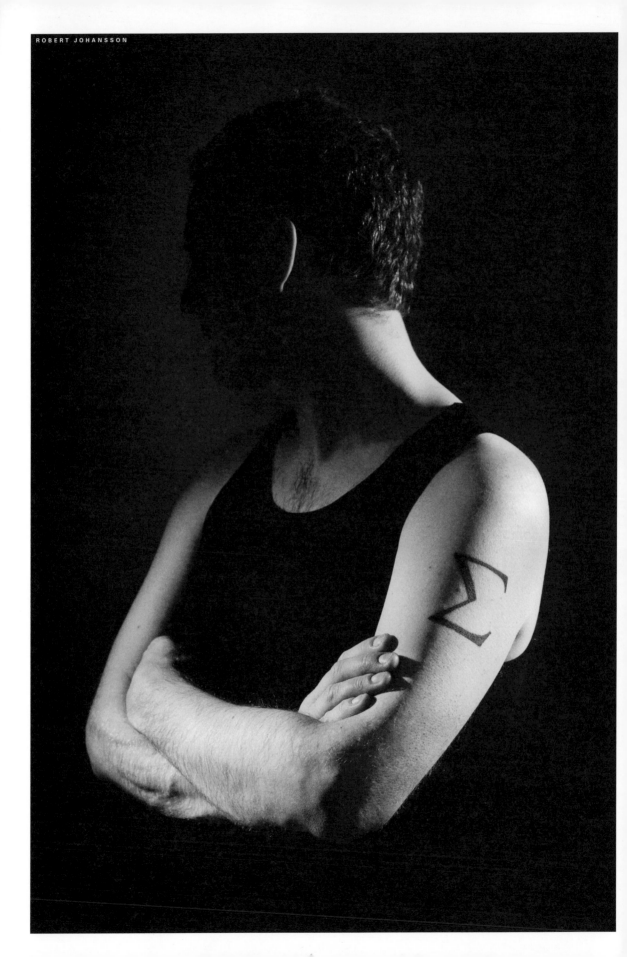

Sigma

T HE GREEK LETTER sigma is an elegant mask for endless tedium. If you put a "j=1" below it, "100" above it, and "j²" to the right, you have given yourself the chore of squaring every number between one and 100 and then adding them all up. Fortunately, mathematicians can hand their sigmas to computers to churn out their sums. They often use sigma without even trying to add anything at all, simply deploying them as part of their proofs.

"I have several reasons for choosing a sigma," writes Robert Johansson. "The simple reason is that I think sigma is really beautiful. The tattoo also represents my love of mathematics in general, and of the beauty of abstract patterns in particular. I'm studying the fourth year on the clinical psychologist programme and didn't want to forget my roots. Mathematics and computer science has shaped my thinking a lot, in a way that's very functional for me these days. I'm very proud of being a mathematician among the psychologists, or maybe a psychologist among the mathematicians."

Golden Ratio

AS NUMBERS GO, ½ (1+√5)—about 1.618033988749—doesn't seem like it should be all that interesting. But a little geometry shows that it's about as close as a number can get to an acid trip.

Start with a rectangle that measures 1 unit on one side, and ½ (1+√5) units on the other. Draw a line across the width of the rectangle, so that it becomes a square and a smaller rectangle. The new rectangle you've drawn has the same proportions as the one you started with: one side is ½ (1+√5) times bigger than the other.

Draw a line through that smaller rectangle to make a smaller square, and you'll find, once more, that the even smaller rectangle you've drawn has the same shape. Draw and draw, and each time you'll be left with a rectangle that's a perfect replica in miniature of the original one.

The magical power of this ratio led mathematicians to dub it the Golden Ratio. It seems to travel throughout the mathematical world, surfacing in unexpected places. Draw a line and cut it into two parts, which we can call a and b. Now imagine that the ratio of a to the entire line is the same as the ratio of b to a. Mathematically, we'd say a+b/a is equal to a/b. A little algebra reveals these two values will only equal each other if they match the Golden Ratio.

The Golden Ratio turns up in arithmetic, too. Add 1 to 1 to get 2. Then add 1 to 2 to get 3. Add 2 to 3 to get 5, and continue adding each sum to the previous number in the series. You get a pattern, known as Fibonacci numbers, that runs 1, 1, 2, 3, 5, 8, 13, 21... Now divide each number in the series into the one that came before. The results are 1, 2, 1.5, 1.666, 1.4, 1.62... The higher you climb through the Fibonacci numbers, the closer this procedure takes you to the Golden Ratio.

The Golden Ratio has even penetrated life itself. If you cut up a rectangle according to the Golden Ratio and then draw a curve across each square, you trace a spiral. This spiral just so happens to have the same proportions as the chambers of a nautilus shell. The spirals of seeds on the head of a sunflower are Fibonacci numbers.

The Golden Ratio is reason for hope. It hints to us that the order in our heads reflects hidden order in the universe.

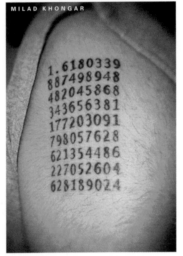

MILAD KHONGAR

1.6180339
887498948
482045868
343656381
177203091
798057628
621354486
227052604
628189024

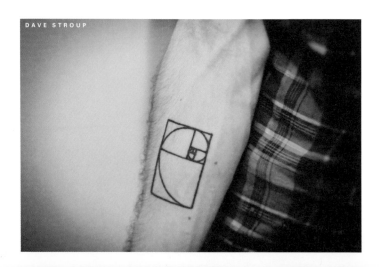

DAVE STROUP

SIOBHAN BRAYBROOK

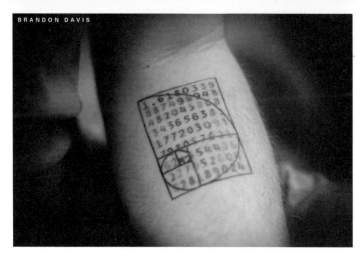

BRANDON DAVIS

Euler's Identity

THE BRIEF EQUATION $e^{i\pi} + 1 = 0$, is known as Euler's identity, named in honor of its discoverer, the eighteenth-century mathematician Leonhard Euler. It may not take up much room on the bodies of physicist Tristan Ursell and mathematician Billy Hudson, but what it lacks in size it makes up in majesty.

"Numbers are the language of nature," writes Ursell, "and as a physicist, I always felt this was one of the most beautiful sentences in that language."

It takes a little while to unpack that beauty. We must begin at the equation's beginning. The mathematical constant e is equal to about 2.718281828, although its digits will run on forever, if you let them. The curve on the graph below is $y = 1/x$. The area under the curve between 1 and e is 1.

need only use this equation: 100 times $e^{.05}$. Simple as that.

Next comes i. It's the square root of negative one. By the ordinary rules of mathematics, no such number should exist. If you multiply a number by itself, even a negative one, you always end up with a positive number. Some Renaissance mathematicians pondered the square root of negative one anyway, but eventually it came to be known by the derogatory name, "imaginary." It wasn't until Euler and other mathematicians in the 1700s explored imaginary numbers that they realized how important they could be. Euler's identity is a case in point.

Euler did what might seem a dangerous thing. He raised e to the power of i and then multiplied it by π—the ratio of the circumference of a circle to its radius. Like e, π is

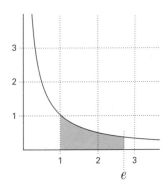

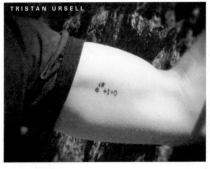

TRISTAN URSELL

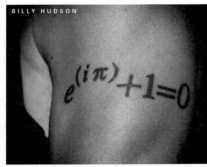

BILLY HUDSON

You might think that e is an arbitrary number with no particular importance. But it turns up again and again in mathematics, often making the life of a mathematician much easier. Say, for example, that you have a hundred dollars in a bank account that is continually accruing interest at an annual rate of five percent. To figure out how much money you'll have at the end of the year, you

a number with a beginning ($3.14159265\ldots$) but no end. You'd think that combining these numbers together would be the mathematical equivalent of a train wreck. And yet just the opposite happened. Euler did not end up with gibberish. Instead, he simply added 1 and ended up with zero: the perfection of silence.

Taylor's Sine

"MY TATTOO IS the Taylor expansion of sine," writes Nicole Ackerman, a physics graduate student at Stanford University. "I consider it the most beautiful thing I have ever learned."

It's nighttime. You clip a light to a spoke on the wheel of your bicycle. It starts out at the top, and as you start to ride, it starts to travel around the wheel. When it comes back up to the top again, it—and the bicycle—have moved forward. If you plot the position of the light on a graph—its rising and falling height versus its forward movement—you end up with a series of crests and troughs known as a sine wave. The distance from the top of one crest to the next is not hard to figure out: it's simply pi (π) times the diameter of the wheel.

But how high is the light if you ride two feet? Or two miles? Pi can't help you now. Now you need the help of an eighteenth century mathematician named Brook Taylor.

Taylor realized that he could approximate the Platonic beauty of a sine curve by bending a straight line into a series of curves: $y = x$ is simply a diagonal line, for example, but $x - x^3/3!$ bends the line into a pair of humps, one veering off to positive infinity, the other to negative infinity. Each new term bends the line more, adding more humps. If you let x stand for how long you ride your illuminated bike, y will tell you, to a good approximation, how high the light is. You would have to add an infinite number of terms to a Taylor series to reach a perfect sine curve. But in this life, a finite Taylor series will do just fine.

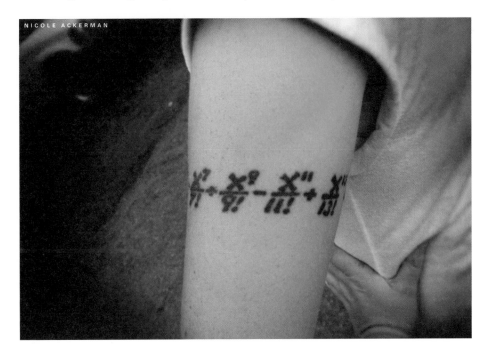

NICOLE ACKERMAN

Fourier Transform

NOISE—SUCH AS the noise that assaults our ears on a bad phone line—is actually the sum of many different frequencies of sound. In the early 1800s, the French mathematician Jean-Baptiste Joseph Fourier discovered a procedure, now called the Fourier transform, to break noisy signals down into their ingredients. The Fourier transform pervades technology today. Cell phones use it to separate the voice of a caller from the static that envelops it on its journey from cell tower to cell tower. Computer programmers use a variant of the Fourier transform to shrink the complexity of a picture down to a series of waves, the equations for which can be quickly shot across the internet and then used to rebuild it on another computer. And scientists use the Fourier transform to expose the hidden regularities in nature's noises. Over millions of years, for example, the Earth's climate has warmed and cooled in a series of spikes of many sizes. Like a prism dividing light into a rainbow, a Fourier transform reveals the many cycles that help drive the climate: the wobble of the Earth, the twinge of its orbit.

"I got this tattoo, which encircles my left wrist, in 2000," writes Andrea Grant, who earned a Ph.D. in climate science in Switzerland before becoming a high school science teacher in Minneapolis. "I had done a lot of work with Fourier transforms on the research project I was involved in as an undergrad physics student, and I just find the entire concept very beautiful.

"As an added 'feature,' the artist made a small mistake on the inside of my wrist (the $n=4$ line disappears for a bit). This really bugged me at first until I decided it was a good metaphor for how the messy reality of life is never perfectly represented by our mathematical theories."

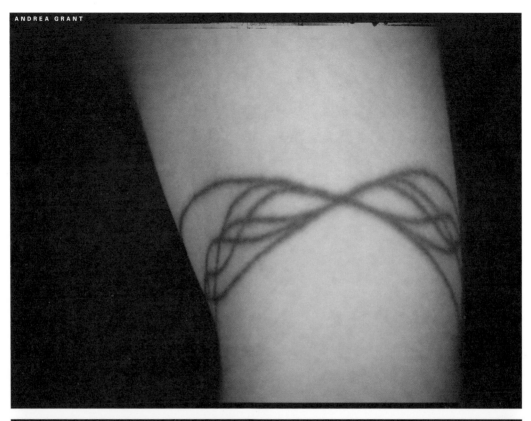

Cantor's Theorem

THE NINETEENTH CENTURY mathematician Georg Cantor discovered that infinity comes in many flavors. He realized this great truth as he pondered sets of numbers. A set can be finite—such as a set that includes the numbers 1 and 2. But if you counted forever, your set would expand to infinity. By thinking of numbers as sets, Cantor was able to uncover some of infinity's rules.

Consider the set that contains the numbers 1 and 2, which mathematicians write as {1,2}. It contains two members—1 and 2—but it also contains four subsets: {}, {1}, {2}, and {1,2}. (The set {} is known as the empty set.) Collectively, these four subsets are called the power set of {1,2}. In general, Cantor realized, a set with n members has a power set with 2^n members.

"Cantor's Theorem," writes Melissa Schumacher, a philosophy graduate student at MIT, "says that the power set of any set is strictly larger than the set itself. For finite sets, this is pretty obvious. But Cantor's Theorem is also true for *infinite* sets, which is kind of unexpected. After all, the set of all even numbers is the same size as the set of all numbers—why does the power set of the set of all numbers have to be bigger? That's why the proof of the theorem is so cool. It proves it for finite sets and infinite sets, no matter how huge, at the same time."

An infinite set must have a power set that's bigger than itself. In other words, there are infinities bigger than infinities. While this may be a mind-boggling thought, Cantor's Theorem actually made life easier for all mathematicians since. He gave infinity a solid philosophical footing, making it more manageable in mathematical equations. "No one shall expel us from the paradise which Cantor has created," declared the mathematician David Hilbert.

"When I saw how short and simple (and beautiful!) the proof of such a powerful theorem was," writes Schumacher, "I knew I could spend the rest of my life doing set theory and logic. So last year, when I got my bachelor's degree in philosophy and went on to grad school, I celebrated by getting the theorem tattooed on my arm."

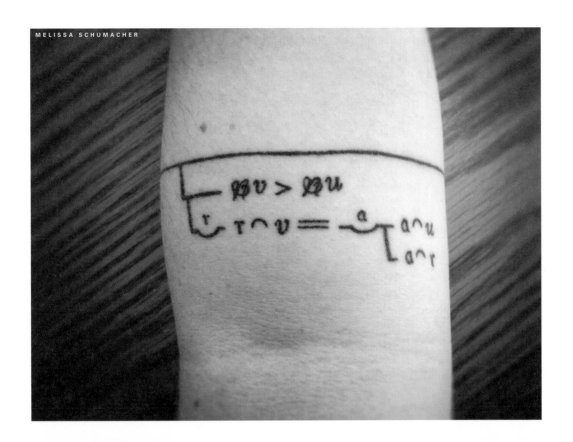

Set Theory

THE GERMAN MATHEMATICIAN Georg Cantor took some crucial things for granted when he established set theory. He never precisely stated what a set actually is, for example. Could any collection of objects be a set? In the early twentieth century, Ernest Zemelo started to rebuild set theory at a deeper level, so as to answer such basic questions. Over the next few decades he and other mathematicians were able to turn set theory into a series of logical statements, from which all of mathematics could be derived. Their work came to be known as the "Zermelo-Fraenkel with Choice axioms" of set theory. This hideous name must play some part in the fact that most people don't know what makes modern mathematics possible.

"From these nine axioms," writes Turing Eret, a software designer in Colorado "one can derive all of mathematics. These provide the foundation of mathematics, a field that you can likely tell that I love dearly."

$$\lambda f.(\lambda x.(f\,(x\,x))\,\lambda x.(f\,(x\,x)))$$

Null Set

FOR LEXICOGRAPHERS, the origin of many words will always lurk in a fog. No one can say who first uttered the word *eye*. But historians of mathematics have it easier: often they can point to the very page on which a mathematical symbol first appeared. In the case of the empty set, the year was 1939, and its creator a French mathematician named Nicolas Bourbaki, who in that year published one part of a multi-volume work called *Elements of Mathematics*. Bourbaki called for a symbol for the set that contains no elements in it, and proposed a circle with a diagonal slash to represent *"la partie vide."*

Nicholas Bourbaki, it turns out, was himself an empty set. In the 1930s a group of French mathematicians started meeting to write a new mathematics textbook. Soon they decided they couldn't write the book until they had reorganized mathematics into a much clearer system than the one they had been taught. Rather than just teach ordinary two-dimensional geometry—the sort you can draw on a piece of paper—they wanted a full-blown theory for geometry in any number of dimensions. They decided that they would publish their work not under their real names, but as a single pseudonym—Nicholas Bourbaki.

The name itself came out of a deception: many of the members of the group had gone to a lecture at school given by an old mathematician who called himself Nicholas Bourbaki, but who turned out to be another student who put on a fake beard and spouted nonsense.

The Bourbaki group met three times a year. They shouted at each other, threatened to resign, vetoed anything they didn't like, and otherwise had a grand time. "Certain foreigners, invited as spectators to Bourbaki meetings, always come out with the impression that it is a gathering of madmen," wrote Bourbaki member Jean Dieudonné.

Science fiction author Scott Sigler wears the symbol for the empty set on his shoulder. Unlike most of Bourbaki's innovations, it was actually the idea of one member in particular, Andre Weil. "The symbol came from the Norwegian alphabet," Weil later wrote, "with which I alone among the Bourbaki group was familiar." Years later, he was able to see just how big of an effect Nicholas Bourbaki had on the world. In addition to their new ideas in mathematics, the group behind Bourbaki also influenced how math was taught to children. The push away from rote memorization of arithmetic to concepts of *greater than* and *less than*, of overlapping sets—what came to be known as "New Math"—was driven by Bourbaki.

"My own part in these discussions earned me the respect of my daughter Nicolette," Weil wrote, "when she learned the symbol Ø for the empty set at school and I told her that I had been personally responsible for its adoption."

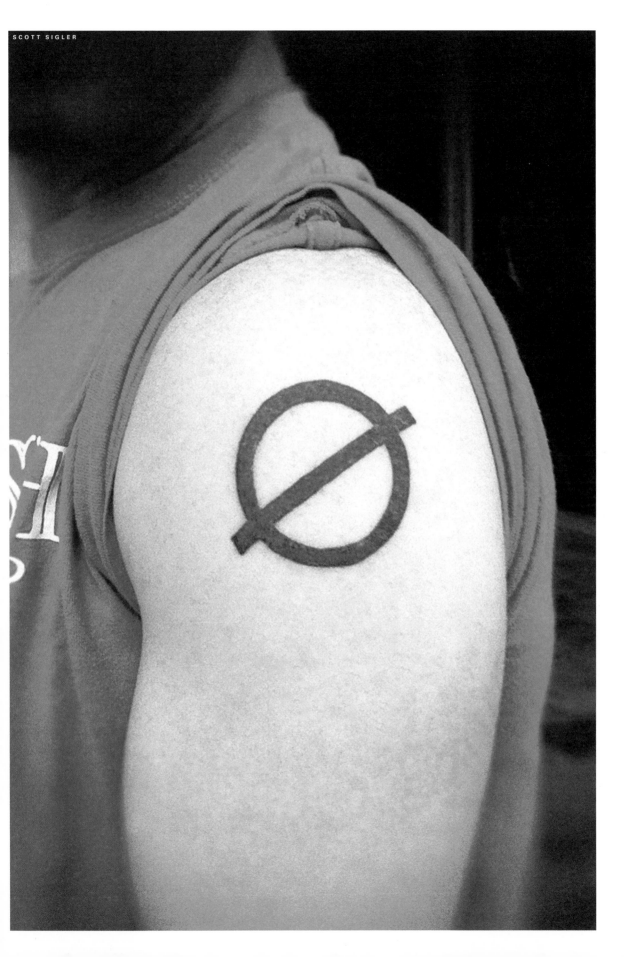

Infinity Laplacian

"ONE OF MY clearest memories from childhood was when I first saw the Greek symbol π, when I was about six years old," writes Gregory von Nessi, a physicist at Australia National University. "I had asked my father to tell me what the symbol meant, and even though I didn't understand what he was saying about circles or mathematical constants, my curiosity about all the secrets locked up in this odd looking symbol exploded.

"Over the next few years, I kept asking my parents for books on calculus and trigonometry; and soon, I was swamped with symbols and ideas that were new, mysterious and wonderful to me. Even though I didn't understand many of the concepts in those books I was reading as a child, I was hooked and have been pushing the limits of my understanding of math and science ever since.

"Two of my great loves are pure mathematics and experimental physics. Eventually, I ended up getting my Ph.D. in pure mathematics studying partial differential equations (PDEs). After completing my Ph.D. I decided to try to apply my understanding of PDEs to physics. I am now working as a scientist studying nuclear fusion as a future clean energy source."

One of von Nessi's tattoos (shown opposite, upper right) is of a formula called the Infinity Laplacian. It represents the ways in which the universe minimizes energy—why objects fall to Earth, why certain radioactive elements cast off particles, why a film of soap bends into a bubble. By understanding how the universe minimizes energy, von Nessi may learn how to unleash more of it here on Earth.

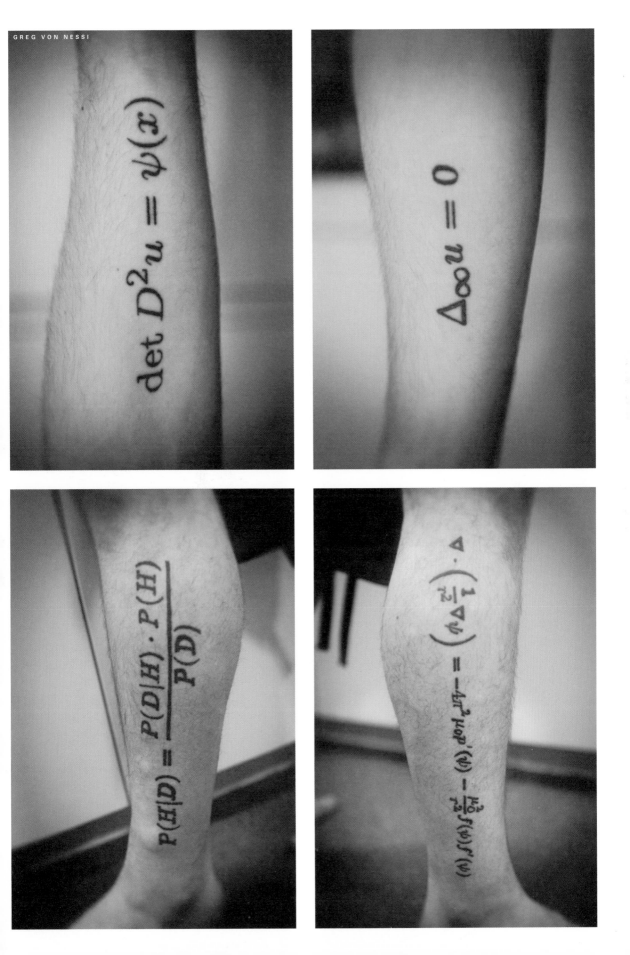

Binary Ink

HELEN HYDE AND Zacharia Hoffman both encoded names using binary code. Hyde wrote her own maiden name just before she got married, while Hoffman's tattoo spells out his daughter's name, Lain.

Our digital age is defined by ones and zeros, but binary codes reach back centuries. Mathematicians in China and India explored them, as did the seventeenth-century German mathematician Gottfried Wilhelm Leibniz. He converted ten-base numbers down to a string of ones and zeros, and demonstrated how easy they were to add. Two centuries later, the British mathematician George Boole used binary codes to represent logical propositions. If-then statements and the like would later turn out to be perfect for programming computers. And now we spend much of our time on computers sending messages to friends and exchanging photographs of loved ones. We are like Hyde and Hoffman, preserving names in strings of numbers.

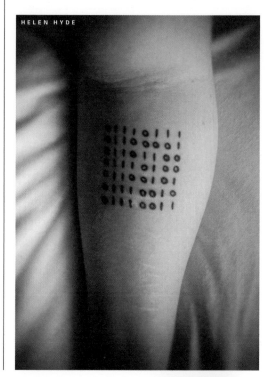

HELEN HYDE

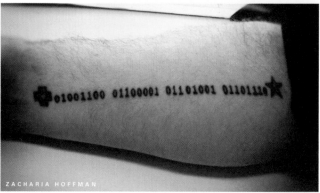

ZACHARIA HOFFMAN

Game of Life

"HOW DO YOU define a cat?" the British mathematician John Conway once asked. "I have no idea."

For Conway, math was easy, and life was hard—hard in its messiness, in its durability, in its unpredictability. He thought that perhaps in the simplicity of math, he might find a clue to how life emerged. And so, in the late 1960s, he developed a game. It is simple enough that you can play it with checkers on a checkerboard, although a computer makes it easier. The Game of Life has only a few rules. If a checker has fewer than two immediate neighbors, you take it off the board. If it has more than three neighbors, you also remove it. Any checker with two or three neighbors survives to the next round of the game. And if an empty square has three neighbors, you set a checker piece in it.

Conway discovered that certain arrangements of checkers seem to come to life. Some glide across the board, retaining their shape for the whole trip. Some split apart, as if breeding. Others blast checkers like artillery. And others flicker like pulsars. These life-like shapes all hint at how complexity can emerge from simplicity. Conway never quite made a cat in the Game of Life, but his checkers certainly purred.

"My tattoo is of the 'glider' formation from John Conway's Game of Life," writes Jordan Bimm, a graduate student in science and technology studies at York University in Canada. "As a history of science student I love this geometric arrangement and its promise of self-contained (not viral) reproduction, and travel."

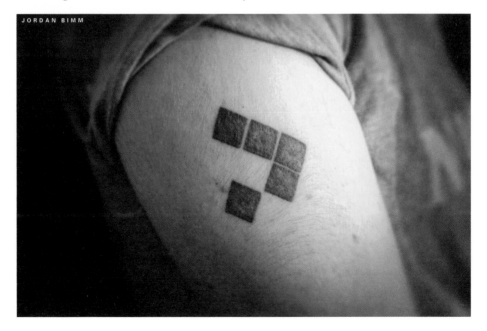

JORDAN BIMM

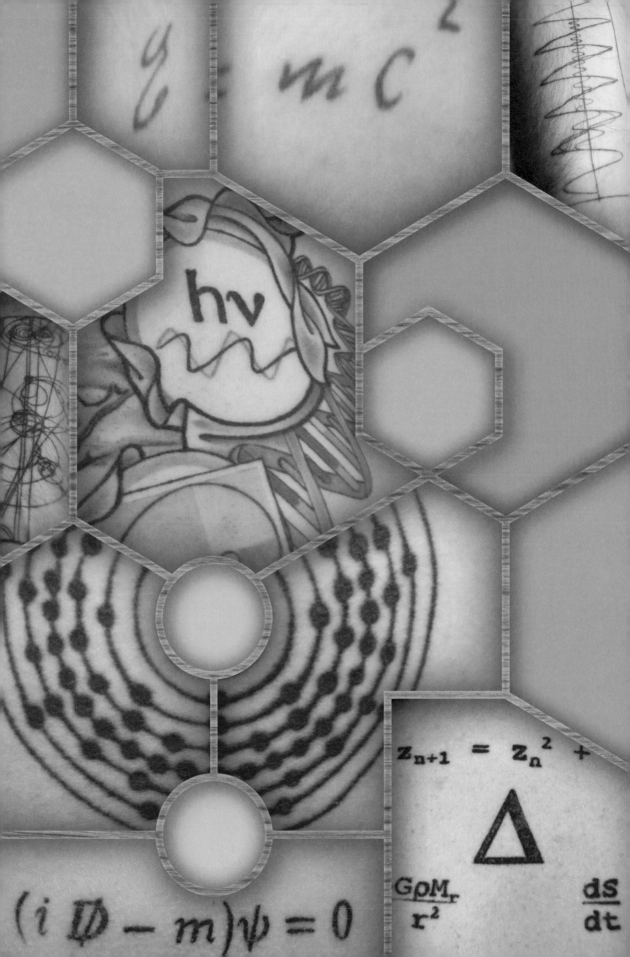

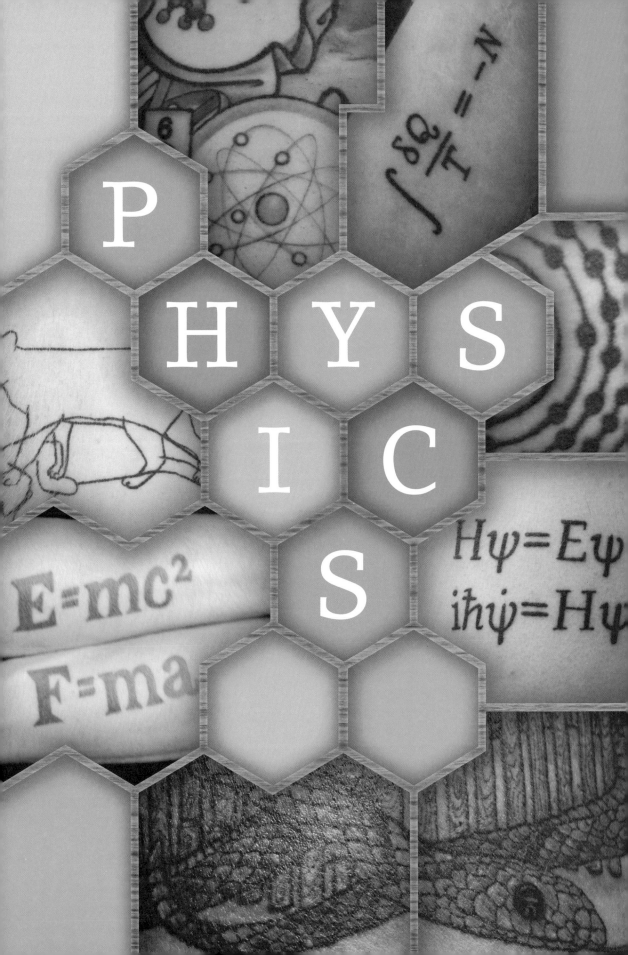

Giants

"MY TATTOO TALKS about the real scientific spirit," writes Dônovan Ferreira Rodrigues, a Brazilian geneticist. "It's a phrase in Portuguese of Isaac Newton: 'If I have seen further it is only by standing on the shoulders of giants.'"

DÔNOVAN FERREIRA RODRIGUES

In the competition for best-known fact about Isaac Newton, the apple on the head wins the gold, but his quip about the shoulders of giants gets the silver. Neither fact is as simple as it seems. Newton never said that he was hit on the head by an apple; instead, he said that watching an apple fall from a tree helped him formulate his theory of gravity. Even the tree itself is a subject of dispute, with different manors and schools in England claiming it still grows on their grounds.

Newton is also famous for talking about standing on the shoulders of giants, but the image is an ancient one. The notion took on different meanings through the ages. For medieval scholars, it meant that their wisdom was meager compared to the great minds of ancient Greece and Rome. In 1621, the Oxford scholar Robert Burton wrote that "a dwarf standing on the shoulders of giants might see further than a giant himself," referring to the paltry talents of the poets and philosophers of his day.

When Newton used the phrase fifty-five years later, he gave it a new shade of meaning. At the time he was in the early rounds of a major spat about the nature of light. The French philosopher René Descartes had envisioned light as waves rippling through the ether. Newton believed instead that light was made of particles; white light was a mix of particles of different colors.

The naturalist Robert Hooke protested that he had thought of the particle theory first, and that he had found evidence for it by passing light through thin plates. Newton responded with a conciliatory note. "What Descartes did was a good step," he wrote. "You have added much several ways, and especially in taking the colours of thin plates into philosophical consideration. If I have seen a little further it is by standing on the shoulders of Giants."

In Newton's letter, physics is not the work of ancient giants. Instead, it ascends. Descartes, Hooke, and Newton are all arranged as if on a scientific totem pole. Newton's now-famous words were not enough to forge peace between the two natural philosophers, however. They continued to bicker until Newton withdrew from public debate for good.

Somehow that bitter ending has been forgotten, as Newton became memorialized by

the giants' shoulders. When the physicist Stephen Hawking published a collection of works by great physicists in 2002, he entitled it, *The Shoulders of Giants*.

It is how we like to think of science. A high school student with a decent physics teacher knows more than Newton. But how tall will we stand in our own time?

Bike Physics

ANDY GATES, a lifelong bicyclist, decided to get a tattoo in celebration of twenty-five years in the saddle. He discovered the book *Bicycling Science*, written by MIT physicist David Wilson. Paging through it, Gates found an equation distilling the act of bicycling to its essence. "It describes the power needed to propel a bike against our everyday foes: gravity, weight, friction, wind resistance," Gates writes. "And it describes beautifully the way that the linear components of the resistance give over to the fat, slamming wall of wind resistance."

ANDY GATES

Continuity Equation

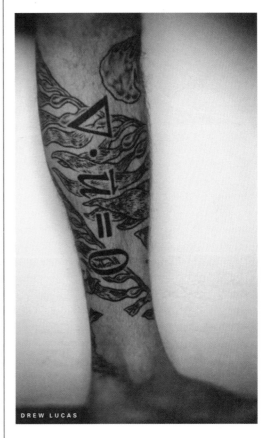

DREW LUCAS

DREW LUCAS, a postdoctoral researcher at the University of Cape Town, studies the flow of the ocean. The formula on his leg, he writes, "is the incompressible form of the conservation of mass equation in a fluid, also known as the continuity equation.

"When people ask what it means, I say it defines flow. What it means in more detail is that, for an incompressible fluid, the partial derivative of the velocity of the fluid in the three spatial dimensions must sum to zero. It therefore concisely states the fundamental nature of a fluid."

Giant kelp envelops the equation. "The kelp is depicted specifically in a flow field—not to mention rendered around the equation for flow—because physical flows are important for the giant kelp," Lucas writes. "As in the case of my research on phytoplankton, fluid flow is the source of the nutrients that are vital for kelp photosynthesis and growth, among myriad other influences. In fact, kelp forests in turn influence fluid flow, baffling coastal currents and damping waves. It is a two-way street, and one of a relatively small number of examples of biology altering physical oceanography on relatively large scales."

𝕰ntropy

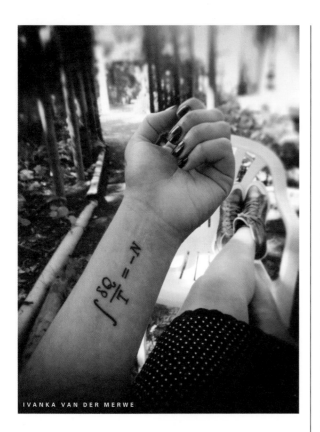

IVANKA VAN DER MERWE

IN THE EARLY 1800s, steam trains began to puff their way across Europe. British trains were far superior to those of France, a fact that annoyed a French military engineer named Sadi Carnot to no end. Carnot began to investigate the physics of steam engines for the good of *la France*. Along the way, he realized that no French engineer would ever be able to make a perfectly efficient steam engine. But at least he could comfort himself with the fact that no British engineer would either. When any steam engine generates energy, some of that energy inevitably turns into heat that is lost instead of being turned into useful work.

Carnot's resignation to imperfection, to loss, to dissipation, gathered more strength over the nineteenth century. It developed into a measurement of the disorganization of a system, known as entropy. In a closed system, physicists realized, entropy always increases. Eggs never unscramble themselves.

Ivanka van der Merwe (left) got a tattoo of the formula for entropy after graduat-

ing from college and heading to the London School of Economics to study game theory. "The sentiment behind this is that now, after undergrad, we begin to disseminate," she writes.

Abigail Garcia got her entropy tattoo (right) in her freshman year at Reed College in Portland, Oregon. "I wanted to be an English major, and I took Intro Chemistry to fill the science requirement. The brief unit on thermodynamics made me fall totally in love," she wrote when she sent it to me in 2008.

"Entropy made sense to me—scientifically, philosophically. I became a chemistry major and love every second of it. I got the tattoo to mark my rite of passage—Entropy going both ways, with its symbol delta-S in the middle, all supported in the roots of Yggdrasil, the world-tree of Norse mythology (harking back to my English-lit days)."

Four months later, Garcia's mother, Tamara Thomas, left a comment about the image on my blog, "The Loom." "Abigail is my daughter. I was with her when she got this tattoo last March," she wrote. "It was an adventure for both of us. She came home for the summer in May, and four days later was in a fatal car accident. I will be getting this same tattoo next week—Abigail's personal design—from the same artist. It will memorialize both my daughter and her intellect and passion for science and philosophy."

A year later, a woman calling herself Sherrie left a new comment on "The Loom." "I wanted to share another side of Abigail, whom I only just 'met' today," she wrote.

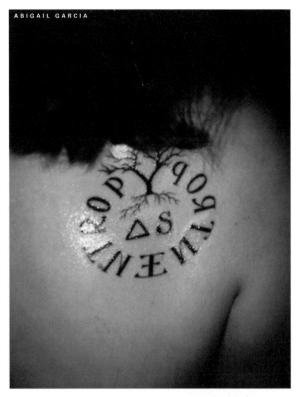

ABIGAIL GARCIA

"On May 23, 2008, my mother had a double lung transplant. On May 23, 2009 we celebrated her one-year birthday with a new life. At this time, my mother initiated contact with her donor's family (via her transplant team). Today, I learned that Abigail was my mother's donor. When my mom finished reading the letter, of course crying the entire time, she said, I feel so honored to have been chosen to receive such an amazing child's gift. We feel truly blessed, and honored, to have been given a second chance."

Life and memory alike defy the relentless grind of entropy.

Newton & Einstein

TWO EQUATIONS, each sweet and short, run along the arms of Adam Simpson, who works at the National Center for Computational Sciences. One appeared in Newton's *Principia Mathematica* in 1687. In three letters, it describes how any object moves through the universe, driven by a push, a fall, a spark. The other appeared 218 years later, in a paper by a young patent clerk named Albert Einstein. An object did not

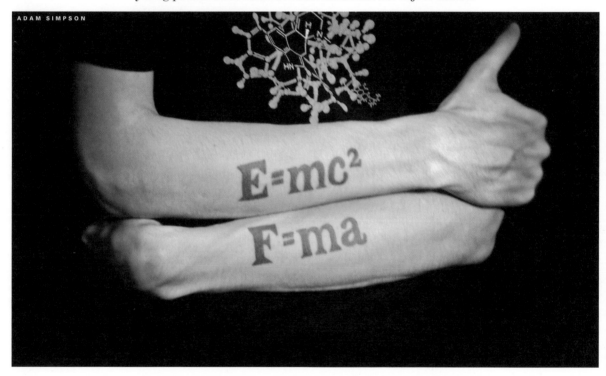

ADAM SIMPSON

just have energy from its movement, Einstein declared, but had energy hidden away in its own mass. $F=ma$ explains to an astonishing degree how the planets make their way around the sun. $E=mc^2$ explains how that sun is able to supply those planets with so much light.

"I got the tattoos because it's amazing to me how just a few characters can impact the world so much, and I want others to know that," Simpson writes. "I don't think most people understand just how important these equations are, but with the tattoos, I have a way to strike up conversations and get people interested in the physics behind them."

𝔈 = 𝔪𝔠²

ERIN MACDONALD IS a graduate student at the University of Glasgow, studying the gravitational waves from pulsars. "When I started studying physics," she writes, "the classic equation, $E = mc^2$ simply blew my mind. So much energy was stored in any mass around us. This surprising and

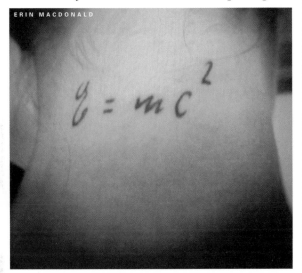

ERIN MACDONALD

enlightening equation is what piqued my interest and made me want to study physics and mathematics further. I decided to get this equation on the back of my neck and in Einstein's original handwriting. Not only did I pick this equation because of my own history with it, but my current Ph.D. is based on Einstein's Theory of General Relativity, so I had to tip my hat to the man himself—hence the handwriting."

𝔘𝔯𝔞𝔫𝔦𝔲𝔪

DENISE AKOB IS a post-doctoral research fellow at the Institute of Ecology at the Friedrich-Schiller University in Germany, where she studies how to clean up uranium in the soil with microbes. When she earned her Ph.D., she celebrated by getting a tattoo of the element.

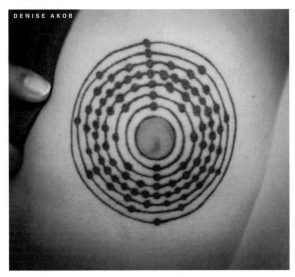

DENISE AKOB

Uranium is an element in flux, always ready to change identity. And our own experience with uranium has gone through a flux of its own over the past two centuries. It was first discovered in the silver mines of Germany, where it appeared as a dark, shiny metal. The chemist Martin Klaproth purified it in 1789. He would have been entitled to name it after himself. It is not Klaprothium thanks to his modesty. Instead, Klaproth decided to name it in honor of the planet Uranus, which had recently been discovered. Hence, uranium.

Now named, uranium slipped into a mundane existence for a century. It brought bright colors to glass, porcelain, and ceramics. But

in 1896 a French scientist named Henry Becquerel discovered a hidden power in the element. He put a uranium compound on a photographic plate and tucked it in a drawer. When Becquerel took it out again a few days later, he discovered that it had become fogged. The uranium was casting off invisible rays that could change the color of the plate, like the light of the sun.

Becquerel's discovery would help open the way to a modern understanding of atoms—as unions of subatomic particles that could, in some cases, break down. Uranium could turn into lead as it produced radioactive particles. Within fifty years of Becquerel's discovery, the peculiar black metal would unleash fireballs over Nagasaki and Hiroshima, would generate power for hundreds of millions of people, and would inspire a cadre of scientists like Akob to figure out how to clean it up.

Rutherford Atoms

BY THE END of the nineteenth century, Henry Becquerel and his colleagues had demolished the old notions of atoms. Something new had to take its place. Physicists knew that atoms contained smaller particles inside of them, each with a particular charge. The physicist J. J. Thompson suggested that the particles were scattered throughout the atom like currants in a bun. To test Thompson's model, the physicst Ernest Rutherford ran a simple experiment in 1911. He used a piece of radioactive thorium to create a beam of alpha particles. He pointed the beam towards a piece of gold foil. Most of the alpha particles passed straight through the foil, but a few bounced back.

Rutherford realized that atoms were not currant buns. He proposed instead that many of its particles were packed tight at the center. Together, the particles could bounce an alpha particle back from whence it came. But alpha particles that missed the center of the atoms just whizzed through the void. Rutherford dubbed this pack of particles the nucleus. He envisioned electrons orbiting

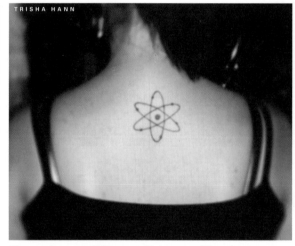
TRISHA HANN

the nucleus at different distances, like planets around a sun.

Today Rutherford's image of the atom has a retro look, a quantum physics version of the tail fins on a vintage Cadillac. We know that the atom works very differently than the Rutherford model. But we must not forget how different the Rutherford model was from earlier ones. In its time, his model did a better job explaining the world than anything that came before. That is all that we can expect science to do.

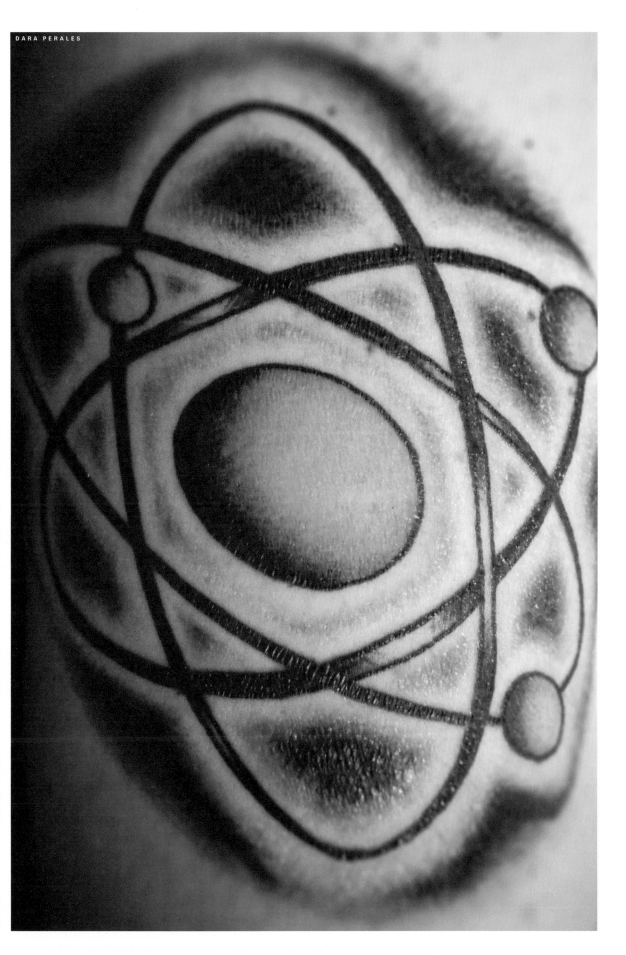

Pi Orbitals

"I MADE THIS TATTOO when I was second year student in physics," writes Anastasia Gonchar, who is getting her Ph.D. in chemical physics at the Fritz Haber Institute of the Max Planck Society in Germany. "I had just started my first scientific project and this simple but beautiful shape impressed me."

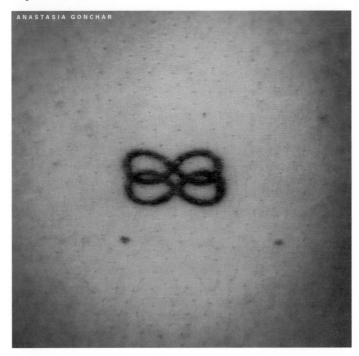

ANASTASIA GONCHAR

This beautiful shape is what took the place of Rutherford's solar-system atom in the early 1900s. Electrons do not in fact travel around the nucleus like planets around the sun. Instead, they exist as a cloud of probabilities. Depending on the atom an electron belongs to, it may pop up in a particular region surrounding a nucleus. Gonchar's tattoo shows one type of cloud, known as a p orbital. When the clouds of two p orbitals overlap, they can bond a pair of atoms together. The electrons may be everywhere and nowhere, but the bonds they create help keep the world from flying apart.

𝔚𝔞𝔳𝔢 𝔑𝔞𝔱𝔲𝔯𝔢

STEVENS JOHNSON, a physicist at Bemidji State University in Minnesota, has turned his limbs into a montage of icons of modern physics.

The tattoo on Johnson's right shoulder (below) is an abstract representation of a photon—a particle of light. The Victorian physicist James Clerk Maxwell realized that light is an oscillation of both electricity and

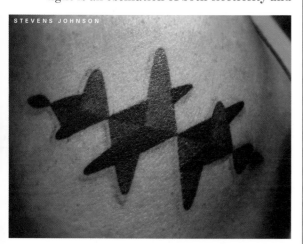

STEVENS JOHNSON

magnetism—here represented in red and black curves respectively. "The tattoo artist suggested adding the faint shadows to give it depth," Johnson writes. "The real reason I agreed was the ironic (oxymoronic?) humor of a particle of light casting a shadow."

The tattoo on Johnson's other shoulder represents another way of thinking of light. When a blacksmith heats up a horseshoe, it gives off light—that is, electromagnetism in the visible spectrum. As the horseshoe cools down, the frequency of the light drops. It turns red, and then it slips off into the infrared—what we feel as heat. At the end of the nineteenth century, German physicist Max

Planck pondered the relationship between the light given off by an object and the energy inside it. He came up with an equation that looked simple but was, in fact, revolutionary. In 1900 he proposed that the energy of an object is equal to the frequency of the light multiplied by a constant.

Planck labeled that constant \hbar. If Planck was right, a molecule's energy did not

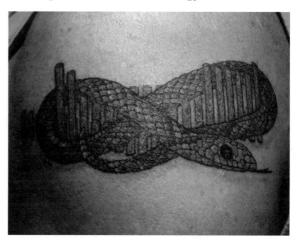

increase or decrease smoothly. Instead, it took little jumps, equal to his constant. Those jumps became the basis of modern physics, and explained how atoms bond together and pull apart.

Johnson's tattoo displays the periodic table of the elements surrounded by a snake with a version of Planck's constant in its eye. "The snake represents the wave nature of matter, and physics in general," writes Johnson. "The combination of the periodic table of chemistry with the Planck snake of physics is also an inside joke at the expense of chemists. It took the quantum mechanics of physics to explain to chemistry its own table of elements."

Quantum Mechs

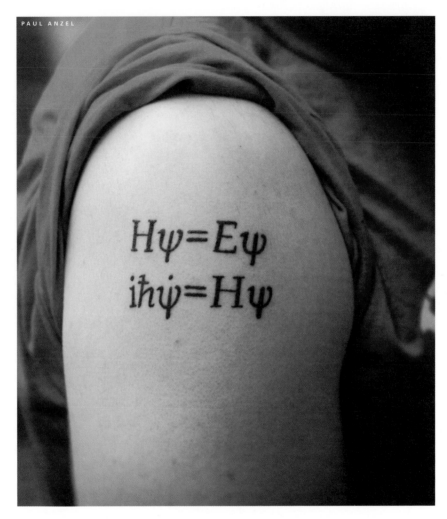

PAUL ANZEL

$$H\psi = E\psi$$
$$i\hbar\dot\psi = H\psi$$

"I GOT THIS TATTOO during my final year as an undergrad in chemical physics," writes Paul Anzel, a graduate student at Cal Tech. "One of my favorite things I've studied has been quantum mechanics; I'm still amazed by its mystery and its particular odd logic, how different the subatomic world is from our 'classical' universe. I'm now a physics graduate student doing acoustics research — a jump back into the 'classical' world but full of its own surprises. Perhaps my Ph.D. will end up somewhere else on my skin."

Schrödinger's Wave

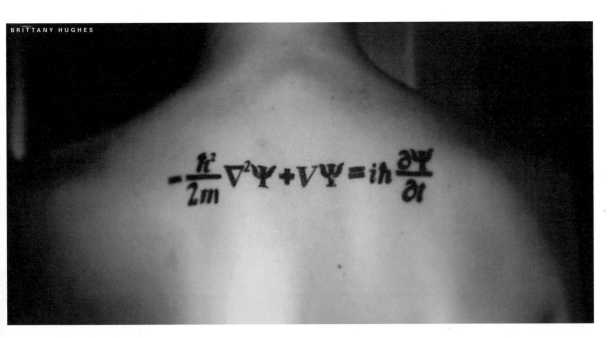

BRITTANY HUGHES

$$-\frac{\hbar^2}{2m}\nabla^2\Psi + V\Psi = i\hbar\frac{\partial\Psi}{\partial t}$$

"I'M 24 YEARS OLD and an aficionado of quantum physics," writes Brittany Hughes, a student at Bryant & Stratton College in Glendale, Wisconsin. "I aspire to be a particle physicist—so watch out, Fermilab. My tattoo is Schrödinger's equation for the wave function of a particle. I chose this equation because its elegance and symmetry reflect that of our multiverse."

In 1925, the physicist Erwin Schrödinger left his wife in Zurich and took "an old girlfriend from Vienna," as he called her, on a vacation to the Alps. It wasn't an unusual thing for Schrödinger to do, but historians have never been able to figure out exactly which old girlfriend she was. Whoever she was, she had a tremendous effect on Schrödinger during that holiday. He spent it working out one of the most important equations in the history of science.

Schrödinger had been pondering a paradox of physics. In some experiments, physicists found that electrons behaved like particles, hurtling through space like tiny cannonballs. But in other experiments, electrons seemed to travel like waves, forming ripples of energy in space. Schrödinger came up with an equation that could embrace both explanations at once. Unlike classical physics equations, Schrödinger's equation simply gave the chances that a particle might be in any particular spot. It traded the clocklike world that Newton had envisioned for a fuzzy universe that our brains will never be able to truly fathom, even in its smallest components.

When Schrödinger came back from his trip to the Alps, a colleague asked him how it went. He didn't get to ski much, he said. He had been distracted by a few calculations.

Schrödinger's Cat

"I'M A BIG FAN of quantum mechanics (regardless of how little I truly understand it)," writes Alex Berg, an actor and comedian, "so getting a tattoo of Schrödinger's cat seemed like a no-brainer. It's on my right forearm, which means it ends up being a good conversation starter after a quick handshake. Either people get what it is right away, or I have the pleasure of explaining 'No, it's not two cats fornicating, it's one superpositioned cat.'"

As quantum physics came into focus in the early 1900s, it became more and more absurd. One prediction of quantum physics, for example, is that particles can be in two or more different states at once. Another is that an electron can be in several different places simultaneously. Still another is that a radioactive atom can decay—and not decay—at the same time. Only when someone observes the particle is it forced into one state.

The Austrian physicist Erwin Schrödinger found this all profoundly ridiculous, despite the fact that he was one of the people who figured it out. In 1935 Schrödinger came up with a thought experiment to show just how ridiculous quantum physics was. Imagine a cat is penned in a steel chamber, he said, along with a Geiger counter. Inside the Geiger counter is a tiny bit of radioactive material. There is a chance that within an hour a radioactive atom will decay and give off a particle. There's a corresponding chance it will not.

If the atom does decay, Schrödinger explained, the Geiger counter triggers a hammer to break a flask with poisonous gas inside. If you leave the cat in the box for an hour without looking at it, the cat will end up both dead and alive. Only when you open the box will it assume either condition.

Schrödinger thought this experiment spoke for itself: something about quantum physics had to be wrong, because cats couldn't be alive and dead at the same time. But he neglected some crucial factors. Superposition—the existence of a particle in two states at once—can only occur in a system that's completely isolated. It has to be isolated not only from observation, but from any interaction with any other particle. Clearly, a Geiger counter in a box alongside a cat and a lot of air molecules is not isolated.

But it is actually possible to build these sorts of systems. In 2000, for example, teams of scientists in the United States and the Netherlands succeeded in building Schrödinger's cats out of loops of superconducting material. Under the right conditions, electric current can flow both clockwise and counterclockwise around the loops at the same time. It may eventually be possible to wire these loops together so that they can process information. Such a network of Schrödinger's cats could serve as a new kind of computer. Far from making the weirdness disappear, it seems, Schrödinger simply helped bring it into our everyday life.

Dirac's Equation

MELINDA SOARES studied physics at the University of California, Santa Cruz before heading for medical school. Before she left, she got a tattoo of Dirac's equation, which is, in its own way, just as beautiful as Einstein's $E = mc^2$.

Its inventor, Paul Dirac, was the sort of scientist who liked to climb trees in a three-piece suit. His biography is entitled *The Strangest Man*. In 1928 Dirac found a way to describe particles using both quantum physics and Einstein's relativity that could account for many of their features. The only trouble with it—at least in 1928—was that it couldn't work unless there existed particles that were opposite all the particles that

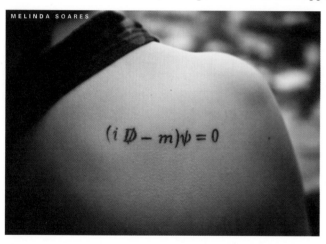

MELINDA SOARES

$$(i \, D\!\!\!/ - m)\psi = 0$$

scientists knew of at the time. Along with the negatively charged electrons physicists were familiar with, the universe must contain anti-electrons: particles with the same mass, but with a positive charge. Fortunately for Dirac, anti-electrons (known as positrons) were discovered not long after he derived his equation. "The fact that a mathematical equation can uncover unknown physical constituents of the universe is absolutely awe inspiring," writes Soares.

Today, this shadow universe is a regular part of ordinary life: the P in PET scans stands for positron. But a great question raised by Dirac's equation remains. When a particle and its antiparticle meet, they vanish in a flash of energy. Why, then, is there anything left in the universe at all? There must be some universal bias, some cosmic thumb on the scale. But it may take another Dirac to identify it.

Particles

"I WAS RAISED WITHIN a fundamentalist Christian sect that admonishes its followers to not seek higher education," writes Darren Cheek, a Colorado musician, "and was otherwise opposed to scientific fact when it came into conflict with a literal interpretation of the Bible. At the age of 33, I *The Demon-Haunted World: Science As A Candle In The Dark* and viewed the entire 'Cosmos' series. As a result my perception of the universe and reality was forever altered. I became obsessed with astronomy and particle physics and began learning everything I could by watching endless documentaries

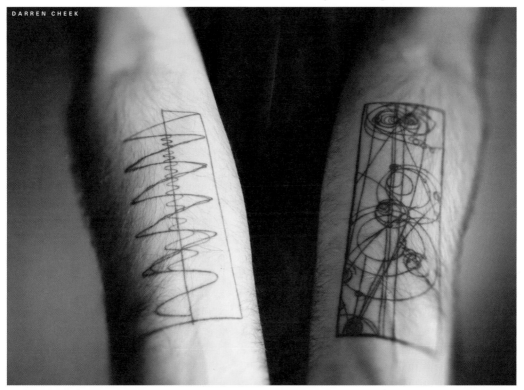

DARREN CHEEK

made the decision to leave the religion and began to voraciously educate myself. As a mark of this transition I decided to have my right arm tattooed (taboo as well within the religion) with a graphic representation of a sine wave being transformed into a sawtooth wave (I'm an analog synthesist to boot).

"Around this time I first read Carl Sagan's and reading incessantly. I got the itch for another tattoo and realized that an image of particles being smashed in an accelerator was just the thing. I had it scaled to match with my previous piece to act as a 'bookend' representing my intellectual journey. By a certain measure of chance, the images combine to portray the properties of light."

Creation Equations

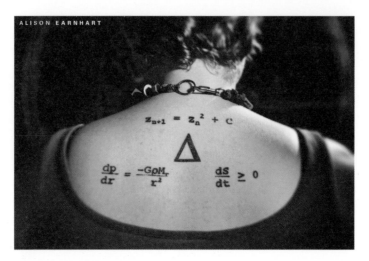

ALISON EARNHART

$$z_{n+1} = z_n^2 + c$$

$$\frac{dp}{dr} = \frac{-G\rho M_r}{r^2} \qquad \frac{dS}{dt} \geq 0$$

"THE WONDER OF the natural laws of the Universe is where I draw my spiritual inspiration," writes Alison Earnhart, a high school science teacher. "I also study the religions of the world, and have been fascinated by the reoccurring theme of creation, preservation, and destruction. The Mandelbrot Set (top) represents creation, with the emergent properties of a simple equation that produces such a rich, complex, and unpredictable fractal pattern that goes on into infinity. The equation for hydrostatic equilibrium (bottom left) represents preservation, describing the precarious balance between crushing gravity and expanding pressure inside of stars (including our own) to keep them in a stable, sustainable size for billions of years. The equation describing entropy (bottom right) symbolizes destruction, simply stating that this fundamental break down of systems and accumulation of disorder either increases or stays the same over time, but never decreases. All three circle around the delta, the symbol for change."

Everything

A GRADUATE STUDENT in molecular biology at Princeton, who asks to be called simply MRL, wears the universe on his chest (overleaf): from the mathematical truths like the golden ratio (bottom right) to the quantum nature of life, and onward to carbon (bottom left), DNA (top right), glucose (top left), and the tree of life (center).

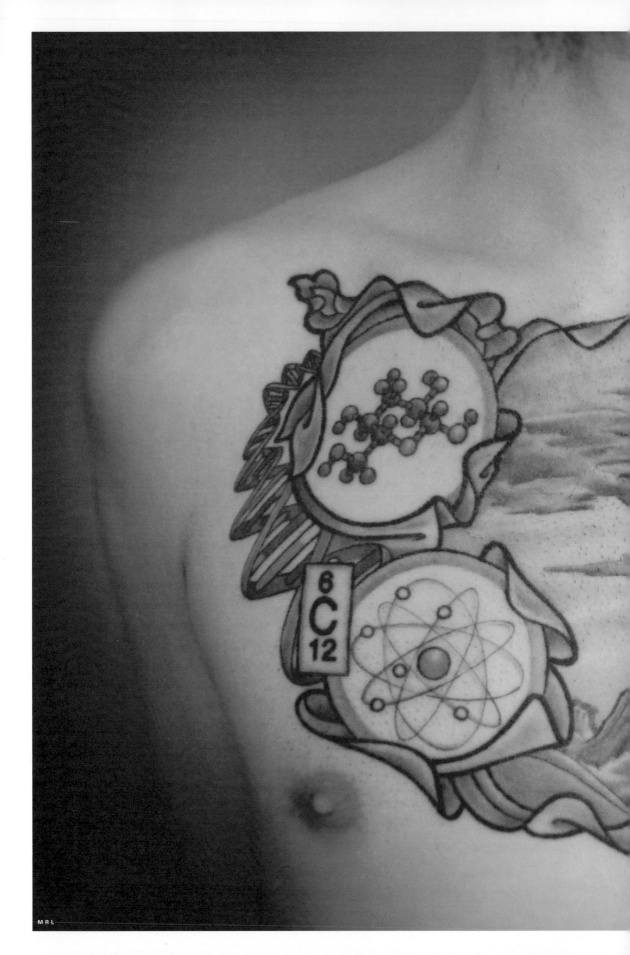

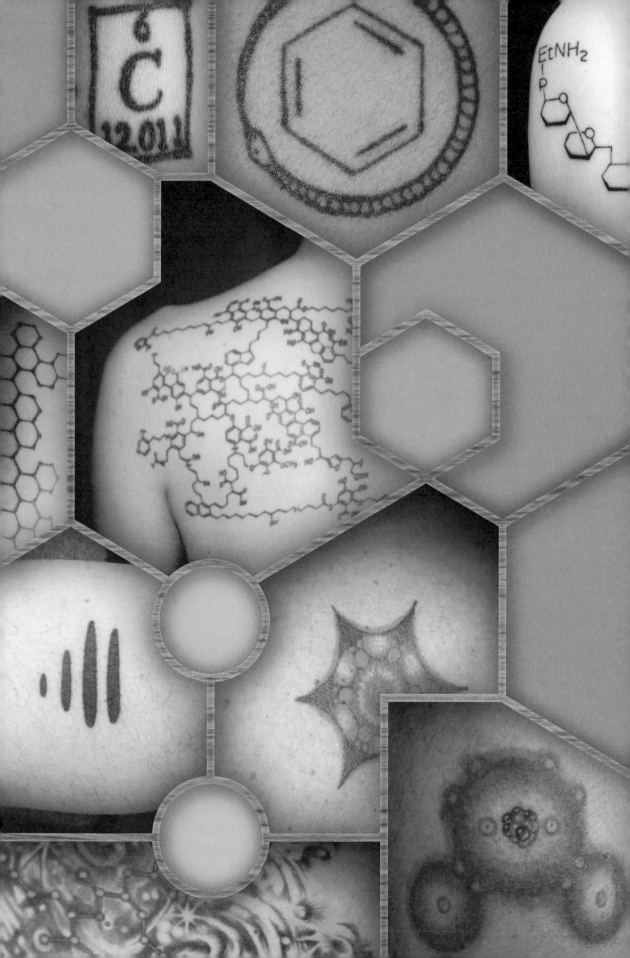

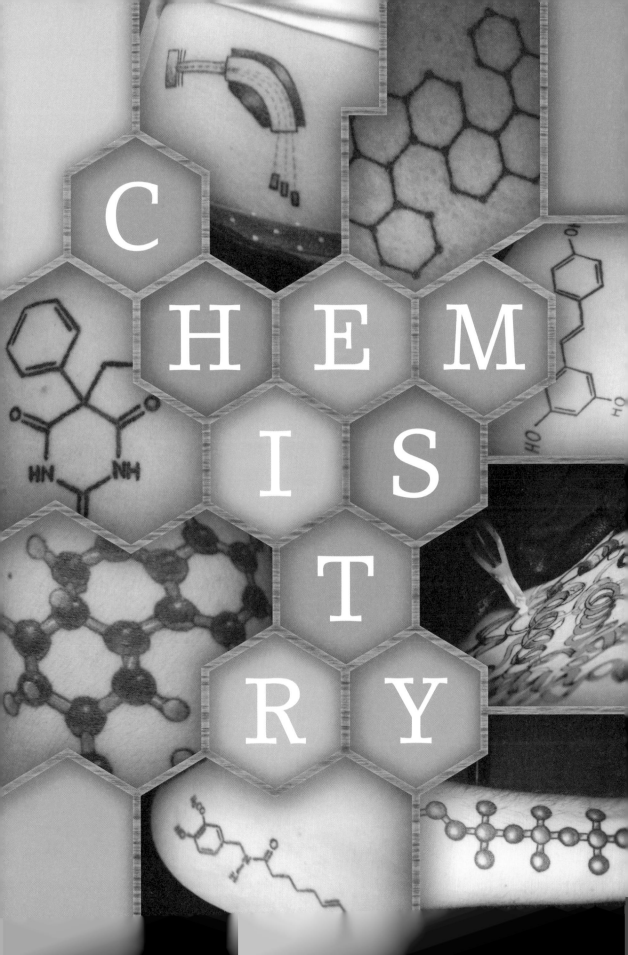

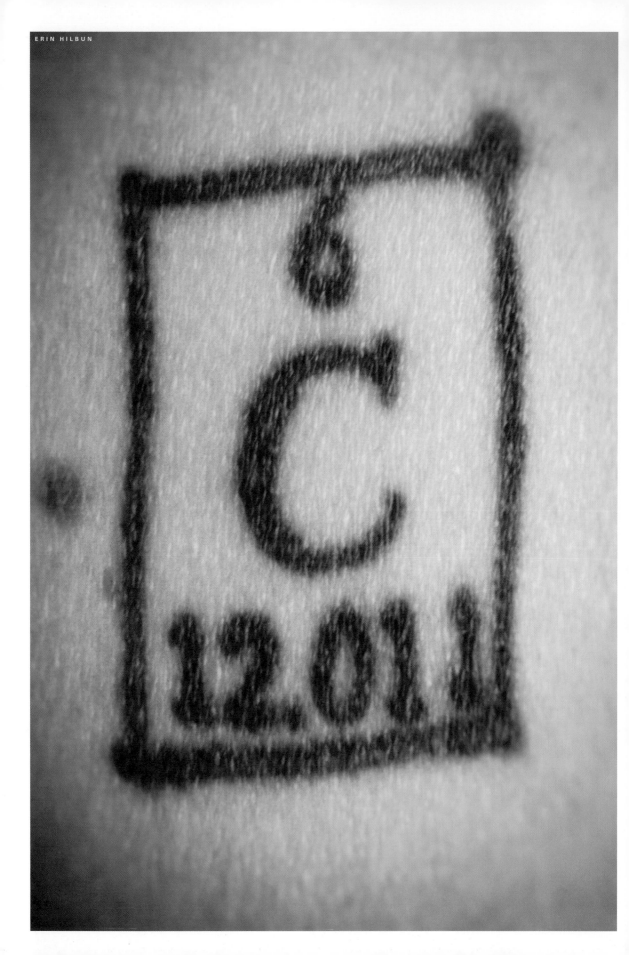
ERIN HILBUN

Carbon

"I AM A BIOCHEMIST, studying to be a molecular biologist," writes Erin Hilbun. "The tattoo I am sending is the entry for carbon on the periodic table of elements. Since all living things (on this planet at least) are carbon based, from a chemical standpoint, it doesn't get much more basic than carbon. Hence, the tattoo."

It's true: we are all carbon-based life forms, from viruses to sequoias, from basking sharks to fleas. Why is that so? One reason is that carbon is a good construction material. It can form scaffolds, such as chains and rings, while forming several different kinds of bonds with its neighbors on the periodic table. Carbon can thus fit snuggly into DNA, as well as other essential molecules, such as proteins and sugars. The bonds between carbon atoms are strong enough that they won't fly apart, yet they are not so rigid that they cannot be altered.

It's conceivable that carbon is the only element in the universe that can support life. We can't really say, since we have only one planet to consider. It's possible that on other planets, with other kinds of chemistry and climate, life could have emerged from other stocks. Perhaps a million light years away, there are silicon-based life forms wondering whether life could be made of anything other than a grain of sand.

Benzene

"ONE THING ABOUT Richmond, Virginia, is that most everyone in the city has a tattoo," writes Jeffrey Ikeda, who recently got a Ph.D. in pharmacology at Virginia Commonwealth University. Eventually, Ikeda decided it was time for him to get one too:

had figured out that the benzene molecule was made up of six carbon atoms and six hydrogen atoms, but they could not agree on how the atoms were arranged. August Kekule threw himself at the puzzle to distract himself from grief after his young wife died in 1858.

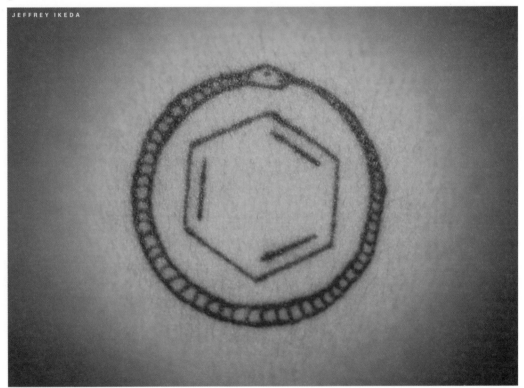

JEFFREY IKEDA

"While searching for inspiration I stumbled upon this story about the German chemist August Kekule, who is responsible for discovering the ring structure of benzene."

To an organic chemist, the benzene ring has the exalting power of a Tibetan mandala. The molecule made its debut in the early 1800s, as a grease-cutting solvent distilled from coal. By the mid-1800s, chemists

The answer came to him at last in a dream, as he later recounted in a speech to his fellow chemists:

"During my stay in Ghent in Belgium I occupied an elegant bachelor apartment in the main street. But my study looked on to a narrow lane and had no light during the day. For the chemist, spending his hours of daylight in the laboratory, this was no disadvantage. I

was sitting there working at my text-book; but I made no progress—my mind was on other things. I turned my chair to the fire and dozed off. Again the atoms gambolled before me. This time small groups remained modestly in the background. My mind's eye, sharpened by repeated visions of a similar kind, was now able to distinguish larger structures of many varied arrangements. Long rows, much more closely packed, all moving, twisting and turning like a snake. And look—what was that? One of the snakes gripped hold of its own tail and mockingly the structure whirled around before my eyes. As if by a flash of lightning I awoke. This time also I spent the rest of the night working out the consequences of the hypothesis."

Kekule was right: the snake eating its tail—the ancient myth of Ourobouros—was a fair representation of benzene. With this profound discovery, benzene became one of the most versatile molecules in organic chemistry. By tacking on various atoms to the ring, chemists made painkillers, bombs, and plastic packing peanuts. Benzene was eventually revealed to be a potent carcinogen, produced not just in chemical factories but in cigarette smoke. Today, a great many regulations and lawsuits seek to reduce human contact with benzene.

But for organic chemists, at least, benzene is an emblem of how they explore the molecular world. "Let us learn to dream, gentlemen," Kekule said after describing his discovery, "then we shall perhaps find the truth, but let us take care not to publish our dreams until they have been tested by our wakened understanding."

Nonane

LISA PARK-GEHRKE, a chemist at Shepherd University, sports a pair of nonane molecules around her wrists. Nonane is one of the simpler molecules in that stew of hydrocarbons that we call petroleum. It's too big and viscous to be used in gasoline; instead, it turns up in diesel and jet fuel. Other hydrocarbons may have a more complex beauty. But for a chemical bracelet, a nonane chain is hard to beat.

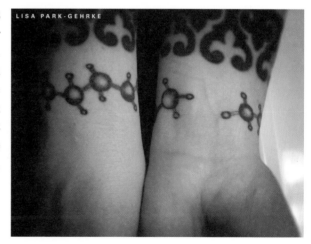

LISA PARK-GEHRKE

Glucose

"HERE'S A TATTOO of glucose (b-D-glucopyranose, to be more exact) that I have on my back," writes a chemistry professor who asked to remain anonymous. "Somewhere out there is a young lady with the same tattoo in smaller version on her ankle. Alas, a lost love."

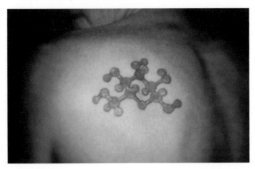

Earth is a factory for making glucose. The sun's photons strike blades of grass, leaves of oaks, acres of pond scum. Clusters of molecules use their energy to forge together carbon dioxide and water in a series of chemical reactions. The result is a planet-wide sugar coating. Photosynthesizers can use glucose as raw material for building proteins and other molecules, or they can use it as a source of energy. Plants tuck away their extra glucose as starch in their roots, tubers, and seeds. Animals and protozoans graze on the photosynthesizers, mainly to steal their glucose. The glucose we extract from our food courses through our blood vessels, turning us into walking fuel tanks. Our bodies are finely tuned to keep the level of glucose in the bloodstream stable, producing insulin to drive extra glucose into muscle and fat for storage. Every moment of our lives we need glucose to survive; it is a love that we cannot afford to lose.

ATP

THE GLUCOSE THAT courses through our bodies seeps into our cells, which then perform another act of alchemy on them. The molecules are carved apart, and their pieces are cobbled into new molecules, called adenosine triphosphate (ATP for short). ATP is a universal fuel, driving life in all its forms. Cells slice off parts of ATP to release a flash of energy, which can power the construction of a protein, the twist of a receptor, or the duplication of a gene.

"ATP is the currency of the cellular domain," writes Daniel Schmoller, a pre-med student at the University of Wisconsin and a research assistant in neuroscience labs there. "Without ATP, protein synthesis halts, metabolism stops, and generally speaking, life stops. It is estimated that the daily production of ATP, in the resting

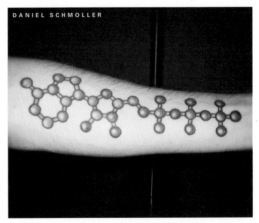

DANIEL SCHMOLLER

state, is around 73,000 grams! Moreover, your body typically produces only enough ATP to survive three to four seconds. Thus, without the constant replenishment of this molecule, you would die almost instantly. Crazy, right?"

Glycolipid

BIOCHEMIST JESSICA KRAKOW'S tattoo mixes two of the great loves of the modern Western world: fat and sugar. A fatty acid and a sugar molecule combine to

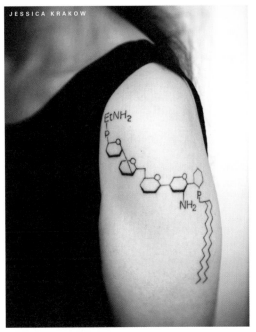

JESSICA KRAKOW

form a compound known as a glycolipid. The fat end of the molecule roots itself firmly in a cell's membrane, while the sugar dangles out like an antenna. Many glycolipids serve as anchors for proteins; the one on Krakow's arm—which she discovered—coats the surface of a blood parasite called *Trypanosoma brucei*. It essentially makes the parasite invisible to our immune cells.

We have glycolipids on our own cells as well. The ones on our red blood cells, for example, determine our blood type as A, B, or O. Fat and sugar, when properly combined, are how we tell ourselves who we are; ignore what they have to say, and your next blood transfusion may be your last.

Phenobarbital

"MY SCIENCE TATTOO," writes Mitchell Fraller, a scientist at a biotechnology company, "is an illustration of the molecular structure of phenobarbital. My cat has epilepsy and I have to give her pheno twice a day to prevent her seizures. I also have a background in chemistry and biology, so this tattoo is a tribute to both my cat and the nerdiness of science in general."

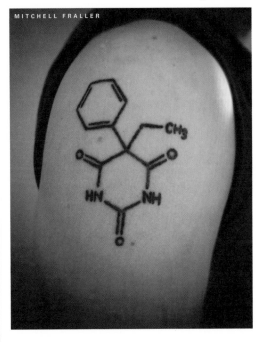

MITCHELL FRALLER

Diazepam

IN 1999 *U.S. News and World Report* put together a list of the 25 people who shaped the modern era. One of the people they included was Leo Sternbach. Poll your friends and you will likely find no one who knows who he was, unless you have a chemist or a doctor in your social circle. It was Sternbach who discovered diazepam—better known as Valium—and soothed the modern mind.

Sternbach started his career as a chemist in Europe but fled from the Nazis to the safety of New Jersey. There, he worked for the drug company Hoffman LaRoche, developing a number of compounds, including antibiotics and hypnotics. And in 1955 Sternbach turned his attention to one of the great challenges of the day: treating anxiety. Phenobarbital could sedate people but was also dangerously addictive. The tranquilizer meprobamate could kill at high doses. So Sternbach cast about for a different sort of drug.

Where to begin? Sternbach decided that for his starting point, he needed molecules that were simple to make and modify, that formed crystals without much trouble, and that had not been studied much before. He remembered a class of compounds he had investigated back in Europe in the 1930s, called benzheptoxodiazines. In 1955, Sternbach whipped up a batch and tried them out. Unfortunately he and his colleagues couldn't find any interesting compounds among them, so they turned away from the project to work on antibiotics.

A year or so later, Sternbach decided his lab had become an intolerable mess, crammed with flasks, beakers, and mother liquors. "A major spring cleaning was in order," Sternbach later wrote. During the cleanup, his co-worker, Earl Reeder, noticed an abandoned flask from the benzheptoxodiazine work. It had a few hundred milligrams of crystals inside. Reeder and Sternbach realized that they hadn't gotten around to testing the stuff before abandoning the project. They sent it off to a pharmacologist, who called back few days later with astonishing news. When the pharmacologist gave the crystals to cats, they hung limp when raised by the back of the neck. Sternbach took the chemical himself, and promptly became sleepy.

With a little tweaking to the molecule, Sternbach created what's known today as diazepam. Roche released it as Valium in 1963, and it immediately became a hit. In fact, it was the most prescribed drug in the U.S. from 1969 to 1982. The Rolling Stones memorialized diazepam in their song, "Mother's Little Helper," singing about how "it helps her on her way, gets her through her busy day."

But by the end of the 1970s the golden age of diazepam was over. Celebrities were confessing to addiction, and its sales began to slide. Sternbach, who died in 2005, had no regrets about discovering the drug. He believed he had saved countless people from suicide. Still, Sternbach admitted that his wife wouldn't let him take Valium, for fear of abusing it. Instead, he enjoyed a glass of Chivas Regal.

This tattoo of diazepam belongs to Richard Aceves, a software engineer. "The pace of my professional life combined with a series of losses in my family led me to remind myself in a geeky but permanent manner to 'relax' even if issues in the short term seem insurmountable."

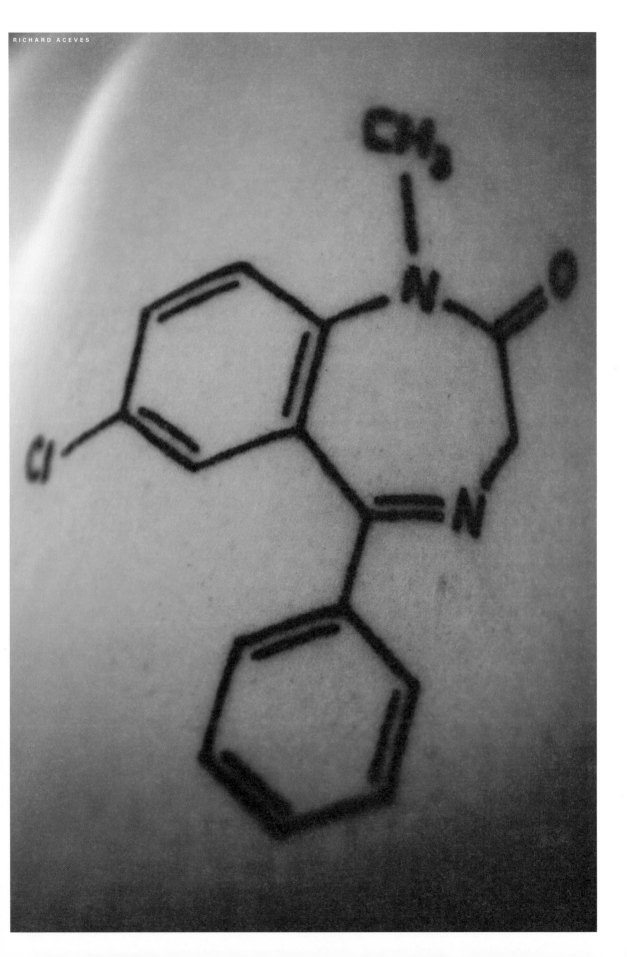

Resveratrol

NICO AZIOS is a scientist who studies wine: an enologist. His tattoo is of resveratrol, a molecule found in red wine. "I wrote my dissertation on its potential biochemical attributes as a metastatic breast cancer preventive," he writes. "Then I got out of research to learn how to make wine.

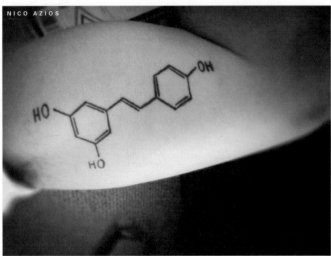

NICO AZIOS

That's what I do now. I think it's better to make wine than study it."

Americans have long looked jealously towards the French dinner table. As the French scarf their truffles and slurp their beef bourguignon, they somehow manage to enjoy much lower rates of heart disease than Americans. Some scientists have argued that the solution to the French paradox is some kind of disease-squelching, life-extending compound in the red wine that the French drink with their high-fat meals. Chemists have dived into the swamp that is red wine to inspect its many organic molecules, in the hopes that one might be the secret of health. And in the 1990s, one molecule—resveratrol—began to look like just what Ponce de Leon ordered.

The first signs came from yeast. When yeast were exposed to resveratrol, they lived longer. Vinegar worms did, too. Mice fed a high-fat diet did not suffer as big a loss of life if they were given resveratrol. These results triggered a reseveratrol boom, with pill purveyors making all manner of claims about how the molecule would give people extra decades of life.

The reality is far more complex. Resveratrol fails as an explanation of the "French paradox," because it would take entire casks of wine for people to a sufficient dose of the stuff. Recent experiments have failed to replicate some of the initial results. But the molecule remains fascinating. It seems to switch on a network of repair genes that can undo the ravages that time wreaks on cells. While it may not be able to undo aging on its own, it may point the way. In the meantime, we can enjoy wine for its taste, if not its cure.

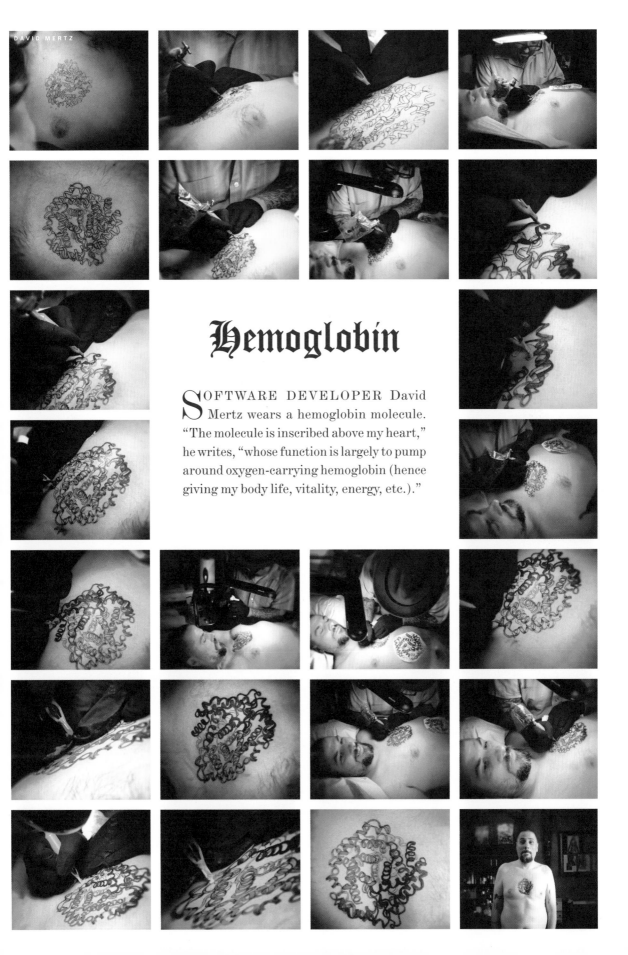

Hemoglobin

SOFTWARE DEVELOPER David Mertz wears a hemoglobin molecule. "The molecule is inscribed above my heart," he writes, "whose function is largely to pump around oxygen-carrying hemoglobin (hence giving my body life, vitality, energy, etc.)."

𝕾𝖞𝖒𝖇𝖔𝖑𝖘

𝕳₂𝕺

"I GOT MY TWO tattoos the summer after I graduated from the University of Massachusetts with a degree in chemical and nuclear engineering," writes Steven Bigelow. "On the left shoulder is the recognizable radiation warning trefoil, and on the right is the U.S. Army's hazard symbol for chemical weapons (I interpret it more as a general chemical warning symbol). Some

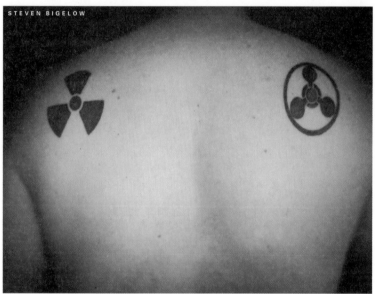

STEVEN BIGELOW

would say that hazard symbols like these represent a desire for isolation, but I like to think of them as my two pillars of training. That no matter what happens to me I'll always have my knowledge of these two sciences to rest upon."

"ENJOYING A CAREER measuring and predicting stream flow, I spend a lot of time in, over, and around water," writes Jerry O'Rourke.

One oxygen atom joined to two hydrogen atoms—the chemical structure of water seems like child's play. Yet this minimalist molecule is deviously complex. Scientists have tallied up 66 anomalies that water displays; 66 cases in which water does not follow the rules that other liquids obey. At room temperature, it will remain a liquid, while its nearest neighbors on the periodic table, ammonia and hydrogen sulfide turn to gas. Its surface tension is so strong that insects can walk on top of it like a trampoline. Most liquids get denser as they get colder, but when water freezes, it becomes less dense than its liquid form—hence, floating ice cubes.

In 2009, chemists at Stanford University bounced X-rays off of a spray of liquid water. The deflections of the X-rays revealed that liquid water is akin to a night club for molecules. Groups of water molecules—up to a hundred—congregate together like people huddled around nightclub tables. Meanwhile, other molecules hit the dance floor: they swarm and bounce around in dense swarms. Some molecules leave the tables to join the dance floor and vice versa. The social life of water may go a long way to account for its uniqueness.

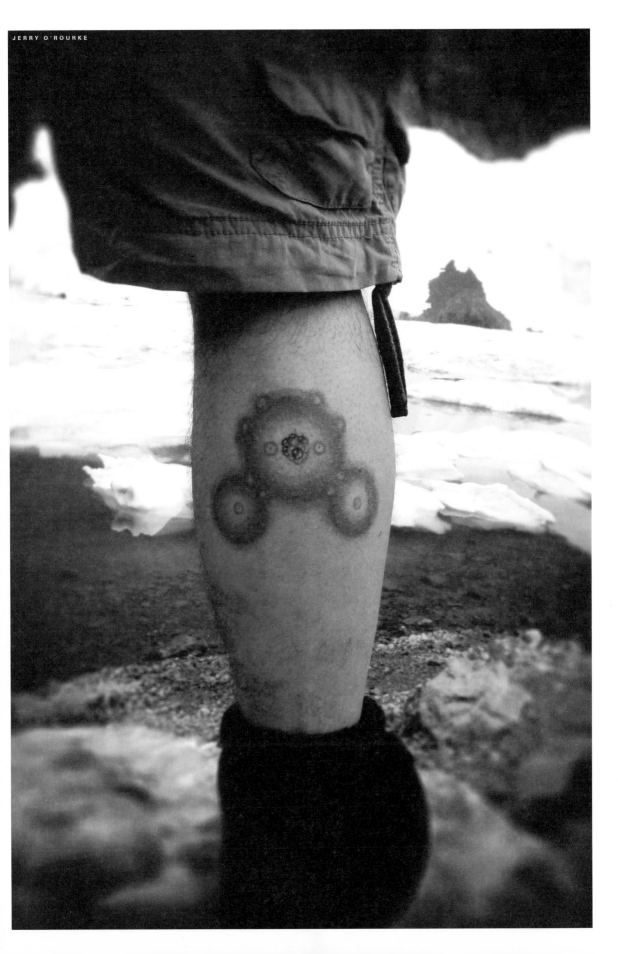

Celiac

"I AM A CHEMISTRY Ph.D. student at University of Washington," writes Jessica Pikul, who studies enzymes that are partly made of iron and sulfur. She also suffers from celiac, a disorder in which eating gluten triggers the immune system to attack the intestines. "The tattoo on my leg is one of the segments of the gluten protein that I cannot digest. The ball and stick

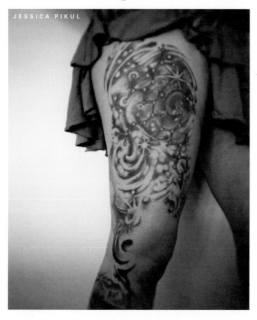

JESSICA PIKUL

molecule is of a Proline-Serine-Glutamine-Glutamine peptide that I can't break down, which then stimulates T-cells to start the fun chain reaction that ends in my small intestine villi being attacked by antibodies. The background to the molecule is an artsy space-scape.

"I chose this to speak to the universality of the physical laws that govern the microscopic and macroscopic, an idea that has kept me excited about chemistry and in the lab to this day (and hopefully longer)."

LSD

IN 1943, A SWISS chemist named Albert Hofmann was tinkering with chemicals made by a fungus that grows on rye. He was hoping to find, perhaps, a cure for migraines. One morning he synthesized a compound called LSD-25, short for the 25th analog in a series of diethylamide derivatives of lysergic acid. Whereupon, he started to feel woozy. Hofman felt so bad that he went home and took the rest of the day off. Lying in bed, Hofmann felt as if someone had placed a giant kaleidoscope in front of his eyes. Watching the images flow before him, Hofmann suspected that the LSD in his lab had somehow caused his hallucinations—perhaps by slipping into his skin in trace amounts.

Hofmann returned to his lab after he recovered and prepared what he thought would be a safe amount of the drug—250 millionths of a gram—in a glass of water. He drank the water and waited. In forty minutes, he was so dizzy that he had to go home again. He got on his bicycle and rode back to his house, his familiar route now transformed into a trail of surrealism. He tried to speak to his assistant, who was riding next to him, but could not make a sound. When Hofman got home, he had to hide from his neighbors, who seemed like witches and demons.

Hofmann survived the night and felt himself again in the morning. He walked through his garden, the leaves vibrating with vitality. He returned to work and wrote a report on the first experience any human had had with LSD. When his boss read the report, he could not believe that such a long, strange trip could have been launched by a mere fungal speck.

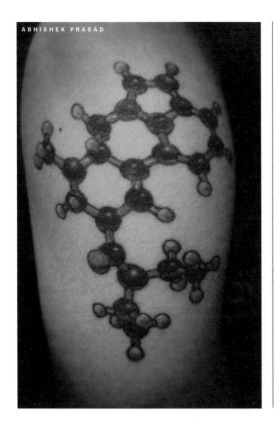

ABHISHEK PRASAD

In the six decades since Hofmann's wild bike ride, LSD has been tested by the CIA as a mind-control drug, used by hippies to drop out, and banned by governments around the world. But it may now be entering a new incarnation, as neurobiologists work out how a mere speck of LSD can trigger such profound experiences. It appears to latch onto a select group of receptors on certain neurons in the brain, mostly in a region called the prefrontal cortex.

LSD causes extra glutamate to surge through the prefrontal cortex, making it possible for the neurons there to establish new kinds of connections. Those connections may cause hallucinations and strange feelings of bliss, but they can also counteract the damage to the brain caused by depression and other disorders. It's possible that before long, LSD may become what Hofmann had wanted all along: a drug to heal the brain.

Fulvic Acid

"I GOT THIS TATTOO as an homage to the pain of my graduate work," writes Corey Ptak. "It's a model of fulvic acid, which is a representation of natural organic matter in the soil. I work with this molecule for my grad work, and I figured I might as well get it etched into my skin so I can look at it and say, 'Well, at least it hurt less than grad school at Cornell.'"

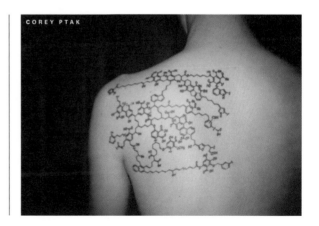

COREY PTAK

Caffeine

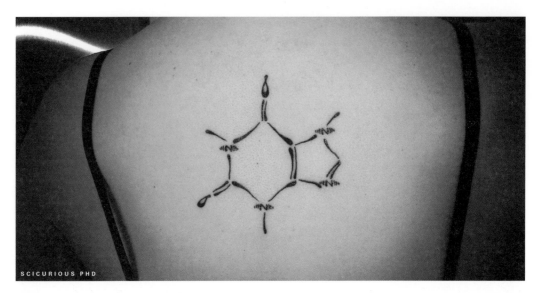

SCICURIOUS PHD

THIS TATTOO OF caffeine graces the back of a neurophysiologist who writes under the pen-name Scicurious, in celebration of finishing her Ph.D.

"Why caffeine, you ask?" she writes.

"1) I had a friend once tell me that my friendship was like a hot cup of coffee. Warm, vivacious, stimulating, and comforting. It was one of the best compliments I ever received.

"2) I have spent the last six years of my life studying drugs in various forms. Caffeine always spoke to me as a stimulant, because it is so different from other traditional drugs classified as stimulants. I've always been a little different myself.

"3) I also spent the past six years studying various neurotransmitters. I will spend more years studying different neurotransmitters. Which ones I study and why will change over time, but caffeine will be with me through all of it."

Caffeine is bug poison. Many plants make it to repel—or even kill—the insects and slugs that would eat them. And in one of those strange coincidences that occur when humans dabble with nature's pharmacopeia, caffeine also happens to fit fairly well into our own nervous systems. It docks in a receptor on neurons that normally receives a neurotransmitter called adenosine. Adenosine has many jobs in our brains. It can trigger various changes in neurons, depending on the particular cell it binds to, but in general it's a soothing chemical, tamping down excited signals and easing the brain to sleep.

Caffeine produces its effects by interfering with adenosine's work. When caffeine grabs onto adenosine receptors, the fit is awkward. As a result, it doesn't trigger the same changes as adenosine does. At the same time, it blocks adenosine from the receptors. Caffeine, thus, doesn't actually stimulate the brain, so much as prevent it from slowing down.

Capsaicin

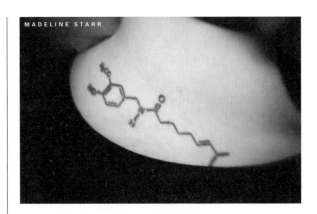

MADELINE STARR

MADELINE STARR, a food scientist, has the molecule capsaicin on her hip. The molecule, produced by chili peppers, gives them their kick. It's possible that peppers evolved capsaicin as a weapon to help them spread. Their seeds are normally sown by birds that eat the peppers and pass the seeds intact in their droppings. If a mammal eats a pepper, however, they will crush the seeds with their grinding teeth. The capsaicin makes the mammals steer clear of the fruits; birds, it seems, aren't bothered by the molecule.

Capsaicin binds to a receptor on tongue cells that normally register heat. The molecule triggers a complex network of changes in the cell, and ultimately those changes produce a sensation of burning pain. After enough exposure to capsaicin, however, the network behaves differently, and we become less sensitive. Drug-makers have exploited this effect and created capsaicin-based medicine that blocks chronic pain. Painless, painful: like so many things in life, capsaicin's effect is merely a matter of timing.

Chemistry Chick

JANET STEMWEDEL

"YES, SHE'S HOLDING a bubbling Erlenmeyer flask; clearly this must be the international symbol for woman chemist," writes Janet Stemwedel of San Jose State University in California.

"Of course since I'm now a philosopher of science rather than a chemist, one might wonder why I chose to tattoo myself with the international symbol for woman chemist. I guess there's a way that tattoos still serve as tribal markings…and since the tribe of chemists is the first professional/disciplinary tribe I joined, I feel like my heart is still there even if my faculty billet is in philosophy."

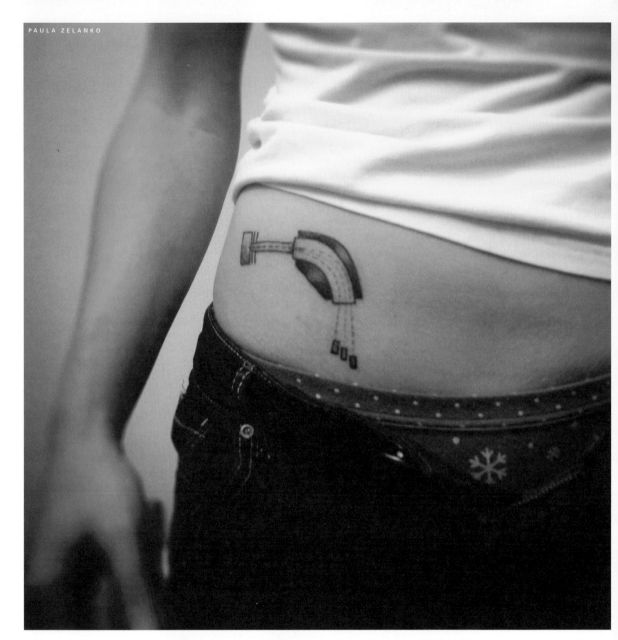

𝕸𝖆𝖘𝖘 𝕾𝖕𝖊𝖈𝖙𝖗𝖔𝖒𝖊𝖙𝖗𝖞

THE TATTOO ADORNING Paula Zelanko, a chemist at the Academy of Natural Sciences in Philadelphia, represents a machine called an isotope ratio mass spectrometer. Scientists use it to measure the proportion of different isotopes of a particular element in a sample of material. The number of neutrons in an atom determines how heavy it is. When heavier isotopes travel through a mass spectrometer, they take a different path than lighter ones.

The particular mix of isotopes of a particular element can speak volumes about a piece of ice or a hunk of rock. It's possible,

for example, to measure isotopes of strontium in rocks and use their ratio to figure out the temperature of the ocean ten million years ago.

"Gas is introduced on the left, into the 'Source,' where it becomes ionized," Zelanko explains. "Then the gas travels past a large magnet that bends the negatively charged gas ions into three distinct paths. The amount of bend is relative to the mass of the different isotopes contained in the gas. Then the three different masses of the gas are measured on the right side in 'Collector Cups.' The three different isotope paths are green, red, and blue because that is how they are color coded on the computer program that reads the information from the mass spectrometer.

"I got this tattoo because I run a stable isotope lab and I work with a mass spectrometer every day. This is the image shown to mass spec virgins when the inner workings are first explained. I wanted this tattoo particularly because it is comical (to me at least) how simple it makes a mass spec look. In reality, the inside of a mass spec is so complicated that if a true to form picture was shown in demonstration, nobody would ever get into the field. They would run away screaming."

Isotopic Peaks

SCIENTISTS ALSO USE mass spectrometers to figure out the identity of mysterious molecules. If they isolate a protein, they can't simply take a snapshot of it. Instead, they must rely on subtler clues. Proteins are assembled from building blocks called amino acids, and their number and types of amino acids give them a distinctive mass. Scientists can determine a protein's mass by tracking its path through a mass spectrometer.

Damon May, a scientific software engineer at the Fred Hutchinson Cancer Research Center in Seattle, Washington, carries the signature of a peptide—essentially, a very small protein—on his leg.

"This distribution of 'isotopic peaks' on my calf is what a peptide of mass 2,005 Daltons looks like in a high-resolution mass spectrometer," he writes.

"That peak distribution is due to the relative abundance of the different isotopes of

DAMON MAY

the elements that make up peptides, particularly carbon. 2005 is the year I got married and also the year I gave the corporate world the boot in favor of science."

Alloy

ABRAHAM ANAPOLSKY, an engineer who designs solar energy panels and lithium batteries, wears a tattoo of titanium alloy. The image is an abstraction of the alloy, produced by the bouncing of electrons off its crystal structure. The repeating patterns of the crystal send the electrons away in a beautiful pattern of their own.

The form of titanium that Anapolsky wears, known as 6-4 Ti, is a mix of titanium, aluminum, vanadium, iron, and oxygen. It's a versatile metal, used in everything from surgical implants to jet engines. "Being light-weight, high-strength, and corrosion resistant, I felt it was appropriate to put on my back, to keep it strong," Anapolsky writes.

Buckyballs

IN THE 1960s, the Earth developed an eruption of architectural warts. The visionary engineer Buckminster Fuller had developed new kind of building he called a geodesic dome. From the outside, it looked like an insect's eye, thanks to its interlocking struts and triangular facets. Fuller's design allowed a geodesic dome to support itself without the need for pillars or buttresses. It could thus enclose vast amounts of space. People built geodesic domes to live in; corporations built them as warehouses; the New York World's Fair erected one in 1967 as an emblem of the future. Fuller envisioned a day when a geodisic dome would cover the entire island of Manhattan.

The rage for geodesic domes petered out in the 1970s, and the world returned to making drearier buildings with ordinary right angles. But the elegance of the dome's geometry remained in the minds of many, including three chemists named Richard Smalley, Harold Kroto, and Robert Curl. In the 1980s, they puzzled over a strange form of carbon they had created in their lab. At the time, pure carbon was believed to only take a few forms. It could form sheets of graphite, for example, or a lattice-work in diamonds. But the scientists found that their carbon could form molecules of sixty atoms apiece. Like August Kekule dreaming of a benzene snake (see p. 48), Smalley, Kroto, and Curl pictured a microscopic geodesic dome— or, more precisely, a sphere made of carbon

atoms, each linked to its three closest neighbors. It turned out that the spheres were real, and the scientists named them Buckminsterfullerenes, or fullerenes for short.

The discovery (which won Smalley, Kroto, and Curl the Nobel Prize in chemistry) opened the way to a new field of technology. Fullerenes can take many different shapes—big domes and small ones, ellipsoids and tubes—and each kind has its own chemical properties. Tubes, for example, may conduct electricity. And while geodesic domes may have seemed the height of artifice, fullerenes are everywhere in nature, from the soot of candles to the vast clouds of interstellar gas. These tattoos, sported by Robert Wesel and Jessica Eskelsen, show a flattened diagram of a sixty-carbon fullerene of the sort that has been found in meteorites. The universe, in other words, is full of warts.

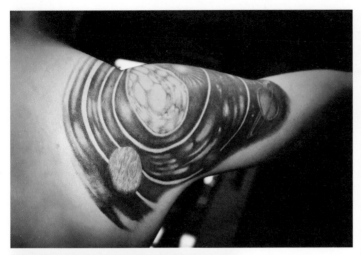

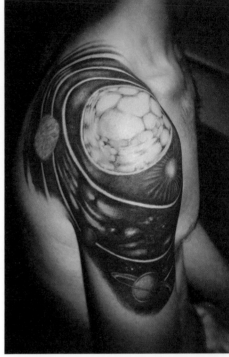

Space

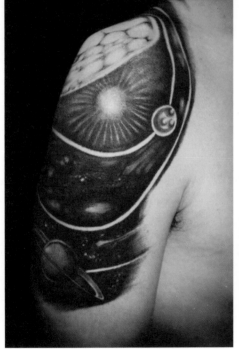

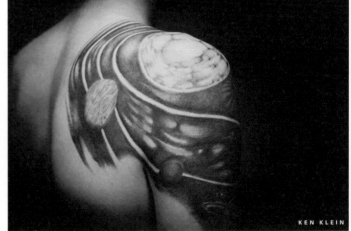

KEN KLEIN

Comets

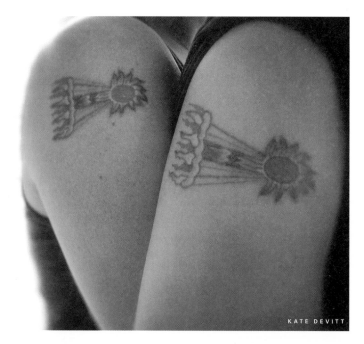

KATE DEVITT, a philosopher, started out in college studying the history of science. "For our second wedding anniversary," she writes, "my beloved proposed getting matching shooting star tattoos to immortalize our first date under the night sky. The Halley's Comet design from the Bayeux tapestry was a perfect way to celebrate."

In the spring of 1066 A.D., a star appeared in the sky with three long rays streaming towards Earth—"as is wont to be seen when a kingdom is about to fall," wrote a chronicler of the time. Shortly before the star appeared, Harold Godwinson had been crowned king of England. William of Normandy then invaded England and defeated Harold, establishing a dynasty that would last for centuries.

The victory was memorialized in the medium of the day: a tapestry. The 224-foot-long cloth displayed a Norman version of history, including the celestial omen of Harold's overthrow. It would take astronomers over seven centuries to determine that the streaming star was in fact a comet—Halley's Comet, to be exact. And so, in hindsight, we can now recognize the Bayeux tapestry as a vital document in the history of science: the first depiction of these icy wanderers of the Solar System.

Astrarium

"ALTHOUGH I'M NOT a scientist by trade," writes Lauren Caldwell, "my work on seventeenth- and eighteenth-century British literature has provided ample opportunity for me to become acquainted with the work of some brilliant scientific innovators. Though we have discarded some of their ideas, their work retains all of its vital visual force.

"Years ago I discovered and fell in love with the comprehensive diagrams in Giovanni de'Dondi's 1364 *Il Tractatus Astarii*, which contained the plans for the first famous astrarium. Each piece has its own delicate mechanical beauty, but I chose for my backpiece the Mercury wheelwork. Of course, you couldn't track Mercury with it—de'Dondi followed Ptolemy— but his astrarium remains a lovely and impressive testament to human ingenuity and curiosity.

"The more spare geometrical diagrams that surround the de'Dondi piece are taken from Sir Isaac Newton's *Principia Mathematica*—of which little enough, I imagine, need be said. Though in many respects these two men couldn't have been more different, they shared a vision of a universe as elegant and aesthetically compelling today as it was when they lived and worked."

Navigation

"WHILE I AM by no means a scientist, I have been fortunate enough to be paid by the government to get ships from point A to point B serving in the US Navy as a Quartermaster," writes Marc Morency.

"Celestial navigation has been something I have become profoundly interested in since I joined ten years ago. In this

MARC MORENCY

age of GPS, it is, in my opinion more important now than ever for navigators to remain proficient in the old ways to fix a ship's position using a sextant and trigonometry. My tattoo is the visual depiction of how to plot a line of position from a celestial body using the altitude intercept method, a method which has been time-tested for more than a century. For me it serves as a reminder that while technology improves, the sea remains an unpredictable place, and it is up to the older generation to teach the younger the old-school ways of doing business."

Libra

WHEN JESSE ROGERSON entered graduate school in astronomy at York University in Canada, he decided to get a tattoo. He chose the constellation Libra, his astrological sign.

"Now constellations are a very small part of active astrophysical research," he writes. "At most, a researcher may

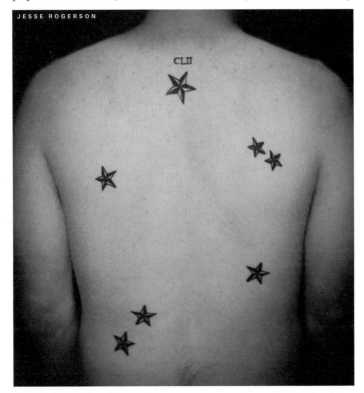

relate the location of the object they are observing as 'in the constellation Sagittarius' or 'towards Perseus.' I don't study constellations; I study active galactic nuclei and the gaseous universe. The reason a constellation made so much sense for me was because of my second passion: public education. As an astronomer I find myself fortunate enough to have people interested in my work. People love to hear about what Mars is like, or how big a galaxy actually is. And I love telling people all they want to know about astronomy. Sitting out under a dark sky and having people point to things and asking 'What's that?' is a very rewarding experience."

Copernicus

IN 1543, THE POLISH astronomer Nicholas Copernicus redrew the cosmos. He published a book called *De revolutionibus orbium coelestium* (*On the Revolutions of the Heavenly Spheres*) from which high school science teacher Chris Farnsworth borrowed two images for tattoos. The top image represents the cosmos as it was taught to Copernicus, with Earth at the center, and a planet revolving around it. But planets don't travel across the sky in a straight line; they double back from time to time. So ancient astronomers added epicycles to their models—such as the extra loops in Farnsworth's tattoo—so they could make accurate predictions.

The lower image is Copernicus's drawing of the planets revolving around the Sun. Gone are the epicycles, replaced by clean circles. The simplicity of the picture belies the agony of its creation, however. Copernicus carried out decades of astronomical observations and carried out thousands of mathematical calculations to build a model to match them. Copernicus was reluctant to publish his research and was only coaxed to do so a few months before his death. But another few years of life would not have been enough for him to witness its full impact on humanity. Mathematicians and astronomers of Copernicus's day read his book, but they paid close attention to his mathematics and ignored what he had to say about the arrangement of the universe, considering it a convenient fiction. Only much later, with the work of Kepler and Galileo, did the world come to realize that this picture was not just pretty, but true.

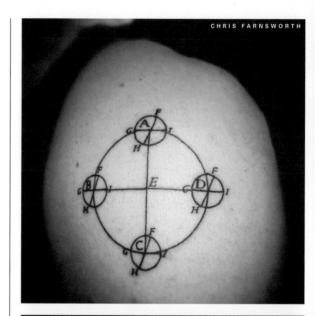

CHRIS FARNSWORTH

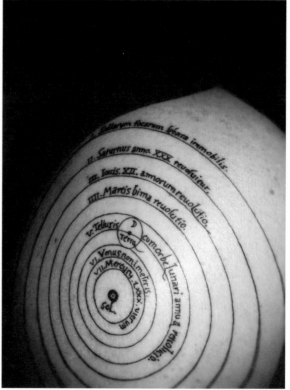

The Moon

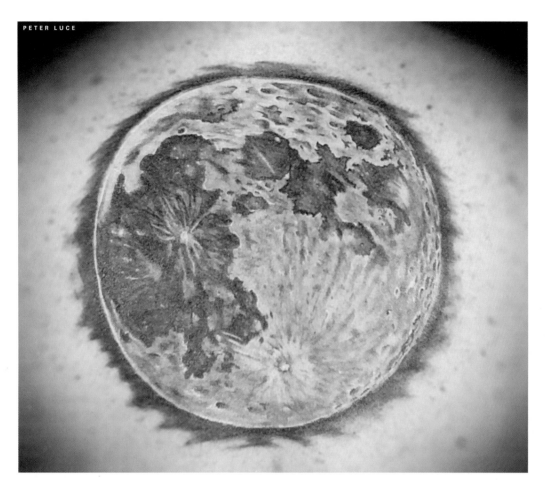

PETER LUCE

"BACKSTORY," WRITES Peter Luce, "my parents met at a wedding on July 20, 1969, a very important date in the annals of human scientific achievement—the night humans first set foot on the Moon. All my life, I have had a fascination with the Moon not just as a tangible, graspable place (science fiction made real) but as a symbol for what the human race can achieve when we apply the best abilities of the best minds."

The Moon was science's first glimpse of cosmic imperfection. For centuries, natural philosophers declared the heavens to be beyond decay and change. Everyone could see that the Moon was irregularly colored, but they explained it away in various ways— perhaps the reflection of the Earth itself, or the glint of sunlight bouncing off of celestial vapors. But when Galileo turned his telescope towards the Moon in 1609, he could clearly see the Moon's pock-like craters, changing with the shifting shadows. The Moon is not timeless, but mature, its battered face the sign of experience. Astronomy is no longer has the purity of mathematics, but the fascinating quirks of biography.

Galileo

THE ITALIAN PHRASE, *Eppur si muove* (or *E pur si muove*) means "It still moves." Few phrases have gathered more power in the history of science. Galileo, having antagonized the Vatican with his radical ideas about physics and the cosmos, was condemned by church authorities. In 1633, they demanded that he recant his

tained. The firmness of Galileo gave way at this critical moment of his life: he pronounced the recantation. But at the moment he rose, indignant at having sworn in violation of his conviction, he exclaimed, stamping his foot: *E pur si muove* (It still moves!). Upon this relapse into heresy, he was sentenced to imprisonment in the Inquisition."

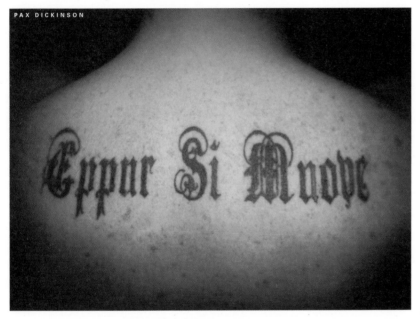

PAX DICKINSON

The scene rivets our imagination. But it may not have ever happened.

There's no written record of Galileo putting on this performance at his trial. The story of *Eppur si muove* did not emerge in print until a century after Galileo's death. In 1911, a seventeenth-century painting of Galileo in the Inquisition was discovered to have the phrase *Eppur si muove* inscribed along

view that the Earth went around the Sun, and accept the Church's teaching that the Earth was the fixed center of the cosmos. Here is a version of the story of what happened next, published in 1855 in *Exemplary and Instructive Biography: For the Study and Entertainment of Youth*:

"Being brought before an assembly of his judges, he was condemned to renounce, kneeling before them, with his hand upon the Gospels, what were called 'the sinful and detestable errors and heresies' which he main-

an edge. So it's possible that the story was already circulating while Galileo was still alive, either as a fictional rumor, or as a seed of truth transposed from a different time and place to give it suitable drama.

The story is deeply satisfying, rather than deeply true. And that satisfaction has sustained it over the centuries, from Enlightenment encyclopedias to present-day television shows, to science fiction novels, rock albums, and tattoos. If Galileo didn't actually say it, we will say it for him.

Calvin & Hobbes

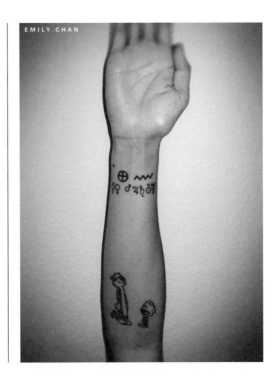

"EVER SINCE I was a kid, I have had a love for astronomy," writes Emily Chan. "I studied Earth and Planetary Sciences in college and am now in graduate school, studying to be a middle school science teacher. Another love I had as a kid was reading Calvin and Hobbes. My science tattoo combines these two childhood loves—with Calvin and Hobbes looking up at the eight planetary symbols and the symbols for a star and water. Just like Calvin and Hobbes, I will always be gazing up at the sky with wonder and awe."

Astronauts

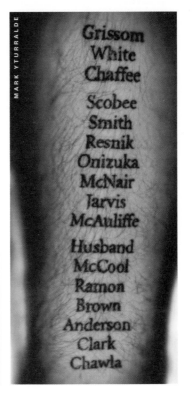

"AFTER THE *Columbia* space shuttle accident, I felt compelled to do something," writes Mark Yturralde. "Space has always meant so much to me, and I felt I wanted to memorialize them somehow. I donated to college funds and other charities in their name, but still felt like I needed to do more, and I found myself reliving and considering *Challenger*, and *Apollo 1* too, Gus Grissom being a long-time hero of mine. One morning, I made a list of all of them. It just struck me: I'll put their names on my forearm. People will see them. They'll ask who they are. I can then tell them about my tattoo, and what it means to me. Every time someone asks, and I explain it, they take a second. They reflect. They remember."

Solar System

"WHENEVER I WENT to the library, my mother always said, 'Why don't you get some kids books instead of planet books?'" says Ira Klotzko, who grew up to get a Ph.D. in physics and start a software company.

The Solar System across Klotzko's torso

joined—not as planets, but as a smear of boulder-like remnants of the early Solar System. Finally Pluto was admitted to the league of planets in 1930.

But by the end of the twentieth century, astronomers had telescopes so powerful that

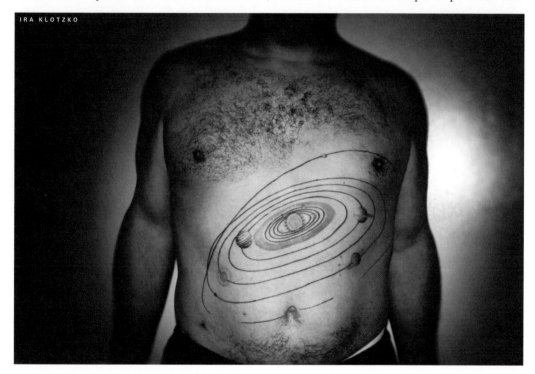

IRA KLOTZKO

may look like a simple map of our corner of the galaxy, but it's actually a statement of scientific opinion. Ancient people knew of the inner planets, Mercury, Venus, and Mars, as well as the gas giants Saturn and Jupiter. Later, these six planets were joined by Uranus (carefully depicted on Klotzko with its axis of rotation tilted nearly ninety degrees) and Neptune. The asteroid belt

they revealed vast numbers of objects in the distant Solar System, some tiny, some fair-sized, and at least one bigger than Pluto itself. In 2006 the International Astronomical Union decided to demote Pluto to a "dwarf planet," along with the far more distant object, Eris. Modern astronomy has turned the geometric elegance of the Solar System into a rocky, ice zoo.

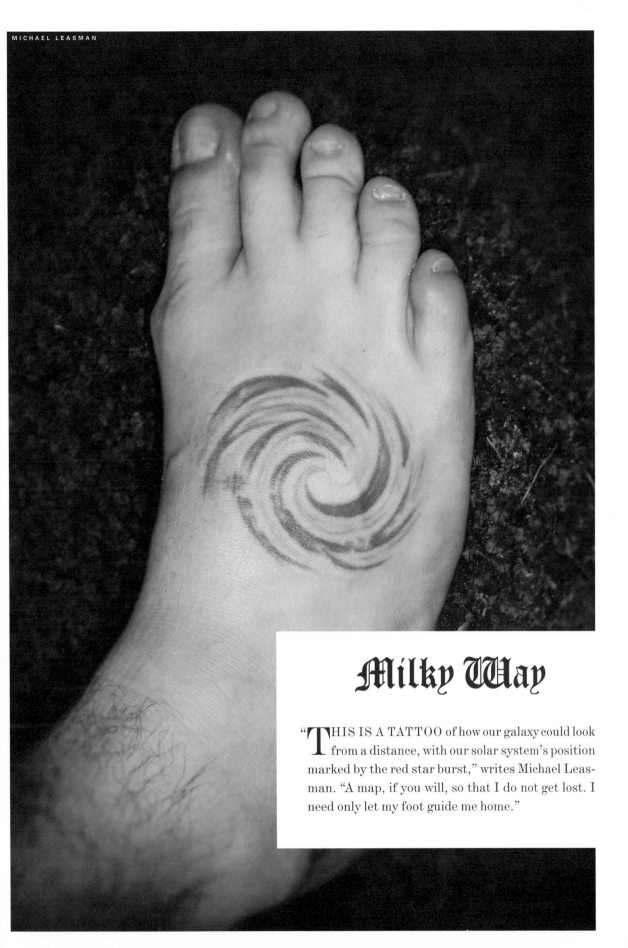

Milky Way

"THIS IS A TATTOO of how our galaxy could look from a distance, with our solar system's position marked by the red star burst," writes Michael Leasman. "A map, if you will, so that I do not get lost. I need only let my foot guide me home."

Cigar Galaxy

SARA MITCHELL, who works at the NASA Goddard Space Flight Center, walked into a tattoo parlor one day with a picture of M82, otherwise known as the Cigar Galaxy.

"This image was so incredibly striking to me—it just seemed right to commit it to skin. I don't think I could've gotten that image of M82 by itself, but worked into the abstract shape it really fits. No one immediately sees it as an 'astronomy tattoo,' but they can see the inspiration when I explain. Though it does mean that I have to reassure people that the little inkless dots are clusters of stars—not mistakes!"

Pleiades

"MY TATTOO IS of seven of the stars in the M45 star cluster—known to most as the Pleiades—located in the constellation Taurus," writes Maia Weinstock, the editorial director of a science education website. "The seven stars I chose aren't actually the seven sisters from Greek Mythology (Alcyone, Celaeno, Electra, Maia, Merope, Sterope and Taygeta); instead, they are the five brightest sisters (in apparent magnitude) plus their parents, Pleione and Atlas.

"I wanted to get the tattoo because the Pleiades have had a number of special meanings for me over the years. For one thing, my namesake star is Maia, a.k.a. 20 Tauri. But the cluster is also one of the few celestial objects that we in the Northern Hemisphere can pick out with the naked eye. When I was a teenager first getting excited about the world of astronomy, this was a very cool thing indeed!

"Interestingly, physics class wasn't the only place the Pleiades came up. During my senior year of high school, our English class read Edith Wharton's *Ethan Frome*, and I completely identified with the title character's sense of wonder at being able to pick out, to the right of the star Aldebaran, 'the bunch of little ones—like swarming bees' under a crisp New England night sky. Later in college, I considered a career in astronomy, but instead decided to concentrate on journalism. I was still able to study the cosmos as a science writer and editor, but the focus was much broader, and I wasn't required to specialize in just one particular area. It also gave me great pleasure to help those without science degrees learn about and appreciate some of the awesome work that astronomers in the trenches are constantly producing in an effort to unlock the secrets of our universe and how we came to be a part of it."

MAIA WEINSTOCK

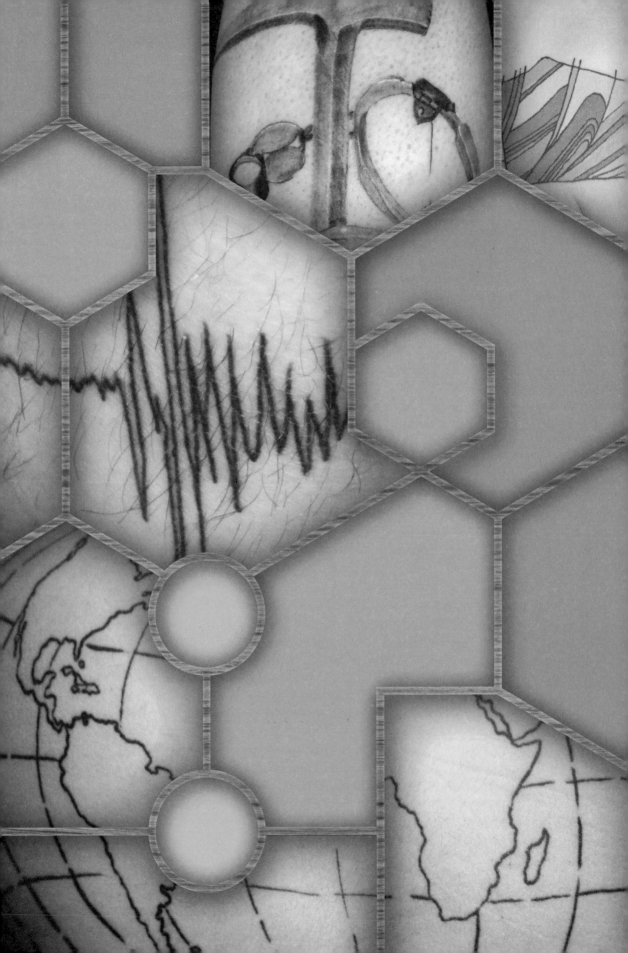

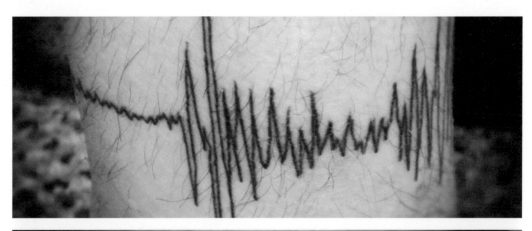

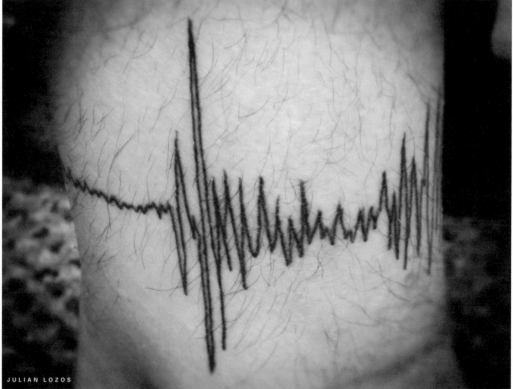

JULIAN LOZOS

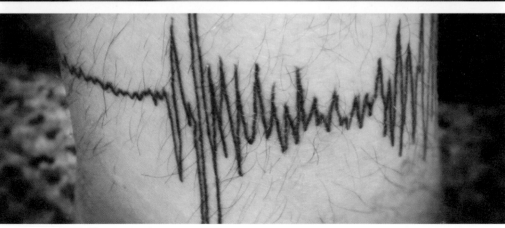

Seismograph

"**I**'M A PH.D. STUDENT in earthquake physics (specifically, I work on fault dynamics)," writes Julian Lozos. "I have the seismogram of the 1906 San Francisco earthquake around my right ankle. That particular earthquake is not the actual subject of my research, but it was extremely important in terms of the development of theories on how faults work, and it was also instrumental in bringing me into the field of seismology to begin with.

"As to the first point: before 1906, people didn't realize that earthquakes and faults had anything to do with each other. The 300-mile-long surface rupture on the northern San Andreas Fault (a fault which had previously been identified only as a contact between rock types in San Mateo County, and which hadn't been named) indicated that there was a connection. Observations of freshly-offset natural and manmade features along the fault led to the development of the elastic rebound theory: faults build up strain over time, and at a certain point, their ability to hold up under that strain is surpassed and they slip, causing an earthquake. Our understanding of the details of the earthquake cycle has become more complex since 1906, of course, but that basic theory still stands. Also, mapping of the 1906 rupture led to mapping the San Andreas through the rest of California, and to the discovery of many of the other major faults that cross the state. Both of these things do tie more directly into my work, since I do numerical models of fault dynamics, specifically in settings where multiple faults interact.

"As to the second point: I came into earth science via a very bizarre route. I always had an interest in earthquakes and volcanoes when I was little, growing up in the Washington DC area. Not sure where the interest came from, but it was there in the background for a long time. My undergraduate studies were in music, however, and when I was done with that, I headed to music grad school in California. I made the decision to move across the country around the time of the centennial of the 1906 earthquake, and reading newspaper articles about the anniversary reminded me that I was moving to earthquake country. I figured that learning more about earthquakes was the responsible thing to do if I was going to be living with them. The more I read, the more I remembered why I thought they were fascinating. The more I read, the more I wanted to know. I went out on road trips to visit the fault, I took a bunch of geology classes while working on my music degree, and through all of that, I was realizing that I didn't enjoy music academia at all. I decided to apply to the earth science department, got in, and am thoroughly enjoying the research far more than I ever enjoyed music school. This was the right decision to make, I have no doubt, though I have to wonder if I would've started reading about quakes so intently if the 1906 centennial hadn't coincided with my decision to move to California.

"So, I can look at my ankle seismogram and be reminded of many important discoveries and realizations in my field, and of what sent me in the direction of this field to begin with. It also reminds me of the fabled Big One, the kind of earthquake that *will* happen again, which is why we need to understand the science as well as we can, in order to minimize the disaster that results from the inevitable rupture."

Cross-section

"THIS TATTOO," writes Helen Malenda, "is a geologic cross section which was a final project for a structural geology course I had while studying a semester at Humboldt State University. It is a graphical representation of rock types found in a slice of a mountain chain, created from a geographical map of the ground surface."

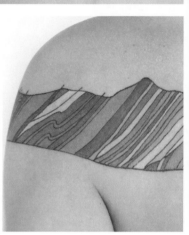

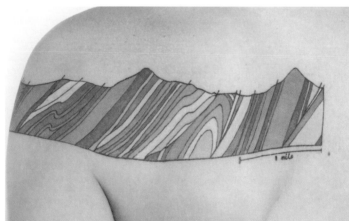

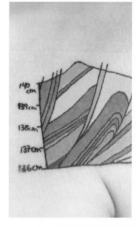

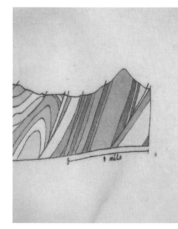

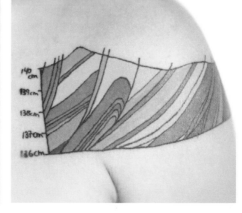

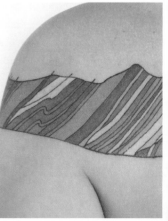

Cloud

A METEOROLOGIST WHO asked to remain anonymous writes: "This tattoo is of a cumulonimbus (thunderstorm) cloud with bolts of lightning. My childhood fascination with weather led to a career in it. Storms are embedded in my psyche & soul, and during a stormy time in my life I decided to embed a storm in my skin. I sketched a cumulonimbus cloud for the tattoo artist, and he and the other people in the parlor said something along the lines of, 'Dude, we can make that tubular!' And this is how it turned out. It retained meteorological accuracy via the bit of an 'anvil' in the upper right."

Volcano

"AS A GEOLOGIST, and in respect to my temperament, I though a volcano tattoo would be just adequate," writes Renate Schumacher, a German geologist.

RENATE SCHUMACHER

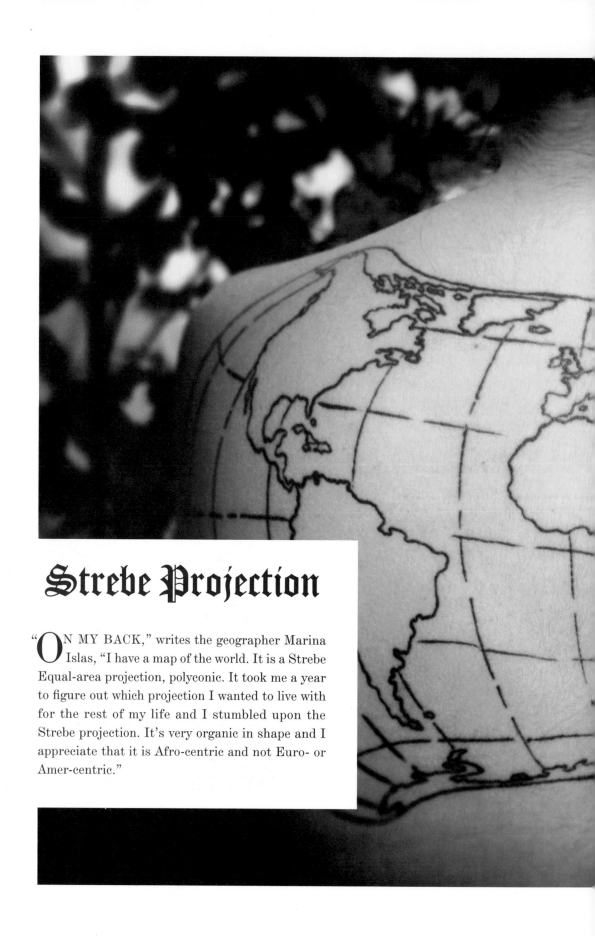

Strebe Projection

"ON MY BACK," writes the geographer Marina Islas, "I have a map of the world. It is a Strebe Equal-area projection, polyconic. It took me a year to figure out which projection I wanted to live with for the rest of my life and I stumbled upon the Strebe projection. It's very organic in shape and I appreciate that it is Afro-centric and not Euro- or Amer-centric."

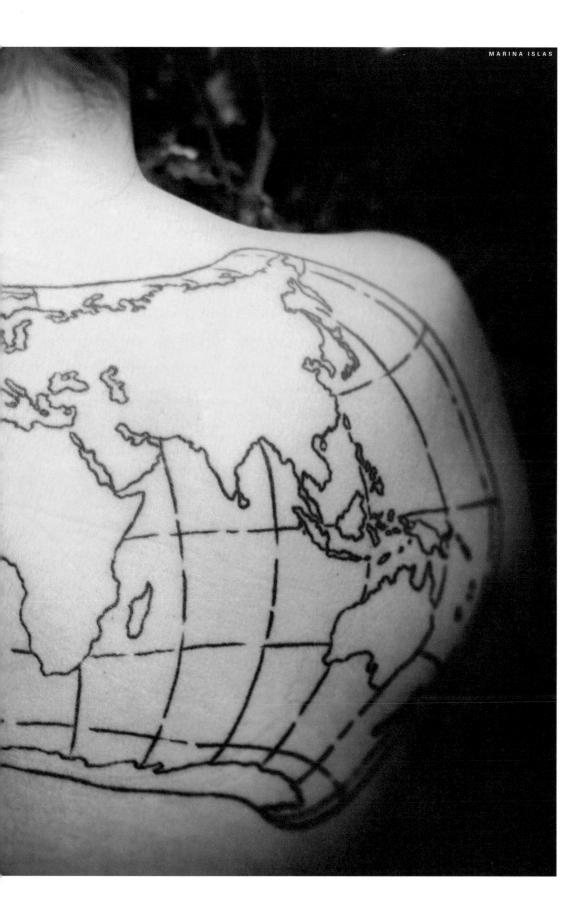

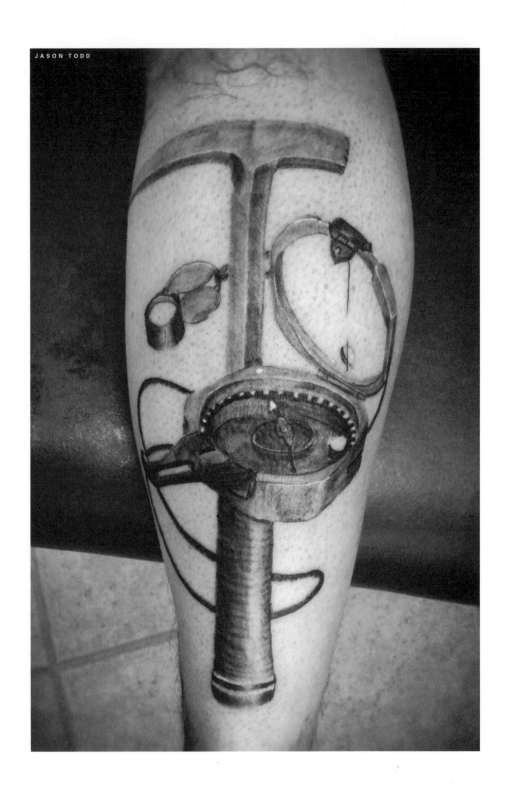

JASON TODD

Tools of the Trade

"MY INTEREST IN geology started at an early age, while my mother was studying for her geology degree," writes Jason Todd, a consulting geologist. "In lieu of daycare, she would set me up with an optical microscope and a stack of thin sections. Studying geology was almost preordained for me. I've spent the last 16 years working in the field. As I worked my way up the corporate ladder, I spent less and less time in the field, but I have always devoted time to keeping the fundamental skills sharp. I have known hundreds of geologists and the most competent ones have the most complete understanding of the fundamental tools: rock hammer, compass and hand lens. My little sister began tattooing about 10 years ago, and when she worked this one up for me, I just couldn't resist."

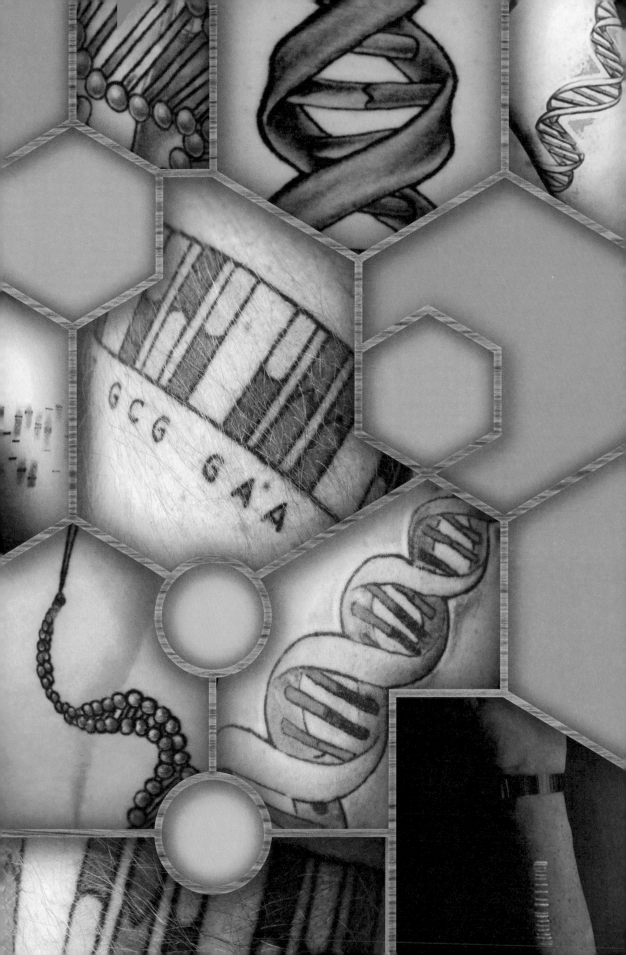

ON APRIL 25, 1953, the journal *Nature* ran a short paper by James Watson and Francis Crick, two scientists then working at Cambridge University. It was barely more than a page long. "We wish," they wrote, "to suggest a structure for the salt of deoxyribose nucleic acid (DNA). This structure has novel features which are of considerable biological research." It was accompanied by a single figure: a line drawing of two ribbons spiraling around each other, joined by cross-pieces like a twisted ladder.

The paper marked the dawn of modern biology, for it revealed how the instructions for building people, plants, and all living things could be stored in a molecule. The rungs are actually a combination of units called nucleotides; the four nucleotides of DNA serves as an alphabet for genes. And the paper created a new scientific icon. Amidst the tangled proteins and other molecules in the cell, DNA had the elegance of a modernist sculpture. The image of DNA has taken on other meanings in the decades since its debut. It can stand for our inner nature, or life itself.

But the image is also an abstraction. Real DNA is not laid out neatly like a spiral staircase—it coils and loops. A retinue of proteins keeps regions of DNA wound tight around spool-shaped histones, and folds it into ugly chromosomal clumps. Real DNA is also not the essence of life. It's actually a hub in a complex network of chemical reactions, stretched and unzipped by proteins, tickled by environmental signals, muffled by epigenetic clamps. The double helix does not represent reality so much as the fact that this particular aspect of reality—how life replicates itself through the generations—can even be known.

COLM O'DUSHLAINE, a geneticist at Trinity College, Dublin, decided to get a double helix tattoo to mark the submission of his Ph.D. thesis. "I felt I should have something that records my passion for genetics in the same way that another one I have, a Celtic knot, records my ancestry," he writes.

"A year later, my research group started

COLM O'DUSHLAINE

up a collaboration with James Watson, co-discoverer of the structure of DNA. I thought it was pretty cool that I had the chance to meet him, so I showed him the tattoo! I was pleasantly surprised (and also felt *very* nerdy) when he at first couldn't believe it was real!"

When James Watson co-discovered the structure of DNA in 1953, scientists weren't even sure that DNA was where our genes were stored. Today, nearly sixty years later, O'Dushlaine is discovering subtle differences in DNA that can be used to determine a person's nationality, even the village of their ancestors. He is finding extra copies of certain genes that raise the risk of schizophrenia. One wonders if Watson's bemused expression is in response to the tattoo, or to his legacy.

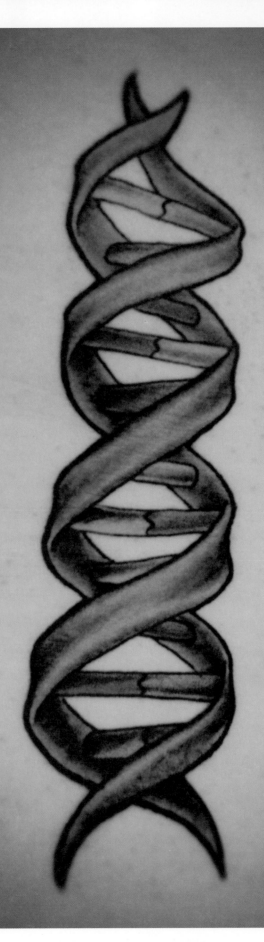

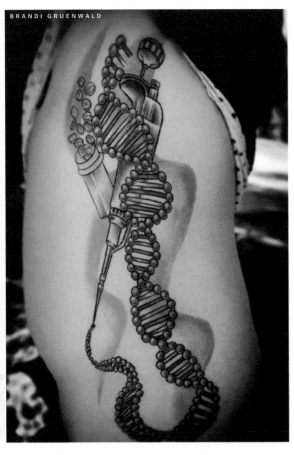

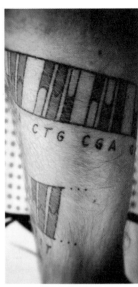

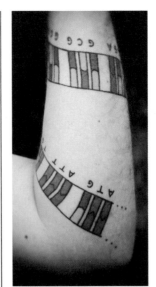

MICHAEL RAASCH, a self-described "computer scientist and geek" sports MICHAELRAASCH spelled in amino acids encoded in codons of DNA (triplets of nucleotides). Raasch has searched the world's genetic databases to see if any living thing carries this particular sequence of DNA in its genes. So far, it remains entirely fictional. But with millions of species left to examine, he may someday find his name inscribed in nature.

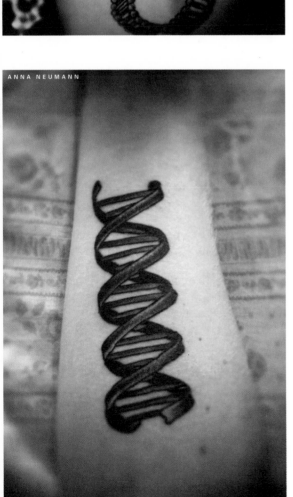

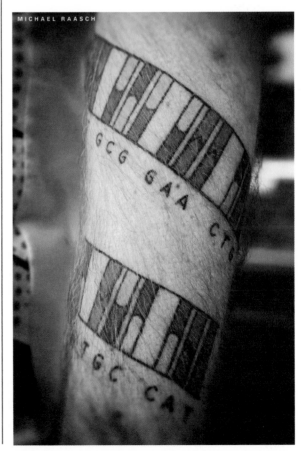

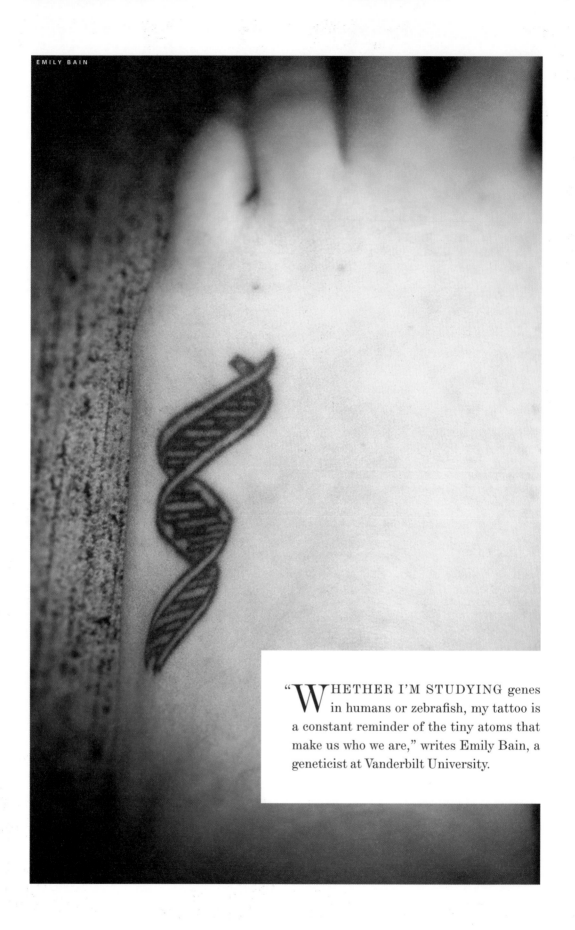

EMILY BAIN

"WHETHER I'M STUDYING genes in humans or zebrafish, my tattoo is a constant reminder of the tiny atoms that make us who we are," writes Emily Bain, a geneticist at Vanderbilt University.

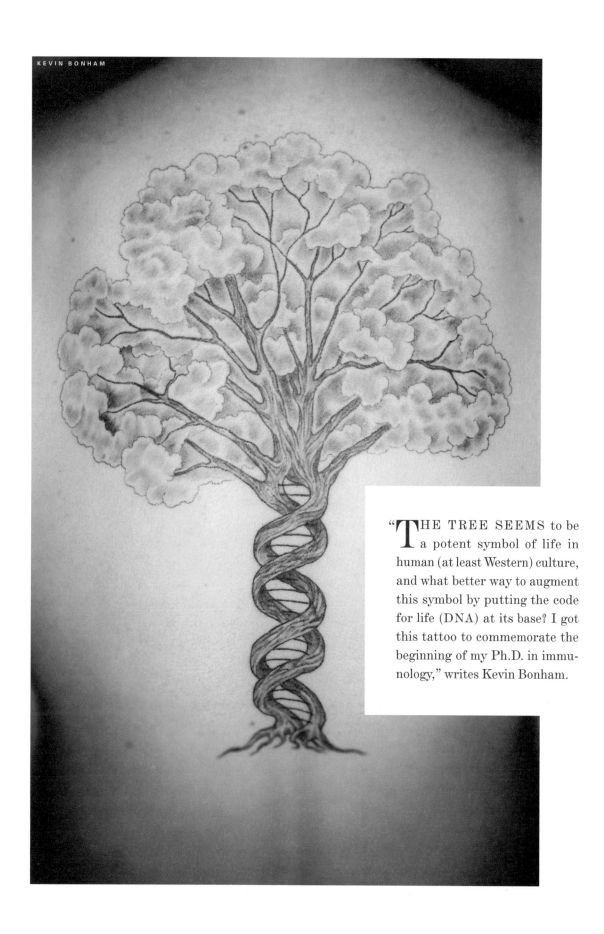

"THE TREE SEEMS to be a potent symbol of life in human (at least Western) culture, and what better way to augment this symbol by putting the code for life (DNA) at its base? I got this tattoo to commemorate the beginning of my Ph.D. in immunology," writes Kevin Bonham.

SUSANA CHUVA DE SOUSA LOPES

SUSANA CHUVA DE SOUSA LOPES is a geneticist at the University of Utrecht in the Netherlands, where she studies how the genes in a fertilized egg guide it through its development into a full-blown human being. Like many other biologists, she had to travel a long road to get there. She was born in Portugal, and there she began her studies in biochemistry. She wasn't happy with her choice and ended up finishing her degree in the Netherlands. To make that shift, she had to spend a lonely year trying to learn Dutch and not doing any science. To remind herself of why she was putting herself through such an ordeal, she got a DNA tattoo on her forearm.

CARRIE LOONEY WRITES, "I am an immunologist, and a second-generation biologist; my mother was a cell biologist (she passed away from brain cancer, which influenced my choice of career). I find DNA to be elegant; the code is so simple, and yet capable of enormous complexity. So I had my artist make a stylized DNA double-helix for me.

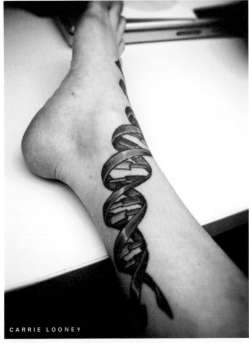

CARRIE LOONEY

JAY PHELAN, a biologist at UCLA, got his DNA tattoo in 1990 while he was in graduate school. "As I got deeper into the study of evolution, genetics, and human behavior, " he writes, "I realized that there was a tension between what my genes 'wanted' me to do and what I wanted to do, from the fattiness of the foods I ate, to the selfishness/selflessness I showed to others, to issues with managing my money, my risk-taking, and my relationships, and more. It dawned on me that I was fighting a never-ending battle. Anyway, I tried to come up with a design that captured that tension and, once I did, decided to get it tattooed on my back."

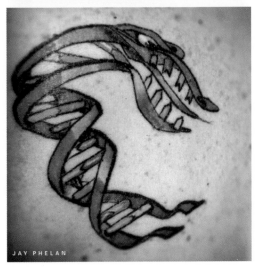

JAY PHELAN

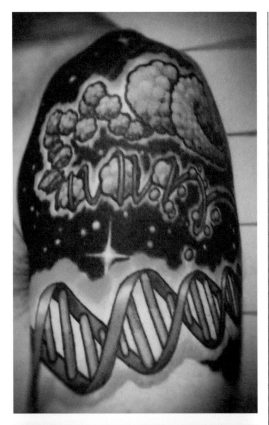

"THIS TATTOO I got as a post-doctoral fellow studying protein folding," writes a scientist who wishes to remain anonymous. "The tattoo is sort of a telescoping view of the contents in a cell (many contents omitted, obviously). This came about from a very vague idea of something I wanted, and the artist really ran with it. He has no scientific training but came up with some really amazing artwork. He was so enthusiastic and wanted to know all about what it all meant and how it works. I enjoyed the experience of sitting with him for three days as much as I enjoy the result."

DNA ART

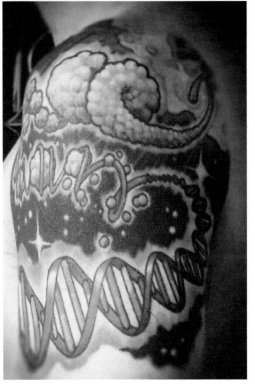

A BRITISH COMPANY called DNA Art has found beauty in the craft of sequencing DNA. In a process known as gel electrophoresis, scientists purify DNA from cells and then use enzymes to cut them into pieces. They then squirt the fragments into one end of a gelatin-like slab. When they switch on an electric current, the DNA fragments are drawn towards the other end. But the weight and the sequence of each fragment sets its particular speed as it moves through the goo. Any individual piece of DNA will produce a distinctive pattern of fragments in a photograph: a genetic fingerprint.

THE SIX MOST important letters in molecular biology are DNA and PCR. DNA is the biological book in which our genes are inscribed. PCR is the magnifying glass that lets scientists read their tiny script.

To appreciate why PCR is so important—important enough for its discoverer, Kary Mullis, to win the Nobel Prize—it helps to

ARPIAR SAUNDERS

try pulling DNA out of a cell. The molecule is so delicate—a pair of strands three feet long but just a few atoms wide—that it snaps into a vast number of fragments. Pull DNA out of a thousand cells, and you'll end up with a thousand different jumbles of genetic jetsam.

Mullis worked out a reliable way to carve out any particular piece of DNA. He placed the molecule in a flask and gently heated it until its two strands melted away from each other. He then added a mix of molecules. One set, known as primers, latched onto each of the strands. Thanks to their sequences, they

could latch onto the two ends of the piece he wanted to copy. Another set of molecules, called polymerases, then added nucleotides to the ends of each of the primers. Before long, the polymerases had reassembled the complete stretch of DNA.

Mullis then separated the new strands and used primers to make a new copy of each. In a process Mullis dubbed the polymerase chain reaction, he produced billions of copies of the piece of DNA—enough pieces to analyze it and decipher its sequence.

Arpiar Saunders, a Harvard graduate student in neuroscience, wanted to honor PCR—"the cornerstone of all molecular biology," as he puts it—with a tattoo. "Biologists often hijack biological systems to understand more about biology," he writes. "PCR, or polymerase chain reaction, represents an inspiring example to me. PCR uses components of the cell's own DNA replication machinery to amplify arbitrary DNA segments in a tube. Having PCR on my chest is first and foremost a joke to make molecular biology girls giggle. But my tattoo also serves as a reminder for this young scientist to look toward biology for simple, creative solutions in the face of bewilderingly complicated biological systems."

I asked Saunders to explain the snow plows. "The snow plows are an ode to my New Hampshire roots and to science style," he replied. "If you need snow removed—or data piled up—I'm your man."

BEN EWEN-CAMPEN, a graduate student in evolutionary biology at Harvard, sports a "DNA ladder." The ladder is produced by electrophoresis, a technique used to analyze DNA molecules. The tattoo is made with black-light-sensitive ink, glowing in the ultraviolet just like real DNA in some electrophoresis kits. "The fact that it looks like a barcode from a futuristic dystopic society is an accident," he writes.

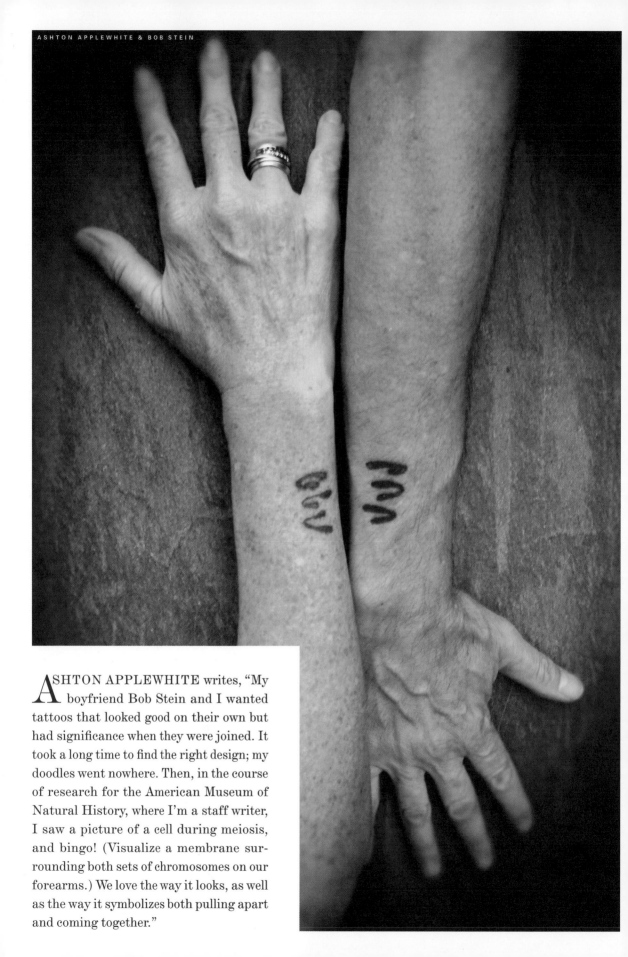

ASHTON APPLEWHITE writes, "My boyfriend Bob Stein and I wanted tattoos that looked good on their own but had significance when they were joined. It took a long time to find the right design; my doodles went nowhere. Then, in the course of research for the American Museum of Natural History, where I'm a staff writer, I saw a picture of a cell during meiosis, and bingo! (Visualize a membrane surrounding both sets of chromosomes on our forearms.) We love the way it looks, as well as the way it symbolizes both pulling apart and coming together."

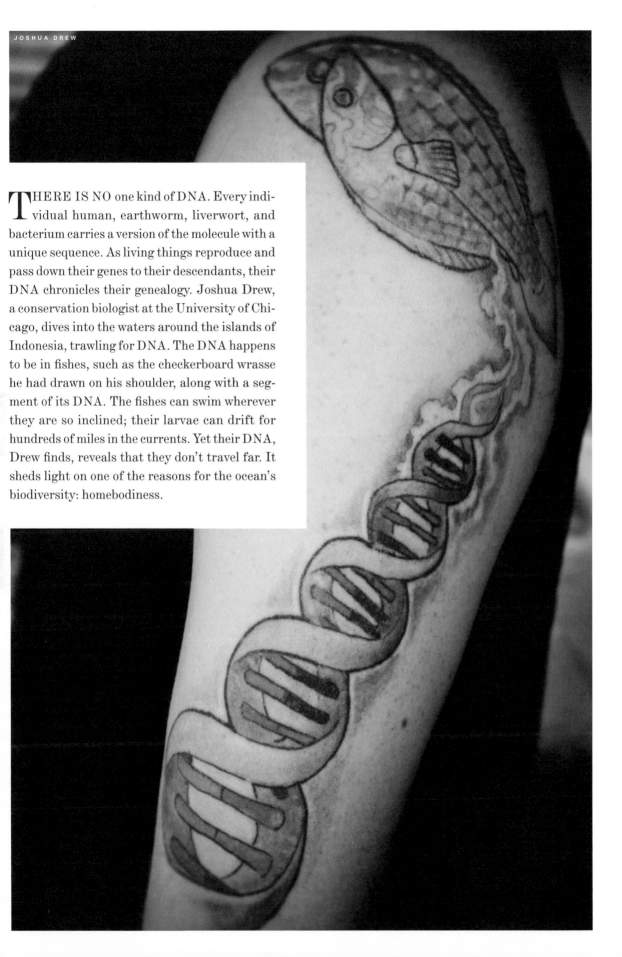

THERE IS NO one kind of DNA. Every individual human, earthworm, liverwort, and bacterium carries a version of the molecule with a unique sequence. As living things reproduce and pass down their genes to their descendants, their DNA chronicles their genealogy. Joshua Drew, a conservation biologist at the University of Chicago, dives into the waters around the islands of Indonesia, trawling for DNA. The DNA happens to be in fishes, such as the checkerboard wrasse he had drawn on his shoulder, along with a segment of its DNA. The fishes can swim wherever they are so inclined; their larvae can drift for hundreds of miles in the currents. Yet their DNA, Drew finds, reveals that they don't travel far. It sheds light on one of the reasons for the ocean's biodiversity: homebodiness.

JACYLYNN ROSENTHAL'S tattoo represents part of a gene called p53, which is sometimes called the guardian of the genome. If a cell gets damaged, p53 proteins switch on genes that cause it to commit suicide instead of going on to become cancerous. "I studied p53 and other targets of the SV40 tumor virus while working on a molecular biology degree at The University of Pittsburgh," writes Rosenthal. "I'm now a medical student at Nova Southeastern University."

The gene for p53 has a deep heritage. Scientists can find recognizable relatives of the human version of the gene in sharks, clams, and even jellyfish. At first, perhaps a billion years ago, it ensured that sperm and eggs were of high quality. It could detect sex cells that had acquired defects in their DNA, whereupon it sent out orders to a network of dozens of genes, causing the cell to commit suicide. Thus, an animal could put forward only the finest gametes into the tournament for immortality.

More recently, our ancestors borrowed p53 to keep watch over the rest of our bodies. Each time a cell divides, there's a small chance it may make a mistake copying its DNA. That mistake may make the cell a little bit more reckless in its divisions, a little closer to becoming cancerous. The p53 gene monitors this copying, and it can cause a dangerous cell to die. If p53 should fail, we face a far graver risk of developing cancer. About half of all cells from tumors have mutations in their p53 gene. Some viruses, such as SV40, attack p53 for this very purpose. They force their host cell to replicate quickly, making more copies of themselves. By shutting down p53, they avoid getting destroyed.

Each time p53 kills off a cell, we pay a price. The molecules that are released from a dying cell can damage the surrounding tissue. As years pass, the tissues become old. They can even develop cancers of their own. A billion years of evolution has turned p53 into a powerful solider in the war our bodies wage against cancer. But p53 can only hold off cancer for a while—long enough for us to have a chance to reproduce and pass down our genes. Evolution cannot offer us cures; it can only find trade-offs between life and death.

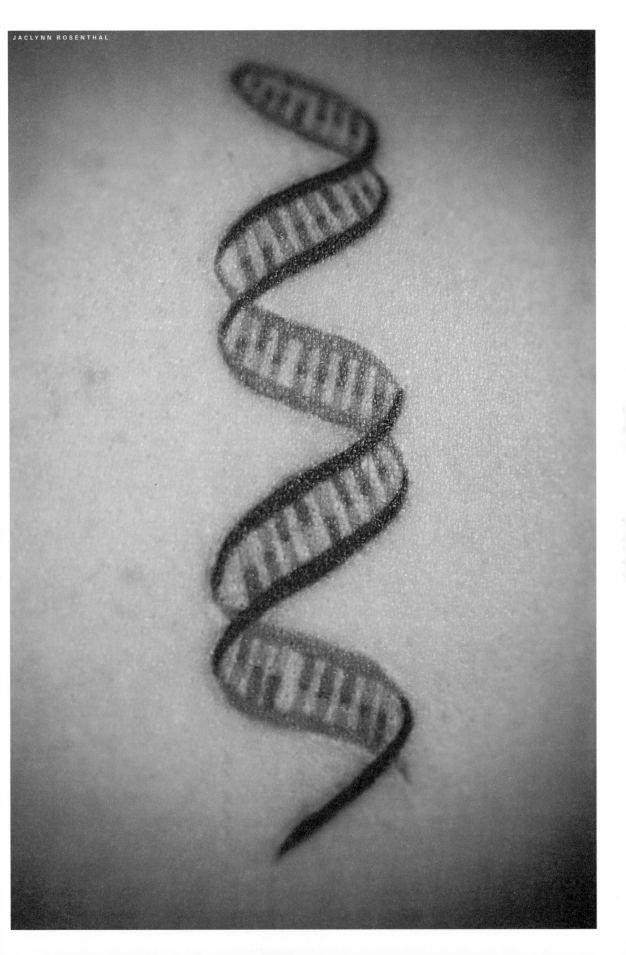

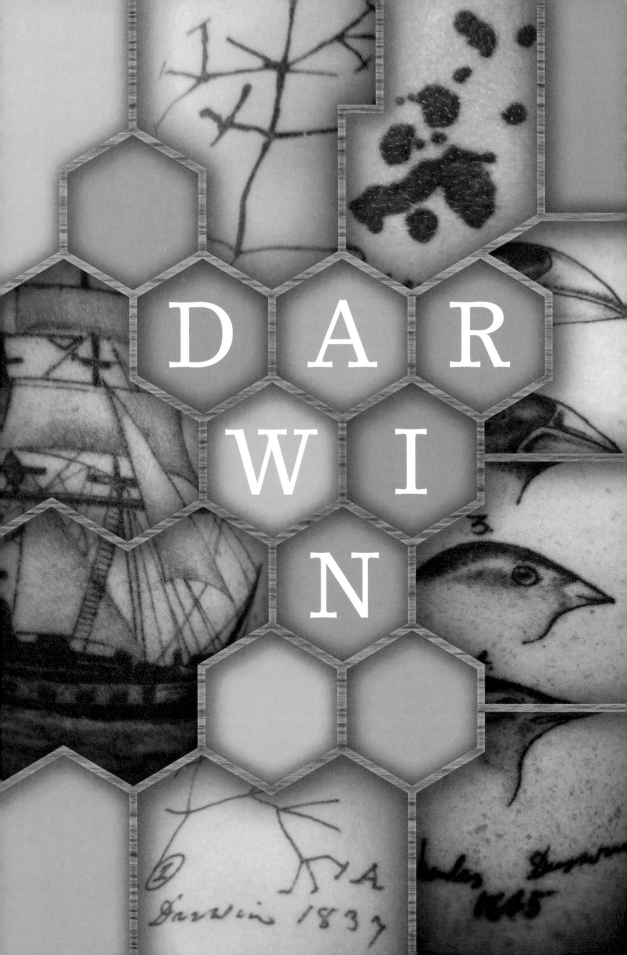

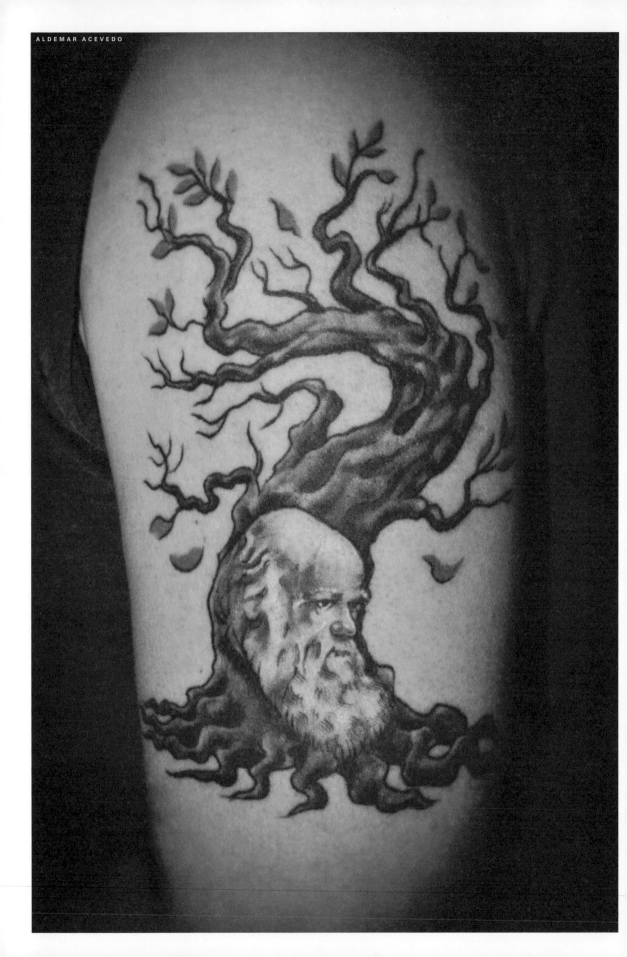

Blind Watchmaker

MOST SCIENCES GREW slowly, like redwood trees. Chemistry sprouted from the rich soil of alchemy in the seventeenth century, but it took two centuries to blossom forth with a periodic table. Another century passed before chemists could understand how chemical reactions take place. Evolutionary biology, on the other hand, turned into a science thanks in large part to the work of one scientist.

Much of the evidence for Charles Darwin's theory of evolution had been discovered by others. And Darwin was not the first naturalist to imagine life undergoing gradual change. But he knitted theory and evidence together into a single book, *The Origin of Species*, that could not be ignored.

So it's not a big surprise that a fair number of evolutionary biologists (and other scientists) have tattooed Darwin on their bodies. Of course, the flowing beard and boulder-shaped forehead helped to make his face immediately identifiable. But his somber visage is not the only image Darwin has left us. In his published books and private notebooks, Darwin reveled in pictures that chronicled his journey around the world on the *Beagle* and his struggle to make sense of how new species come to be. Today, evolutionary biologists work far beyond the frontiers of Darwin's world, observing how genes flow between species like braided rivers. But they do not forget where the river began.

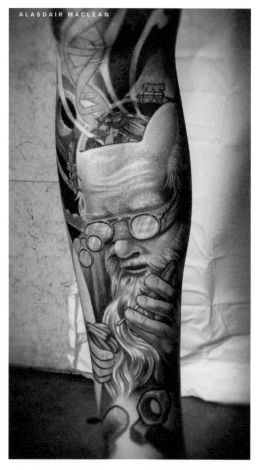

ALASDAIR MACLEAN

"I HAVE ALWAYS wanted a tattoo that would represent science, evolution and skeptical inquiry but struggled with finding something that would make an interesting tattoo," writes Alasdair Maclean. He decided on a portrait of Darwin, inspired by *The Blind Watchmaker*, an account of modern evolutionary biology by the British scientist Richard Dawkins. Darwin plays the role of evolution, unable to see the genes he is engineering."

Darwin Kong

"THIS IS A CARTOON from the *New Yorker* magazine that I cut out and have had on my classroom wall for a couple years now," writes Chris Farnsworth, a high school science teacher from Massachusetts. "It recently dawned on me that it would make a great tattoo. My take on it is the establishment is attacking Charles Darwin for the same reason it attacked King Kong. They just don't understand him."

Beagle

CRAIG BARTHOLOMAUS, an English teacher at Metropolitan Community College in Saint Louis, Missouri, wears the image of *H.M.S. Beagle*. From 1831 to 1836, the British ship carried Darwin around the world, giving him the opportunity to gather the observations that would become the foundation of his theory of evolution.

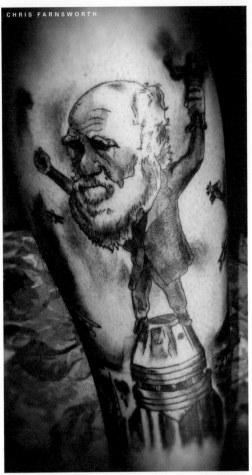

CHRIS FARNSWORTH

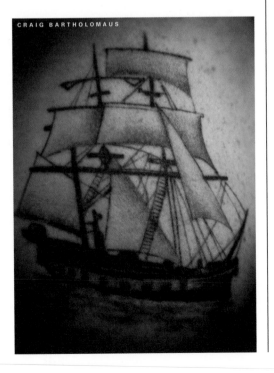

CRAIG BARTHOLOMAUS

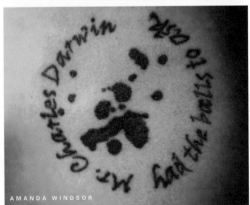

AMANDA WINDSOR

Galapagos

AMANDA WINDSOR, who earned her Ph.D. at the University of Louisiana, combines the Galapagos Islands with a line from the REM song, "Man on the Moon."

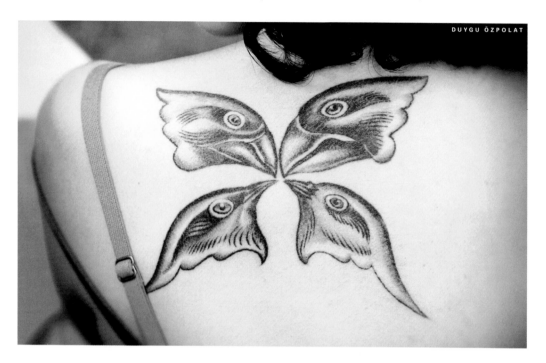

Darwin's Finches

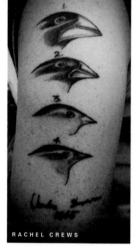

DUYGU ÖZPOLAT, a graduate student in developmental biology at Tulane University, and Rachel Crews, a cartographer for the North Carolina state government, both decided to celebrate Darwin's 200th birthday in 2009 with a tattoo of Darwin's finches. In 1835, Darwin encountered the finches on the Galapagos Islands. He didn't think much of them at the time, carelessly labeling them as he stored them aboard the *Beagle*. He didn't even recognize that they were all finches; their radically different beaks made him think that some were warblers, wrens, or mockingbirds.

Only after he returned to England did an ornithologist who examined the birds inform him that they were all finches. That news struck Darwin at a crucial moment—he was beginning to develop a theory that species were not created in fixed forms, but had evolved from common ancestors. The finches, Darwin concluded, had adapted to the seeds, fruit, and other foods of the islands. In the late 1900s, biologists began to document the average size of beaks in different species of Darwin's finches, year in and year out. They chronicled how natural selection shifted the beak from one size to another as the supply of food shifted from soft to hard and back to soft again. Darwin included engravings of his finches in his first book, *The Voyage of the Beagle*. Özpolat and Crews now wear those engravings, with a far deeper meaning than before.

Trio of Darwin Trees

"ABOUT FOUR YEARS ago, a close friend from college got her first tattoo—something meaningful and marking a particular point in her life—and she asked me if I would ever get one," writes Caitlin Fisher-Reid, who now studies the origin of new species at Stony Brook University. "I said sure, but that at that point in my life there was nothing I could come up with that was meaningful enough to have permanently etched in my skin. That was my first year of graduate school and I was still very unsure of myself and my future.

"Four years of graduate school later finds me in the final stages of earning a Ph.D. in evolutionary biology—a place I was not convinced I was cut out to reach at the start of graduate school. After 2009's year of Darwin celebrations, including my own involvement organizing a conference celebrating 150 years of evolutionary biology, the perfect tattoo came to me in class one day in March, and I found myself at the tattoo parlor by the end of that week.

"My tattoo is Darwin's very first phylogeny, from his *Notebook B* on *Transmutation of Species* and it is on my right shoulder. These notebooks contained much of his brainstorming on evolution after returning from the *Beagle*, and I was able to see this one in person at the American Museum of Natural History's Darwin exhibit in 2006. I also added his signature and the date which can be found on the inside cover of the notebook.

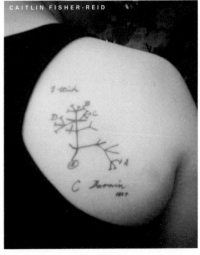

CAITLIN FISHER-REID

"I chose this particular piece of Darwinia for several reasons. As a perpetual student of science and of nature in particular, I love the slight hesitation and perhaps excitement in the 'I think.' I am amazed that Darwin was thinking about phylogenies in 1837, 22 years before the *Origin of Species* was published—that you can see the seed of his great work (and the preface to the only figure in the *Origin*) so early in his writings. The phylogeny itself as an image is meaningful because I study speciation, and spend a great deal of time studying, thinking about, and building my own phylogenies. I had also selected it to be part of the cover of the program for the conference I was involved in, and many attendees asked me about it—in short—it carries a lot of meaning to me.

"So, my tattoo honors Darwin, the father of my field; it represents my own personal research; and it exemplifies the slight hesitation an ad excitement of scientific discovery that I hope will stay with me always as I launch my academic career. It is a mark of confidence, in myself, and my chosen profession. I have no doubt that I will never regret permanently etching this image on my skin, and I know that it will serve as a reminder to me that even though the pursuit of scientific knowledge is a long, sometimes daunting journey, I love what I do and I can't imagine doing anything else."

"AS A YOUNG biologist, I was very taken with Darwin," writes April Wright, a graduate student in evolutionary biology at the University of Texas. "Not just as a scientist, but as a person. His humbleness as a person (the tattoo reads 'I think', not 'I know') and forward thinking with respect to racial issues was what initially drew me to him as a figure. A couple years later, as someone in the field with a growing appreciation for the impact and scope of evolutionary theory, I'm even more awed by his intelligence and prescience—and perhaps more awed by how many biologists think it's totally appropriate to just walk up and peek under my shirt at my ink."

"MY PH.D. IN biological anthropology had been a long haul, with many thoughts of abandonment along the way," writes Julienne Rutherford, an assistant professor at the University of Illinois at Chicago. "So once it was clear I would indeed finish, I wanted to commemorate and celebrate the rite of passage in a ceremonial way. As a collector of body art since 1993 (9 pieces and counting), I knew I would get a tattoo, and as an evolutionary biologist and anthropologist, I knew it would be Darwin's phylogenetic tree sketch from his 1837 *Notebook B* from the *Transmutation* series. I was always captivated by both the 'Eureka!' moment inherent in the sketch as well as its spidery graphic quality. That so simple a sketch could effectively convey the core concept of something as profound as descent with modification is very moving to me. The day I turned my completed paperwork in to the Indiana University graduate school, I went to Skinquake in Bloomington, where I'd been going for 7 years, and had the piece done."

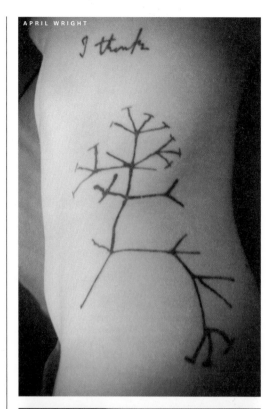

APRIL WRIGHT

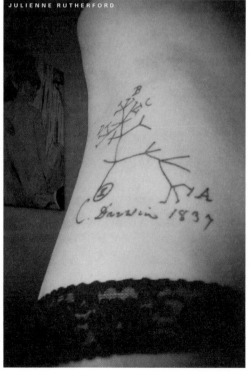

JULIENNE RUTHERFORD

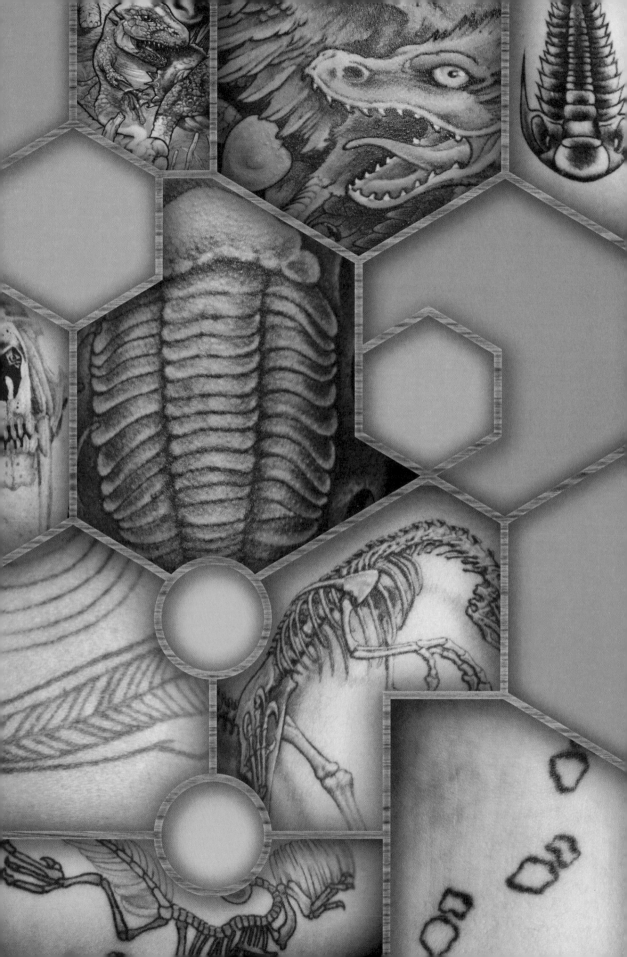

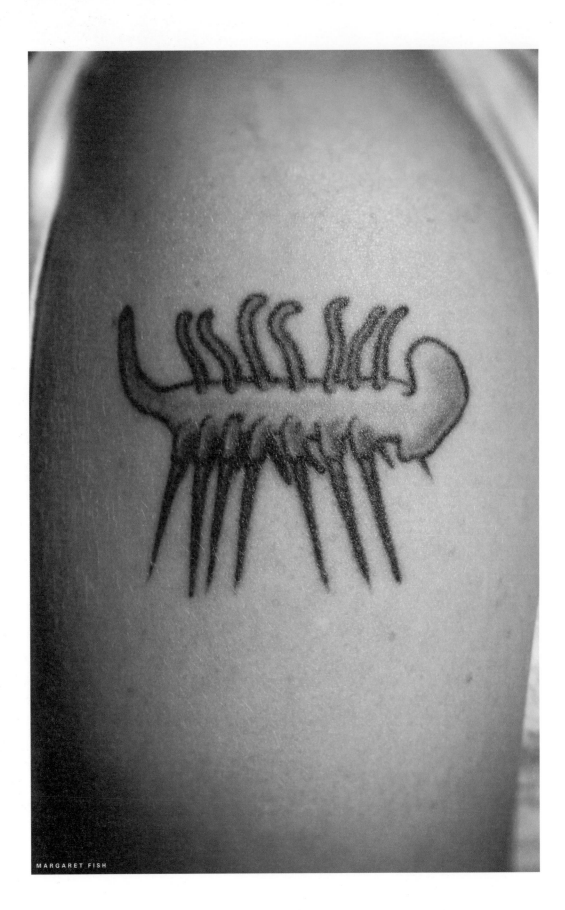

Hallucigenia

543–490 MILLION YEARS AGO

"MY TATTOO IS of my favorite Burgess Shale fossil, *Hallucigenia*," says Margaret Fish of the University of Virginia. "Reading about the 'Cambrian Explosion' and the discovery of the Burgess Shale in Stephen Jay Gould's *Wonderful Life* inspired me to pursue my Ph.D. in biology. I got the tattoo as a gift to myself upon my acceptance into graduate school, where I am now in my fourth year studying developmental biology."

The fossil fish she chose was *Hallucigenia*, a creature so unlike any known animal that it once seemed like a hallucination. "However, more recent fossil specimens seem to indicate that the original researchers were in fact just looking at the organism upside-down, and that it is not so strange after all," says Fish. "Stories such as this one serve to remind me to question my perspective and preconceived notions when trying to explain the sometimes baffling results of my research projects."

Marella

543–490 MILLION YEARS AGO

PALEONTOLOGIST NEIL KELLEY wears a tattoo of *Marella*, an extinct relative of today's arthropods, such as insects and crustaceans. The "C" symbol stands for the Cambrian Period, when *Marella* first evolved, and when it became extinct.

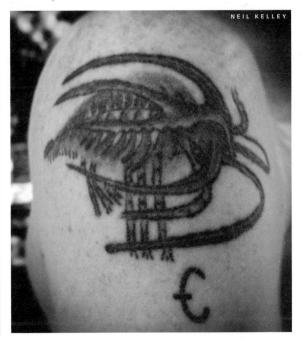

NEIL KELLEY

Opabinia

JAMES KANE WRITES that his tattoo is "a design of *Opabinia regalis*, a Burgess Shale fossil dating from the Cambrian. It has some 'pirate' imagery, including the hourglass, skull, and nukes. As an evolutionary dead end, *Opabinia* reminds me of the diversity and tenacity of life through difficulty (how do you put 'ad astra per aspera' ['through adversity to the stars'] into fossil terms?), and plus it looks awesome."

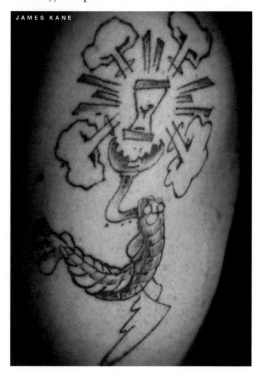

JAMES KANE

Pikaia

KIMBERLY HANDLE of Brooklyn College selected *Pikaia* for a tattoo. Once *Pikaia* was believed to be a close relative of vertebrates—perhaps even our boneless forerunner. *Pikaia* figured famously in a thought experiment crafted by the paleontologist Stephen Jay Gould. What would have happened if the tape of life was rewound to 600 million years ago, and life could evolve all over again? Gould believed that life was governed by contingencies, so that life today might look altogether different. If *Pikaia* happened to become extinct, we would never have evolved.

Paleontologists have continued to study *Pikaia*, and they've concluded that it couldn't be a forerunner. It was probably more closely related to invertebrates like sea squirts. *Pikaia* is now no longer part of Gould's great experiment. It's merely another strange resident of the strange Cambrian seas.

KIMBERLY HANDLE

Trilobites

ONCE THE WORLD belonged to trilobites. These arthropods first emerged in the great flowering of animal diversity during the Cambrian Period, some 520 million years ago. Many of their Cambrian compatriots, like *Hallucigenia*, died away, but the trilobites crept and swam onward for 300 million years. They diversified magnificently, and even today different fossil species can be distinguished by the shapes of their eyes, their ribs, and other parts of their anatomy. Trilobites come so thick and fast in the fossil record that paleontologists can use them to pin the age of rock layers and test ideas about how evolution unfolds over vast stretches of time. It was trilobites that Niles Eldredge and Stephen Jay Gould used to argue that life evolves not at a gradual pace but in fits and jerks. They are wonderfully abundant today; many a fossil-lover first came to face to face with the past by staring into the crystalline eyes of the trilobite.

ELYSE PETERSON

JUDITH SEGALL

AMANDA PINGS

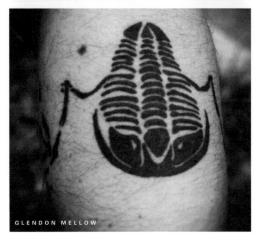

GLENDON MELLOW

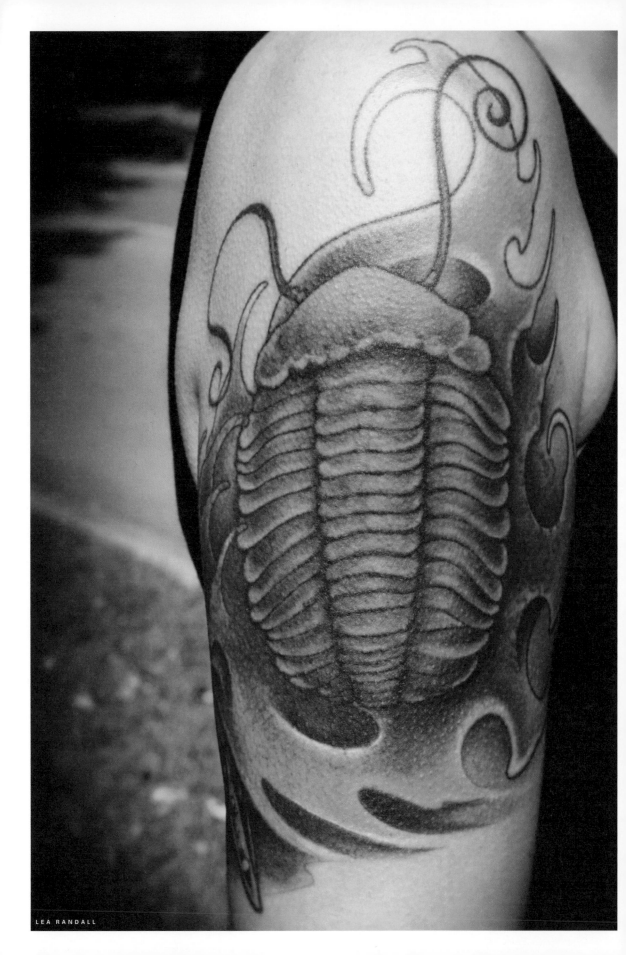

Ammonites

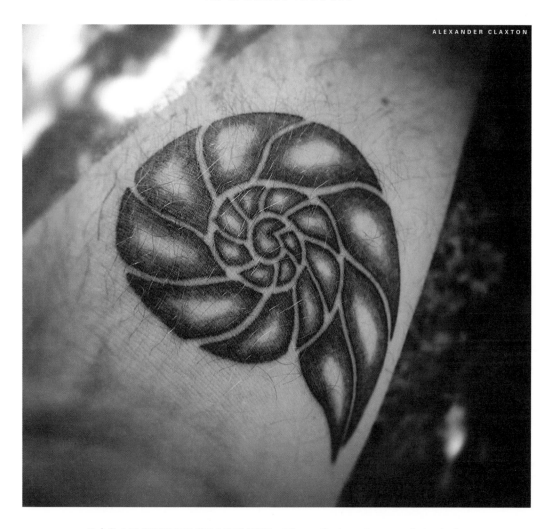

ALEXANDER CLAXTON

"AS AN UNDERGRADUATE at I was fortunate enough to study *On Growth and Form* by D'Arcy Thompson," writes Alexander Claxton, a graduate student studying human evolution at Indiana University. "His synthesis of mathematics, classics and biology was an inspiration to me, and drove me to pursue science as a career. Though I am now studying to be a paleoanthropologist, my tattoo of an (idealized) ammonite fossil is a reminder to me of the material and mathematical processes behind all living things. Plus, extinct cephalopods are more aesthetically appealing than hominin skulls."

Eusthenopteron

MARCUS DAVIS, a biologist at Kennesaw State University, studies how new kinds of bodies evolve. We humans have two arms and two legs, adorned with five digits apiece. So do chimpanzees. So do mice. So do frogs. In fact, most of the vertebrates who live on land have this anatomy. Horses don't have toes, and snakes don't have legs,

but they evolved from vertabrates that did. But before 400 million years ago, there were no vertebrates on land. There were no arms and legs, at least as we know them. There were, however, fishes called lobe fins, such as this *Eusthenopteron* (opposite). Instead of slender rays, their fins were stiffened with stout bones—the beginnings of limbs.

Davis cannot go fishing for *Eusthenopteron*, so he studies how genes in the embryos of living fishes build fins and compares them to our own limb-building. He has also spent summers in the Canadian Arctic, as a member of a team hunting for fossils that chronicle the transition from water to land.

For his tattoo, Davis chose a window into this Devonian world. "I was mulling over which animal to use for my tattoo when I had a chance to visit the Redpath Museum in Montreal and spend a few days studying

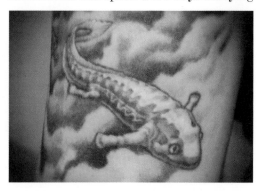

their extensive growth series of *Eusthenopteron*," he writes. The fossils charted the growth of the lobe fin from larva to three-foot-long adult. The growth series was so complete that Davis got a deep sense of its development. "I left feeling like I understood that fish...as much as I possible could understand a creature that ceased to exist hundreds of millions of years before my time."

Davis proceeded to spend 35 hours, off and on, under the needle of the artist Tim Kern for his *Eusthenoteron*. He then decided to get another tattoo, a small early tetrapod scurrying through river-bottom silt (above), trying to avoid getting eaten by *Eusthenoteron*. "It's my statement on the real complexities in the origins of terrestriality," writes Davis. "Tetrapods were, initially, just another specialist fish in a crowded market."

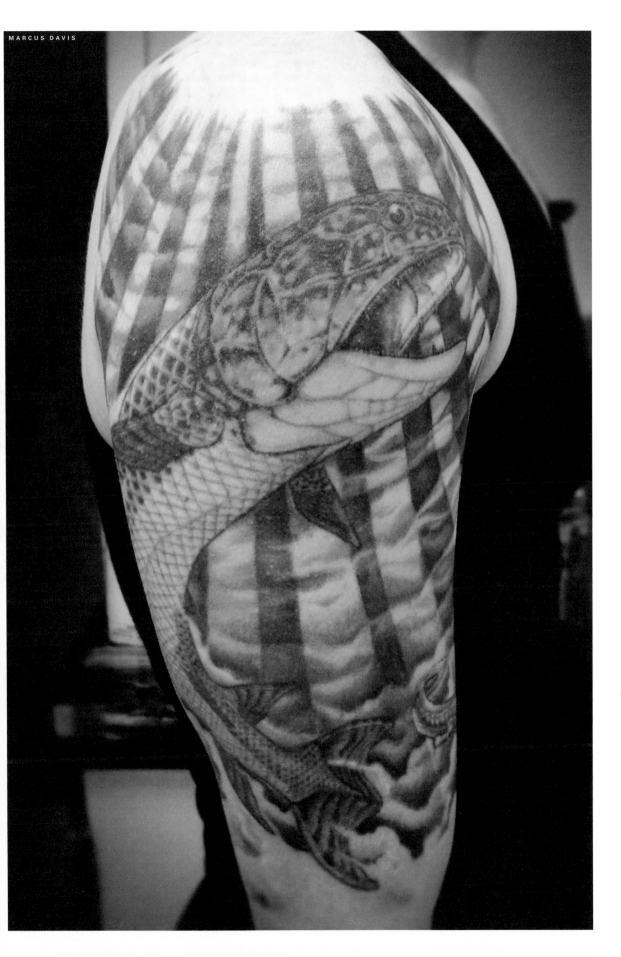

𝔐𝔢𝔰𝔬𝔷𝔬𝔦𝔠 𝔊𝔦𝔞𝔫𝔱𝔰

250–65 MILLION YEARS AGO

THERE'S A MASSIVE mismatch between Wayne Knee's scientific work and his scientific tattoo. As a graduate student at Carleton University, he studies acarology: the science of mites. "I am an acaralogist with an unhealthy obsession with fossils," he confesses. "This tattoo is a tribute to the past monsters of the deep." Knee wears two of many giant vertebrate predators that prowled the oceans. The shark, *Carcharodon megalodon*, grew up to 50 feet long and weighed as much as 50 tons. The other beast is a tylosaur, a marine lizard that sometimes got to be almost as big as *Carcharodon*. Floating in the background are extinct relatives of nautiluses, which tylosaurs cracked open to fuel their tremendous growth.

Dragonfly Rex

NEIL KELLEY is a graduate student in paleontology, studying marine reptiles. But it is an insect that covers his arm. His tattoo is a life-sized reproduction of a wing belonging to a gigantic insect called a titanopteran that lived during the early Triassic Period, 240 million years ago.

NEIL KELLEY

Titanopterons are distant relatives of today's dragonflies and mayflies. While dragonflies may reach a few inches across, titanopterons grew to the size of crows. And they were not the biggest of all the ancient insects that lived between about 300 million and 240 million years ago. One group of dragonfly-like insects reached wingspans of two-and-a-half-feet across.

These insects may have reached their arm-length sizes thanks to the first bloom of forests and swamps. As massive stands of trees grew across the land, they breathed the atmosphere in and out of their leaves. As they grew and died and tumbled into the Carboniferous Period swamps, carbon was buried at a colossal rate. In this way, the plants shifted the flow of chemicals through the atmosphere, the land, and the sea. Instead of reacting with organic matter scattered on the ground, the oxygen in the atmosphere increased. The Earth's oxygen supply doubled over the course of perhaps fifty million years. But the planet cannot tolerate too much of the gas. It makes forest fires too easy to ignite. Animals evolved to feed on plants more efficiently at the same time, and they may have helped draw the oxygen levels back down.

During that frenzy of oxygenation, many animals evolved to bigger sizes. Reptiles swelled; millipedes grew to the size of pythons. Insects grew spectacularly large as well. One hypothesis for their gigantic size builds on the way they breathe. Instead of drawing in air through their lungs, they take it in through microscopic tunnels in their exoskeleton. A quarter of a billion years ago, there was ample oxygen to draw in through those tunnels. But today, insects are starved into relative smallness.

Helicoprion

MEG GODBOUT writes, "I had this tattoo done at age 19, when I was first becoming interested in marine paleontology. It's the jaw of a unique shark species called *Helicoprion*. I got it done on my hip partially because it's aesthetically beautiful and also because it's such a morphological oddity—paleontologists had no idea where the fossil actually went on the shark's body until a few years ago when they found additional fossils. This tattoo represents my great love for marine fossils and my dream of becoming a paleontologist—I'm currently pursuing a B.S. in geosciences here in Florida."

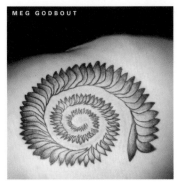

MEG GODBOUT

Paleontologists rarely find full skeletons laid out for them like cadavers in a morgue. They have to settle for debris. Fortunately, there's a consistency to the shapes of living things. A single tooth can be enough for a paleontologist to know that she has found some kind of mammal, and not a reptile or an amphibian.

Some animals, however, defy the laws of consistency. In 1899 a Russian paleontologist named A. P. Karpinsky excavated a spiral of barbs. He thought it was the upper jaw of a shark that bent upwards and back, spiraling in on itself like a surreal elephant raising its trunk over its head. He named the strange creature *Helicoprion*, for spiral saw.

Over the next century, scientists have found more fossils of *Helicoprion*, but never one with its toothed coil firmly attached to its body. Some paleontologists have rejected Karpinsky's picture. They have given *Helicoprion* an equally surreal anatomy, putting its toothed spiral on the lower jaw, hanging down like a razor-shape beard. Others have slipped the spiral into the shark's mouth, or down its throat hiding its glorious spiral from the world.

Cephalopods

SUSAN DRYMALA, a mining geologist, wears a tattoo of *Cooperoceras texanum*, an extinct cephalopod, distantly related to octopuses and squid. "I got my tattoo in 2008 after raising enough money by carrying around a jar marked 'tattoo fund' as I bar-hopped for my 21st birthday," she writes.

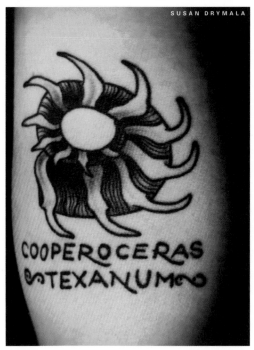

SUSAN DRYMALA

𝕾𝖆𝖚𝖗𝖔𝖕𝖔𝖉 𝕱𝖔𝖔𝖙𝖕𝖗𝖎𝖓𝖙𝖘

163 MILLION YEARS AGO

THE FOOTPRINTS OF dinosaurs trudge across the foot of Julia Heathcote, a biology lecturer in London. We think of paleontology as the study of fossil bones and shells, of the mineralized pieces of dead organisms. But organisms leave their mark on the world, and that mark itself can survive for millions of years. Billions of years ago bacterial mats turn shallow seas into vast expanse of lumps. A hundred million years ago termites burrowed enormous chambers that fill with rock, leaving behind columns of stone. Tracks and traces can tell scientists things that ordinary fossils cannot. Early animals left slithering trails in the sea floor 550 million years ago, millions of years older than the first fossils of the animals themselves that could have made such marks. Dinosaur trackways reveal ancient migrations, how these beasts herded together to protect their young from predators. Fossils are the marks of animals after they've died. Their tracks are their marks in life.

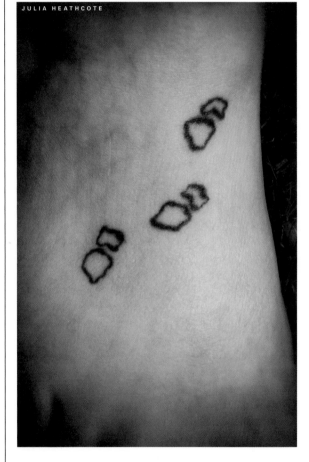

JULIA HEATHCOTE

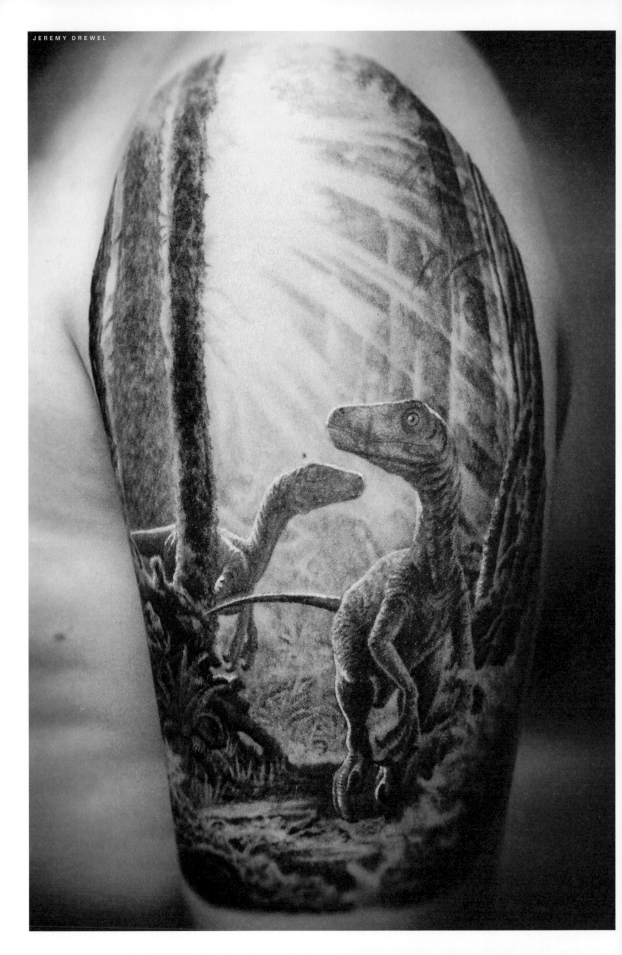

Bird-like Dinosaurs

IN 1964, THE late paleontologist John Ostrom was circling a hill in Montana when he spied some strange bones. He and his colleagues hacked them from the rock and realized they had found the remains of a two-legged dinosaur that lived some 110 million years ago. Paleontologists had found a few scattered bones of similar dinosaurs over the years, but Ostrom realized that he had found the first fossil that was almost entirely complete. It bore a giant sickle-shaped claw on each hindleg, and so Ostrom dubbed it *Deinonychus* (opposite and right), meaning terrible claw.

At the time, paleontologists tended to view dinosaurs as slow and sluggish. Ostrom rejected that image, pointing to *Deinonychus* as evidence. Its claw only made biological sense as a weapon for slashing and ripping. And a torpid reptile could not have wielded such a weapon. Ostrom suggested that dinosaurs were active—even warm-blooded.

That would have made *Deinonychus* important enough, but Ostrom went further. He observed some telling similarities between *Deinonychus* and the oldest fossil bird, called *Archaeopteryx* (see p. 134–135). Discovered in 1861, *Archaeopteryx* was tattoo-worthy from the start. It had feathers and other traits of living birds, but it also had teeth, claws, and a long bony tail that revealed how birds had evolved from reptiles. "It is a great case for me," Charles Darwin wrote to a friend.

But for over a century, paleontologists were divided about which reptiles had given rise to birds. *Deinonychus*, Ostrom argued, provided the answer: birds are dinosaurs.

Paleontologists were divided over whether Ostrom was right, but in the late 1990s, a compelling new line of evidence came to

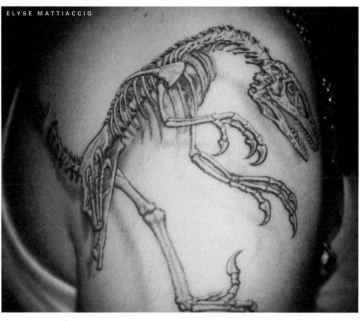

ELYSE MATTIACCIO

light. In China, fossil hunters began to find feathered dinosaurs. Relatives of *Deinonychus*—the most bird-like of dinosaurs—had the most bird-like feathers. It now appears that feathers evolved millions of years before *Archaeopteryx*, when dinosaurs were still ground-runners, perhaps as a way to attract the opposite sex. These new fossils have forced many changes to how we picture dinosaurs. They even suggest that more than a few dinosaur tattoos may need some new ink.

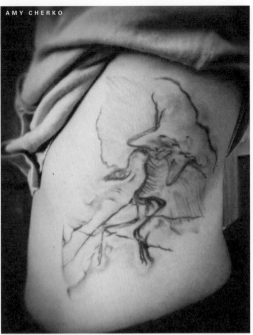
AMY CHERKO

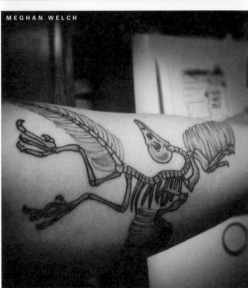
MEGHAN WELCH

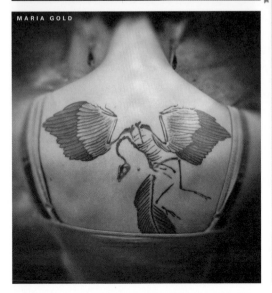
MARIA GOLD

ANTIONE BERCOVICI

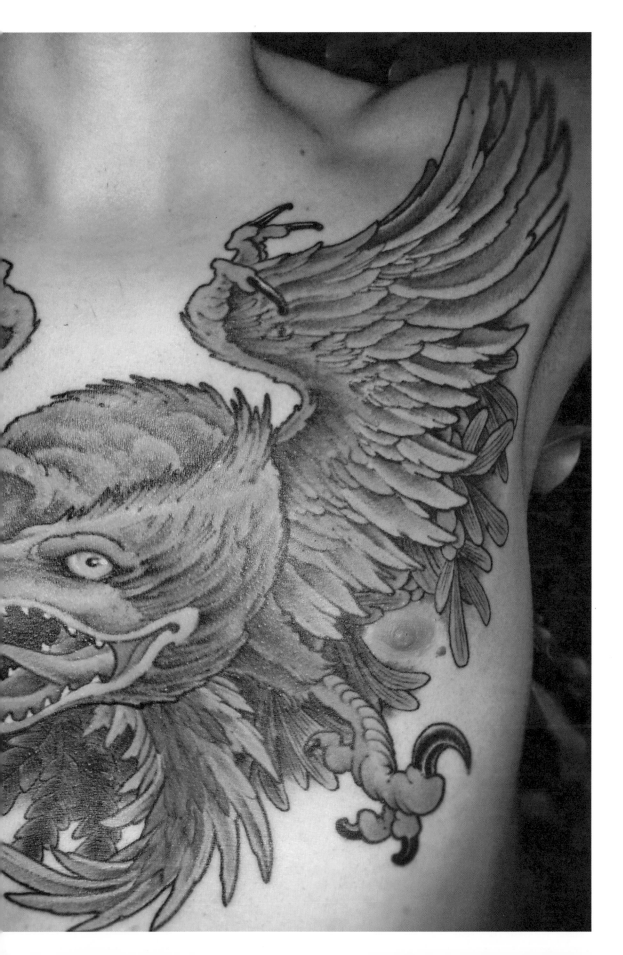

𝕾nakes

"THERE IS NO rational explanation for this tattoo, only post-inking scenarios," writes Gary Richards, an anthropologist who studies human evolution at the University of California at Berkeley.

"I do not study snakes, nor do I particularly like them. There is, however, a 'when.' The idea and the product came

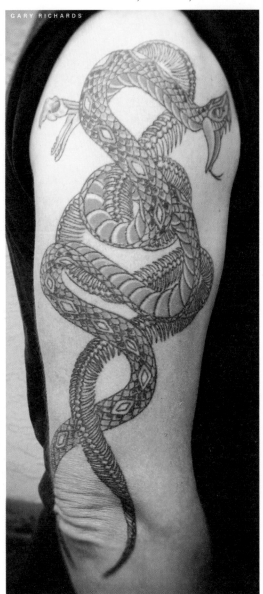

GARY RICHARDS

at the end of a yearlong effort to delineate the biology behind a fossil skeleton. Although I have always sought to explain hard tissue morphology by reference to soft tissues, this work took me way beyond the limits of my previous understanding. The result was a massive expansion of my thinking on how modern biology can be integrated into understanding fossil populations. In the post-publication stupor, the snakes appeared and got inked.

"I suppose you could say that they represent the commingling of knowledge from living forms with that from fossil forms. But then again you could suggest any number of 'rational' explanations for having two large snakes permanently inked on your arm."

Mass Extinctions

RUNNING THROUGH mountainsides and rock cuts around the world is a thin band of rock 65 million years old, sprinkled with destruction. It is rich with iridium, an element that normally drizzles down from the heavens in trace amounts. Sixty-five million years ago, however, an iridium downpour drenched the planet. In the Gulf of Mexico, a ghostly ring of buried rocks records how that iridium was delivered. A six-mile-wide asteroid crashed into the planet, and a pall of pulverized asteroid, boiling sea water, and sulfur-rich sediments rose into the sky. Tidal waves, fires, and darkness ensued. Many scientists think it's no coincidence that those same layers of rock also mark a jarring break in the history of life: a mass extinction that wiped out the dinosaurs that couldn't fly, along with giant marine reptiles, and vast numbers of less charismatic residents of the land and sea. The full story of the mass extinctions may have been more complex: enormous volcanoes were belching toxic gases for hundreds of thousands of years already, and some groups of species were gradually becoming extinct for millions of years. The impact may not have felt like an instant apocalypse for the creatures alive at the time. But when we look back through the geological telescope, this image seems about right.

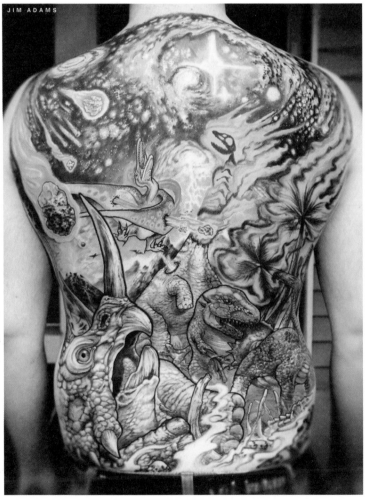

JIM ADAMS

"I've been obsessed with dinosaurs ever since I was a little kid, and I had intentions of doing a large scale dinosaur-themed tattoo," writes Jim Adams, the manager of Nautilus Tattoos in Newington, Connecticut. "One night it came to me that I should do the extinction of them. I figured it would be a pretty epic looking scene but on a deeper level is a reminder that humanity as a whole is not as invincible as we think we are."

Miacis Gracilis

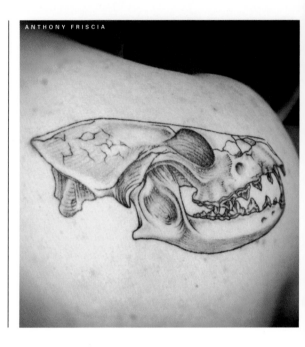

ANTHONY FRISCIA

AFTER ANTHONY FRISCIA graduated from college, he didn't know what to do with his life. He went to his undergraduate advisor for advice. "Come play in the dirt for a month and see if you like paleontology," the advisor replied.

Friscia spent that month in northeast Utah, digging up mammals from the Eocene Period (56–34 million years ago). His advisor studied primates from the period, but Friscia was far more interested in the carnivores that ate the primates. He went on to get a Ph.D. in paleontology, writing his dissertation on how the carnivore community changed through the Eocene. Today he teaches at UCLA, wearing a tattoo of one of those carnivores, the weasel-like *Miacis gracilis*.

Mammoth

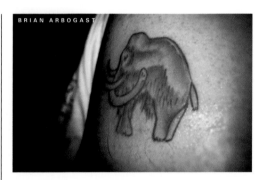

BRIAN ARBOGAST

"I AM A MAMMALOGIST and conservation biologist with a love of the Pleistocene, especially the megafauna," writes Brian Arbogast, who teaches at the University of North Carolina. "I got this mammoth tattoo as a reminder of how close our paths crossed in geologic time, and how I wish I had seen mammoths, giant ground sloths, glyptodonts, etc. This is as close of a connection as I will probably get to the Pleistocene. In terms of style, I tried to draw from European Cro-magnon cave art paintings. I am thinking it will fade a bit over time and take on an even more cave-painting essence."

Sabertooth Tiger

1.8 MILLION TO 10,000 YEARS AGO

This sabertooth skull can be found on the left shin of Trevor Valle, the assistant lab supervisor of the George C. Page Museum at The La Brea Tar Pits in Los Angeles. "The actual skull used for the illustration is currently mounted in the museum," Valle writes. "*Smilodon* is the California state fossil, as well as being the 'mascot' of our museum. They are so distinct and iconic, I wanted to have one immortalized on my skin. That way, I can always take a little bit of my work wherever I go (excluding the asphalt and sediment under my fingernails, of course)."

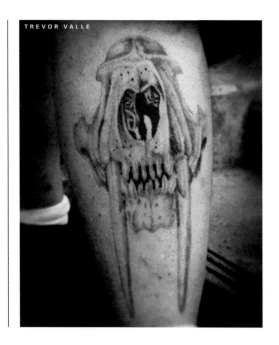

TREVOR VALLE

Sepkoski Graph

543 MILLION YEARS AGO TO PRESENT

Beginning in the 1970s, Jack Sepkoski and David Raup, two paleontologists at the University of Chicago, set out to chart the history of life. They tallied up thousands upon thousands of fossils of marine animals that left behind shells, such as clams, lampshells, and cockles. Sepkoski and Raup then graphed the diversity of the fossils over the past 600 million years. They continued to work together to improve their graph until 1998, when Sepkoski died at age 50. But the Sepkoski Curve, as it came to be known,

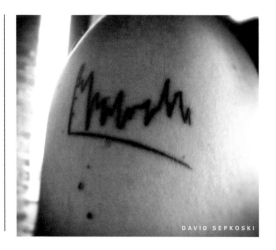

DAVID SEPKOSKI

lived on. It survived not just in countless journal papers and textbooks, but on the arm of his son, David, an historian at the University of North Carolina.

"Basically, my dad and Raup analyzed a computer database of the marine fossil record and found that mass extinctions—where as much of 95% of families and genera died off—appear to have happened at regular intervals of roughly 26 million years," David writes. "The graph (and tattoo) shows this with the regularly-spaced spikes. Dave and my dad declined to speculate about the mechanism for this, but others ran with it, and the data became the basis for the so-called Nemesis 'Death Star' hypothesis, wherein a hypothetical companion star circles the Solar System on an eccentric orbit and passes close enough every 26 million years to kick comets towards the Earth.

"All of this was taking place at the same time that Walter Alvarez and others discovered evidence for a massive asteroid impact at precisely the moment the dinosaurs went extinct, so the mid-1980s were pretty extinction-crazy. All of this stuff ended up in articles in popular magazines and newspapers, and my dad got his 15 minutes out of it.

"I got this tattoo in 1999, shortly after my father died. I stripped away everything other than the outline of the extinction pattern, but the graph itself is copied directly from their original figure. I was in grad school at the time, studying for my Ph.D. in history of science, and I was pretty shaken up by my dad's death. He and I had been close, and he was a big reason I wanted to keep studying science.

"At the time, the tattoo had purely personal significance to me—I was working on the history of seventeenth century mathematics, and the image had no relevance to my work. However, since then I made a big shift in what I study, and I've mostly worked on the history of paleobiology, which is the field my dad was a pioneer in. When I got the tattoo, I really didn't know much about what it signified. Now I do—I even spent most of a chapter in my most recent book discussing that particular extinction study—so the tattoo has taken on a double significance.

"I don't normally tell people about the tattoo, and when people who don't know paleontology do see it, they usually think it's a graph of the stock market or something like that."

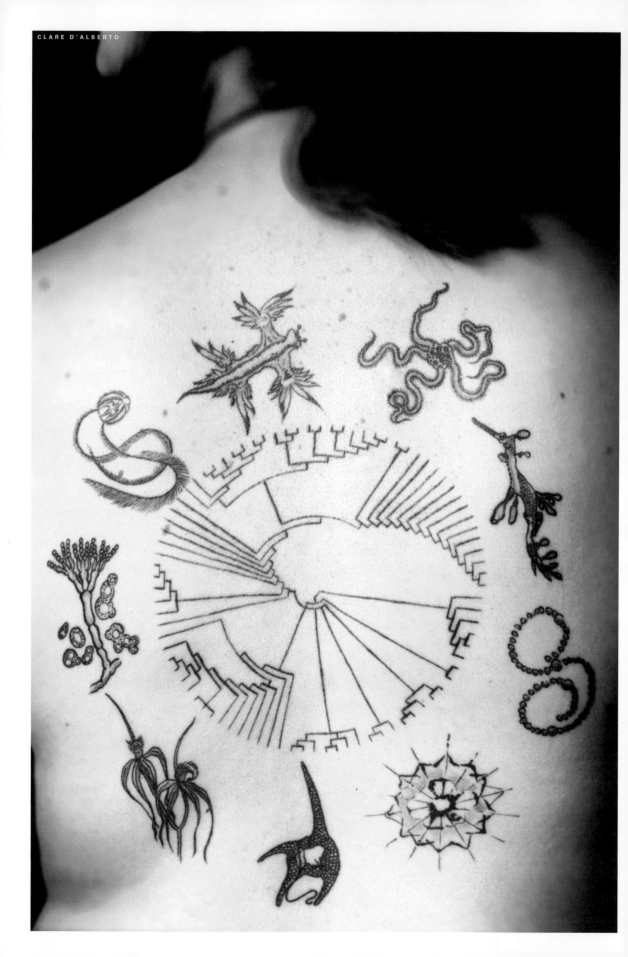

Trees of Life

"I HAVE BEEN fascinated by the biological world for as long I can remember," writes Clare D'Alberto, a graduate student in zoology at Melbourne University, "so when I decided to get a tattoo it seemed logical that I look within my field for inspiration. It took 4 ½ hours, and certainly didn't tickle, but I love that I have such a beautiful representation of evolution and the natural world with me all the time."

The tree of life has changed shape over the years. In nineteenth-century versions, its branches reached upward through time. Today, scientists use DNA to draw the branches of thousands of species at a time. To make space for them all, they must stretch the tree out into a wheel. D'Alberto modeled her tree after a 3,000-species tree created by David Hillis at the University of Texas. She did not have all 3,000 species tattooed on her, obviously, but this simplified version captures the overall shape of the tree.

The creatures around the tree represent the five kingdoms—Monera (bacteria), Protista (amoebae and other single-celled organisms), Plantae (plants), Fungi (illustrated here by yeast and the penicillin mold), and animals (a comb jelly, a mollusk, a starfish, and a seadragon fish). Of course, even 3,000 species is only a tiny fraction of the full diversity of life—1.8 million known species, and perhaps 10 or 20 million more to be discovered. If the current trends of discovery hold up, most of that diversity will be made up of bacteria. So future tattoos will need more microbes and fewer seadragons.

HILLIS'S TREE ALSO inspired Monica Quast, a graduate student at the State University of Campinas in Brazil.

"I am a Brazilian Ph.D. student, working on the molecular systematics of bivalves (the group of oysters, mussels, and clams). I have always been fascinated by the idea that all forms of life are related to each other. During my studies I became even more fas-

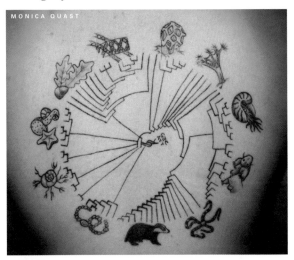

MONICA QUAST

cinated by the fact that such a small thing as a DNA molecule gave rise to all different shapes we see, all biodiversity on Earth. As Darwin wrote: 'From so simple a beginning endless forms most beautiful and most wonderful have been, and are being, evolved.' I think the tree of life represents very well this idea, the evolution of all forms of life from a single, simple start, which, as I see, is the main concept in biology.

"So I had the idea of getting a tattoo of a tree of life with some organisms representing the main lineages. I first thought of using a more traditional design, the 'squarish' kind of tree. But I don't think it is aesthetically

nice. While looking for ideas, I stumbled upon Clare D'Alberto's picture [at "The Loom" website], showing a tattoo that is very similar to mine. I thought: 'That is it! The circular design looks much nicer!' (And then: 'Damn it! Someone already got a tattoo like this and I thought I was being original!') Anyway, I contacted Clare, who didn't oppose to someone having a similar tattoo, and Dr. David Hillis, to ask for permission to use the graphic from his website.

"I made one change at the root of the tree, showing that it comes from a DNA molecule. I tried to choose organisms that depict the variety of biological shapes on Earth. On the other hand, some were chosen to show how sometimes similar shapes arise in complete different lineages, as the foraminifer and the nautilus. Some also were chosen because they are meaningful to me, for instance, the oak leaves. I have always liked their shape, although we don't have oaks in Brazil, so I had never seen one personally before adulthood. Only after I was grown up, I came to know that my grandfather also liked them, because there was an oak tree in front the house where he grew up in Germany. At that time, he had already passed away, but I felt it as a link between us.

"The organisms depicted are (beginning from the string of 'small balls' on bottom, and going clockwise): a cyanobacterium, a foraminifer, three diatoms, oak leaves and acorn, a Spirogyra cell, a red cage fungus, a stauromedusa, a nautilus, a tardigrade, an ophiuroid, and a badger."

JOEL KLINEPETER

"**H**AD YOU TOLD me a few years ago that I'd have a tattoo of the evolutionary tree of life on my arm I wouldn't have believed you," writes Joel Klinepeter. "I'd always enjoyed science but my understanding of evolution was stunted by a creationist upbringing. When I was a child my parents bought me creationist videos, I went to Blackhawk Christian High School where evolution was not taught, and I started my college education as a biology major at Bethel College where I'm pretty sure my advisor and main science teacher was a young earth creationist. Needless to say these conditions were not conducive to an in-depth understanding of the key theory which ties all of biology together.

"I find evolution to be beautiful and fascinating, while the process can be inefficient and bloody, it also carries implications that I find quite elegant. When I look around myself at the other life forms I share the planet with, I am struck with the knowledge of just how connected we all are. Every living thing on this planet is a cousin to humanity; we all share a lineage and in a sense we all share a fate, as ours is tied to this pale blue dot we call Earth. When I look at the design etched into my arm I am reminded of this fact, and thinking over the vast expanse of time it represents, I feel simultaneously ennobled and humbled. Ennobling is the knowledge of how far life has come, how tenacious it has been, the picture of the risen ape bending nature to its will. Humbling is the realization that I am not a goal, that I am not an end product; humanity is another in a long line of transitional species and to me this radial version of the tree of life expresses that elegantly."

Horseshoe Crab

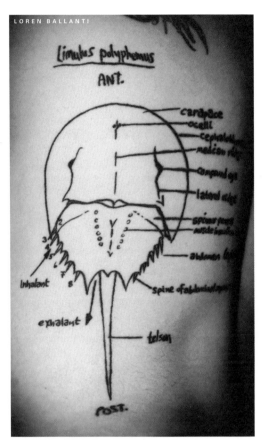

LOREN BALLANTI

Limulus polyphemus
ANT.

carapace
ocelli
cephalon
median ridge
compound eye
lateral ridge
spine (fixed)
movable spine
abdomen (joint)

Inhalant

spine of abdominal segment

exhalant

telson

POST.

"I T'S A SKETCH of the horseshoe crab *Limulus*, such as a zoologist would make (and with the abdominal segments correctly identified)," writes Loren Ballanti, a graduate student in biology at the University of Washington. "Perhaps the most magnificent living fossil of all, the horseshoe crab is the survivor of a lineage that extends back some 445 million years into the Ordovician."

Coelacanth

"T HIS COELACANTH IS on my abdomen," writes Vicki Rosenzweig, a science book editor. "I've been fond of these rare, distant relatives for a while, and got this inked a couple of years ago."

The oceans 380 million years ago brimmed with our close relatives, the lobe fins. Most of them are long extinct, memorialized in rock. One of those lobe fin lineages, the coelacanths, was long believed to have winked out about 65 million years ago. But it has actually been lurking in deep waters all this time.

The first living coelacanth was discovered in 1938 by a South African museum curator named Marjorie Latimer. She would regu-

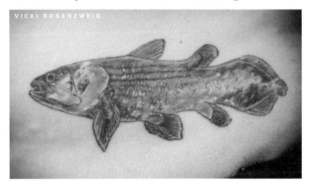

VICKI ROSENZWEIG

larly inspect the catch of fishing trawlers that docked at the port of East London, northeast of Cape Town. One day she noticed a strange blue fin sticking up from a heap of fish. It belonged to a five-foot-long creature with brilliant blue scales. She convinced her taxi driver to let her stuff the reeking monster in the car, and returned to the museum.

J.L.B. Smith, a chemist at Rhodes Univesity, who was also an expert on fish, later inspected Latimer's catch and pronounced it a coelacanth. But by the time he saw it, the fish had been reduced to little more than a

skeleton. It would take fourteen years before he would get to see another coelacanth, this time caught hundreds of miles away in the Comoros Islands.

Since then, the coelacanth has emerged in a few other spots across the Indian Ocean. There are even coelacanths around Indonesia. But they all face a new threat to their survival—large-scale fishing operations that trawl the deep ocean habitats. The next few decades will determine how much longer this living fossil gets to live.

Elvis Taxa

"I CHOSE THE *Metasequoia* cone when I finally gave up 'boring office jobs' to go into teaching/lecturing," writes Julia Heathcote, a paleontologist who teaches at West Thames College in London.

In 1941, a Japanese paleontologist named Shigeru Miki discovered fossils of an extinct tree dating back some five million years ago. He named is *Metasequoia*, for its resemblance to the living sequoias that grow to skyscraper heights in California. Later generations of paleontologists would find fossils of *Metasequoia* dating back seventy million years and more. Dinosaurs might well have grazed their crowns.

But not long after Miki identified the tree, Chinese botanists discovered that it was not, in fact, extinct. A grove of a few thousand of the trees still clung to existence in a remote valley. New groves of the trees, which are also known today as the dawn redwoods, have been planted in other parts of China, and have been brought to other countries as well. While they are conifers, like other redwoods, they are not evergreen. Their leaves turn bright red in the fall like a deciduous tree and then fall away.

"I am a very keen gardener, and I try to grow plants that would have existed in the Mesozoic, at least in sufficient numbers to have been a viable source of food for herbivorous dinosaurs," writes Heathcote. "I have a *Metasequoia* of my own in my garden, which I hope one day will have cones like the one on my wrist."

Metasequoia has changed little since its dinosaur days, which has earned it the title of a living fossil. And, like the coelacanth, it's also known as a Lazarus taxon, because the discovery of living trees resurrected the species from the underworld of extinction. But in 1993 the paleontologists Doug Erwin and Mary Droser warned that their colleagues must be on their guard, lest they think they've found a Lazarus taxon, when in fact they've found a similar-looking species that evolved later. Rather than find a biblical name for such an imposter, Erwin and Droser wrote in the journal *Palaios*, "We prefer a more topical approach and suggest that such taxa should be known as Elvis taxa, in recognition of the many Elvis impersonators who have appeared since the death of the King."

"The tattoo is on my wrist so that I never feel tempted to go back to an office job where it might be frowned upon to have such a visible tattoo!" writes Heathcote. "It has also been a superb teaching prompt, as students cannot resist asking what it is and what its significance is, and then Googling it. It means we can talk about living fossils, Lazarus and Elvis taxa, and the many uses of the fossil record —a wonderful diversion in any biology lecture."

Evo-Devo

TODAY ANTHONY FIRULLI is a professor of pediatrics at Indiana University Medical School. "As a kid I was always fascinated by the similarities in general body plans of animals," he writes. It was the same fascination felt by biologists all the way back to Aristotle. When Firulli started his scien-

tific training, he learned about the molecular underpinnings of those similarities. Six hundred million years ago, a worm-like creature swimming the Precambrian seas used networks of genes to build its body—networks for determining its head-to-tail anatomy, its front-to-back coordinates, its appendages, its organs. That early worm gave rise to many lineages of new kinds of animals, which are still thriving today. And despite

their diversity—from insects to squid to starfish to humans—they still use the same basic gene networks to build their bodies. These networks took on new functions through the evolution of the genetic switches that turned the genes on and off. So in a very deep sense, the heart of a fly is much like our own heart. Ever since, Firulli has been studying the functions of some of these genes.

"I wanted my tattoo to hallmark the evolutionary conservation employed in biology that allows us to learn valuable information from model organisms, and which has fueled my scientific efforts from my post-doc days," writes Firulli. "I wanted to give a homage to Darwin and his initial discoveries that defined the theory of evolution. At the shoulder is Darwin, surrounded by his famous finches, a few monkeys and a bat (images of creatures taken from Darwin's original sketches). From the lower right comes a DNA strand, a puffer fish, frog (*Xenopus*), fly (*Drosophila*), chimeric mouse, and, on the elbow, an iguana (also from a Darwin sketch). The DNA has 18 codons, which code for the first amino acids of a gene called Hand1, which I have studied for 15 years."

Komodo Dragon

BRYAN GRIEG FRY, a biologist at the University of Melbourne, dives after venomous sea snakes and stuffs king cobras into duffel bags. His quest is to chart the evolution of venom. Fry's research suggests that venom evolved long before snakes, in the common ancestor of snakes and their close lizard relatives, such as Komodo dragons. The genes for the venoms started out as proteins for other purposes—digesting food, fighting bacteria, regulating the animal's own blood pressure. But mutations allowed the ancestors of snakes to douse their prey with these proteins in every bite. The victims of venomous snakes die today from molecules that have evolved for over 100 million years into deadlier and deadlier forms.

The molecule at the top of Fry's back is adrenaline: required in abundance for his line of research.

Stickleback

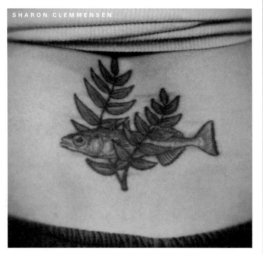

SHARON CLEMMENSEN

T HE FISH ON the back of entomology graduate student Sharon Clemmensen is a three-spined stickleback. As a fish, it may not seem very charismatic alongside basking sharks and moray eels. But the stickleback has been the subject of a natural experiment for the past 10,000 years or so. As the glaciers retreated at the end of the last ice age, sticklebacks swam from the oceans into lakes. The land rebounded as its burden of ice melted away, cutting off rivers that once linked the lakes to the sea. In hundreds of lakes in Canada, the fish were trapped in a profoundly different habitat than their ancestors. And they began to evolve. Without an abundance of predators, they lost much of their defensive armor. And in lake after lake, two distinct types of stickleback emerged—one long and lean, swimming in the open water; the other stout and big, grubbing through the lake bottom muck. Evolutionary biologists have long wondered what would happen if you rewound the tape of life and let it play again. Would the world look different today? At least in the lakes of Canada, the answer seems to be no.

Hawaii

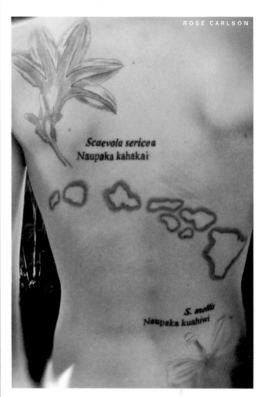

ROSE CARLSON

Scaevola sericea
Naupaka kahakai

S. mollis
Naupaka kuahiwi

" I WAS INCREDIBLY lucky to grow up in Honolulu, Hawaii, and to spend my formative years in the waters and mountains of the islands," writes Rose Carlson, who is now an assistant biology professor at Fordham University in New York. "I can trace my interest in evolutionary biology directly to the incredible diversity of life that I encountered underwater, on the beach or in tide pools, and in the mountains."

If Darwin had come to Hawaii instead of the Galapagos Islands, he might well have waved goodbye to the crew of the *Beagle* and lived out the rest of his life in the middle of the Pacific. Both archipelagos are home to species found nowhere else. But where the Galapagos are ascetically severe, Hawaii is joyously lush. Every plant on Hawaii came from somewhere else, somewhere far away.

Geologically speaking, the islands are young, the big island dating back just half a million years ago. As the islands poked up out of the Pacific, their bare flanks were seeded by plants that arrived by sea or delivered on the webbed feet of birds. As the forests grew, they became home to animal colonists—birds, snails, flies. The immigrants settled in and diversified into new species found nowhere else on Earth. They sliced the islands into fine ecological distinctions, each new species adapting to its own particular niche. Their ecosystem is crowded yet strangely incomplete. No land mammal existed on Hawaii before humans came, bringing pigs, rats, and other passengers on their canoes.

Today Carlson studies how fishes have evolved different ways of making a living.

But for a tattoo, she chose not a fish, but a flower—or, rather, two forms of the same flower, known as the naupaka. The beach naupaka (*Scaevola sericea*) blooms on the beaches of Hawaii, while the mountain species (*S. mollis*) grows at higher altitudes.

"The two flowers, shown much larger than actual size, capture one of the patterns that has long fascinated me: overall similarity in form coupled with subtle differences linked to environmental variation," writes Carlson. "Although there are multiple mountain species of naupaka across the islands, I chose one that is endemic to the mountains of Oahu, so that, in combination with the beach form, it represents my childhood explorations and ties me forever to the evolutionary wonderland of the Hawaiian Islands."

Italian Wall Lizard

THE ITALIAN WALL lizard (*Podarcis sicula*) is native to Italy, but it has been introduced over the centuries to France, southern England, and Germany; it has thrived in all those places, thanks to its fondness for cities. The pet trade brought the lizards over the Atlantic in the past few decades. Reptilian fugitives have escaped into the wild and established thriving populations in New York, Kansas, Ohio, and British Columbia.

"I'm interested in them because I'm interested in invasive species and what they can tell us about natural invasions," writes Russell Burke, a biologist at Hofstra University in New York. He has found that the immigrants to North America have fewer parasites than their European cousins, a difference that might be helping them spread in their new home. Burke has begun to visit Italy to learn what the lizards are like in their homeland; it's likely that settling into their new home, they've been evolving into something a bit new.

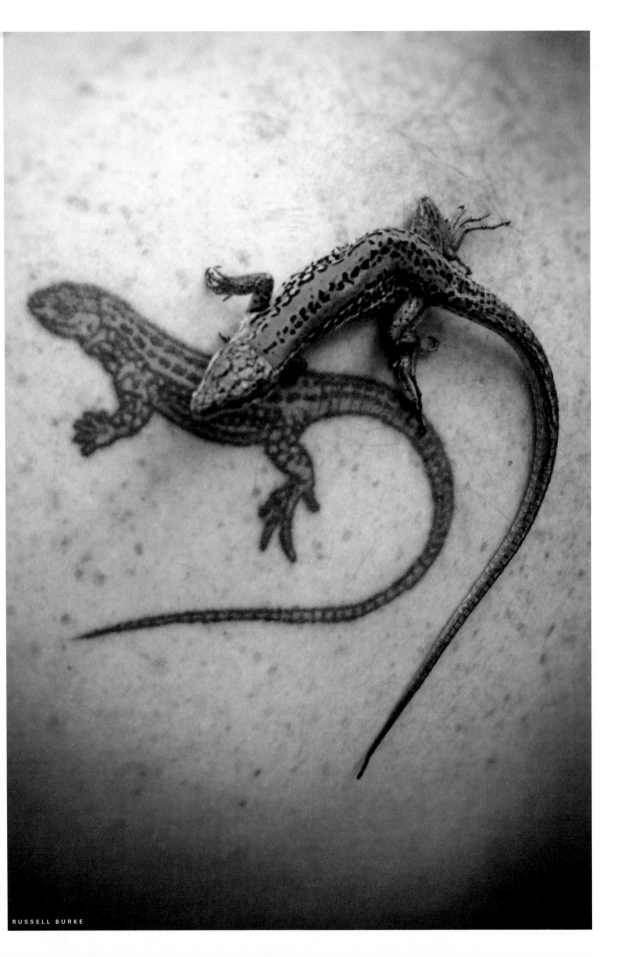

ℌℑ𝔙 Tree

𝔖perm

"**I** AM AN evolutionary biology graduate student working with some of the world's earliest known HIV samples, trying to clarify the early evolutionary history of the virus," writes Marlea Gemmel of the University of California, San Francisco. When she saw an evolutionary tree of HIV strains, she got it tattooed on her back. "I decided I had finally found something I connected with enough to get permanently put on my body."

Not very long ago, there was no HIV. There was only a menagerie of viruses that infected chimpanzees and other primates. At some point in the early 1900s, some of those viruses

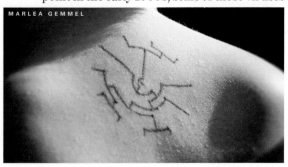

MARLEA GEMMEL

started slipping into our collective bloodstream. Most likely they took advantage of the bushmeat trade in Africa. Hunters butchering chimpanzees became infected through open wounds. The virus was able to spread through sexual contact, and people ferried it from the jungles of Cameroon to the great city of Kinshasa and it spread around the world. As it spread, it mutated and evolved, branching in the same tree-like pattern that animals, plants, and other species have evolved. But the HIV tree has grown in overdrive, branching in just a century instead of billions of years.

"**I**'M AN EVOLUTIONARY biologist who investigates the evolution of sperm form, sperm-female interactions, and sperm competition. So…yeah, it's pretty much about sperm," writes Scott Pitnick, an associate professor at Syracuse University.

The invention of the microscope in the mid-1600s opened up a microscopic world of life forms squiggling around in ponds, ditches, and the scum of our teeth. Even a man's semen contained squigglers. These particular squigglers were not bacteria or protozoans, naturalists realized, but the seed of life.

The discovery of sperm promptly opened up a debate about how a microscopic tadpole could engender an entire person, complete with teeth and toes, jaws and jejunum. Many scholars believed that the body had to be preformed, even before conception. Some argued that sperm stored away this potential body. When it arrived in a womb, it delivered the body into reality. A few illustrators went so far as to picture that potential body as a tiny person, scrunched tight inside the head of a sperm.

The preformationists were actually right, up to a point. A sperm carries DNA, which it delivers into an egg. But eggs have their own supply of genes; we are the result of fusions, not of impositions. Each sperm can sniff its way towards eggs, using some of the same receptors found in our noses. They swim heroic distances. In some species, sperm are cooperative: they link their tails to swim together. Today, sperm may not have a person inside them, but they still have personality.

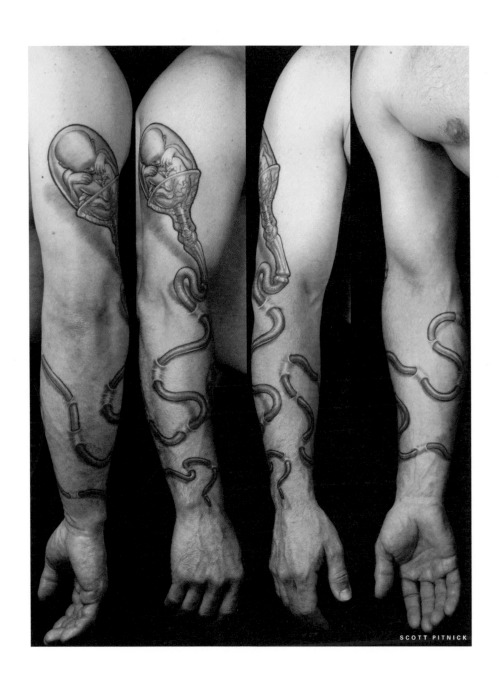

SCOTT PITNICK

Micro Macro

VINCENT PIGNO

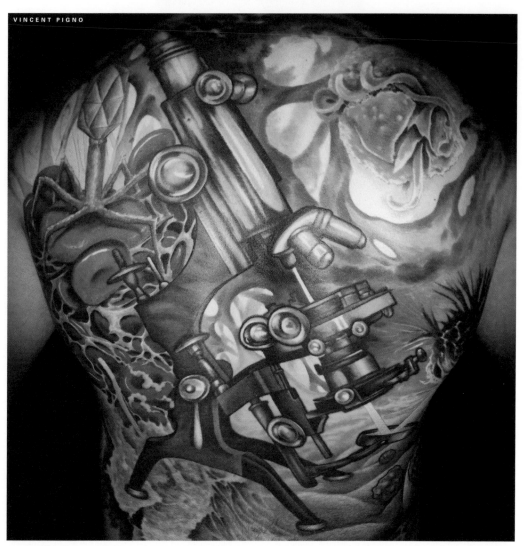

A MICROSCOPE, AND THE world it reveals, cover the back of Vincent Pigno, a self-described "fledgling mathematician."

Among the things one can see with a microscope is a bacteria-infecting virus, called a bacteriophage, on Pigno's left shoulder. Of course, a microscope lit by reflected sunlight wouldn't quite be up to that particular challenge. Bacteriophages were first seen in the 1940s, thanks to the invention of more powerful scanning electron microscopes. Before then, many scientists doubted that bacteriophages even existed. Today, we know them to be the most common form of life on Earth, numbering an estimated 10^{31} all told—that is, ten thousand billion billion billion.

"Ninety percent of the time when I show it to people they say 'Oh! A telescope!'" writes Pigno. "I generally don't correct them."

Eukaryote

GREG MOTZ, a postdoctoral researcher at the Ovarian Cancer Research Center at the University of Pennsylvania, wears a cutaway view of a cell on his shoulder—a present to himself for graduating with a degree in biology.

The tightly packed sacs and folded sheets on his tattoo are the hallmarks of eukaryotes— a group of organisms that includes millions of species, such as animals, fungi, plants, and amoebae. The two other major groups of species on Earth— bacteria and archaea—are microbes of far smaller dimensions. The interiors of their cells are far less complex. Bacteria and archaea are like sheds; eukaryotes are like mansions.

The ancestors of today's eukaryotes probably started out roughly similar to bacteria and archaea. Their first great change took place when they swallowed up an oxygen-consuming species of bacteria. Perhaps they engulfed the bacteria as prey. Maybe the bacteria invaded as parasites. Whatever the case, the two cells became partners. The bacteria provided energy to their host cell, which provided them with shelter and a steady supply of nutrients. The bacteria lost many of the genes they needed for living on the outside. Eventually, they

GREG MOTZ

evolved into the sausage-shaped structures in Motz's tattoo, known as mitochondria. Eukaryotes started carrying dozens of mitochondria in each cell, giving them the energy to grow gigantic. Into that space grew folds, sacs, and vast genomes. The first eukaryotes evolved over two billion years ago. Their origin was the first great leap in the size of life. Later, some lineages evolved groups of eukaryote cells that stuck together, growing big enough to be seen with the naked eye, big enough to thunder across the land, or to tower into the sky.

TROY ROEPKE

MATT MICHEL

𝔘𝔯𝔠𝔥𝔦𝔫

"I STUDIED SEA urchin development for my dissertation," writes Troy Roepke, who is now a post-doctoral researcher at Oregon Health and Science University. "Upon completion, I awarded myself this tat for my academic achievement. The tat is of a sea urchin egg, two-cell embryo, blastula, gastrula, prism stage and pluteus larval stage. Or as my friends say, an orange developing into an Alien face-grabber."

𝔗𝔞𝔡𝔭𝔬𝔩𝔢𝔰

MATT MICHEL, a post-doctoral researcher at Saint Louis University, spent graduate school studying tadpoles and thinking about fate. Like humans, frogs carry genes that encode the proteins their bodies will make. The genes in a fertilized frog egg will steer its development into a tadpole, and then into an adult. Different versions of those genes will give rise to frogs of different sizes, different color patterns, different temperaments. And yet frogs are not merely the sum of their genes. Their experiences can transform them so drastically that they can take on the appearance of another species.

Gray treefrogs lay their eggs in small pools, where they are sometimes attacked by hungry dragonfly larvae. Where there are no dragonflies, the tadpoles rapidly

develop hindlegs and grow a thin, grey tail. But if dragonflies are attacking their pond, the tadpoles delay the growth of their legs, develop a massive tail, and take on dark red spots. As best as scientists can tell, the tadpoles can detect some chemical trace of the dragonflies in the water, which triggers a new growth pattern.

This flexibility looks to be an adaptation driven by natural selection. Frogs that develop the thin pale tails grow faster than the red-tailed ones; but in predator-hassled ponds, the red-tailed tadpoles are more likely to survive. The red spots may camouflage the frogs; it's also possible they direct dragonflies to their expendable tails, rather than their essential head and vital organs. The size of the tail probably lets them swim away faster from an attacking dragonfly.

All animals seem to have this kind of flexibility programmed into their genes. The conditions human mothers experience while pregnant can alter their children, influencing their height, their weight, and even their personality. This flexibility does not detract from the power of genes; in fact, it expands that power, because our genes aren't just restricted to churning out the same traits regardless of what's happening around them. They can pivot and leap.

"For visual purposes, I shaved my chest for the photographs," writes Michel. "However, the presence of chest hair is actually relevant, because for my graduate research, I determined the effects of structural complexity (mostly aquatic vegetation) on the phenotypic responses of tadpoles. I found that structure did not affect these responses, and, appropriately, the presence of chest hair does not change the shape or color of the tattoo."

Haeckel

DARWIN PROPOSED THAT life had evolved like a growing tree, with each major group of species a separate branch. But it was up to a German biologist named Ernst Haeckel to make the first ambitious attempt to draw that tree, reclassifying all of life according to its evolutionary history rather than trying to force it into the artificial boxes of taxonomists. Haeckel even drew Darwin's tree, a majestic specimen rising from bacteria at its base to mammals and other animals at its top.

There is much about Haeckel to criticize. He shared the racism often common to his time and place in the mid-1800s and early 1900s, and he gave it a pseudoscientific gloss by designating new species of humans. Unsurprisingly, he placed *"Homo germanicus"* high above *"Homo africanus."* Haeckel was also responsible for the notion that ontogeny recapitulates phylogeny—which he called the Biogenic Law. He argued that new body plans evolved through the addition of new steps to the development of old ones. Haeckel made it a seductive idea, and many naturalists of his day accepted it. But today scientists can see that new steps can be added to the beginning or the middle of development as well as the end. In other words, the Biogenic Law is indeed true—except when it's not.

Despite Haeckel's shortcomings, many of his accomplishments still abide. He brought the ocean's vast diversity of animal life to the world's attention, both through his descriptions and through his marvelous artwork. Over ninety years after his death, his starfish and radiolarans grace many a scientist's body.

Shell Starfish

KATE DECOSMO

BRONWEN RICE

KATE DECOSMO, a student at Florida State University, with *Fusus longicauda*, a species of sea snail.

BRONWEN RICE, who works in the office of education at the National Oceanographic and Atmospheric Administration, with a basket starfish.

Jellyfish

D AVE WOLFENDEN, a lecturer in Animal Science at Reaseheath College in England, with a jellyfish.

Tubularian

NATASHA MITCHELL, a science radio host on Australian National Radio, with a tubularian, related to jellyfish and anemones.

Radiolarian

ANTHONTY JURD of Australia wears the image of a radiolarian—an amoeba-like creature that extends its tentacles through holes in its spherical armor.

Diatom

DIATOMS, LIKE THE one worn by Richard Marinos, are single-celled algae that ornate shells from silica.

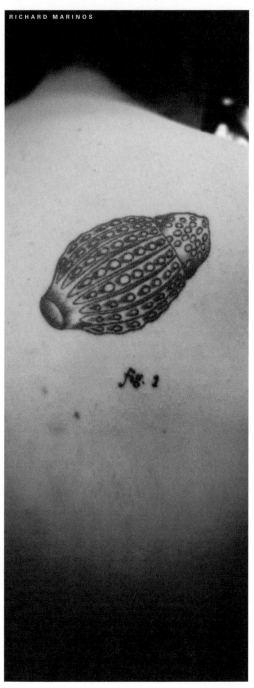

Brittlestar

CHARLES DELWICHE, a professor at the University of Maryland who studies photosynthesis, wears a brittlestar.

Siphonophores

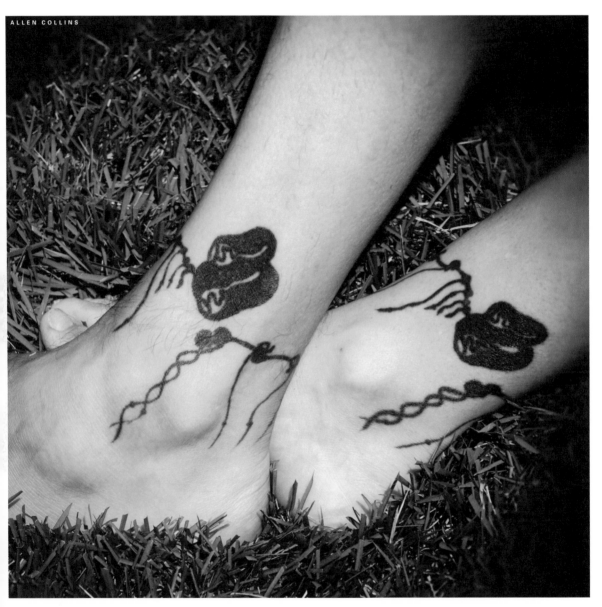

"IN OUR CASE, my wife and I got tat-toos as our wedding rings," writes Allen Collins, a zoologist at the Smithsonian Insti-tute. "I can still hear the guffaw of one of my wife's good friends at the wedding when it was announced what we did. Our tattoos are ankle rings composed of a siphonophore, deep sea relatives of the Portuguese man-o-war. We modeled it after one of Haeckel's plates, but have since been told by the guy who knows more about siphonophores than anyone else alive that it 'doesn't exist.' That is one aspect for which it is not an apt symbol."

Fungi

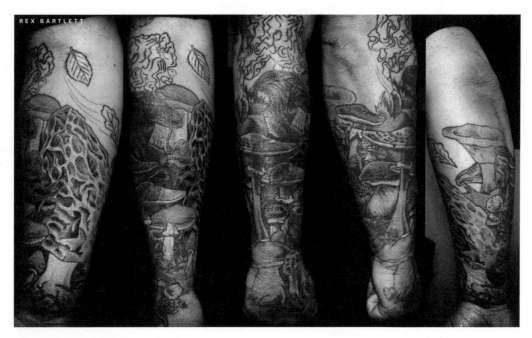

REX BARTLETT

"FUNGI ARE BEAUTIFUL," writes Rex Bartlett, who harvests mushrooms for restaurants and farmers markets. "I'm not."

Someday fungi will get their due. They represent one of the great kingdoms of the eukaryotes, totalling an estimated five million species. In fact, the fungal kingdom and the animal kingdoms are closer to each other than to any other kingdom of species. Our common ancestor, a single-celled marine creature that lived 1.2 billion years ago, gave rise to two lineages, each of which evolved into multicellular species. We animals evolved bodies into which we swallowed our food to digest it. The fungi, on the other hand, evolved enzymes they could spew out, digesting their food on the outside.

Fungi came ashore before we did. They formed a partnership with the first land plants, performing chemistry on rocks and soil to supply the plants with minerals, while the plants supplied them with sugar made with sunlight.

Some fungi today are single-celled molds. But others became magnificently multicellular on their own terms. We see their bodies only occasionally, when they send up their fairy-tale toadstools and puffballs. But hidden away in the ground are networks of fungi, made of miles of threads, which can grow into the largest organisms on Earth.

Chloroplast

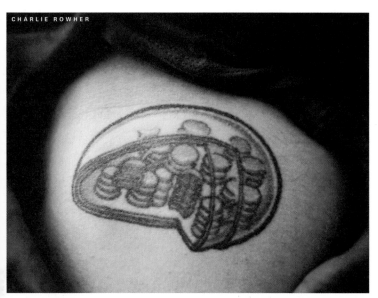

CHARLIE ROWHER

"I AM A SCIENTIST at the University of Minnesota," writes Charlie Rowher. "In 1999, as an undergrad on a plant science internship, a friend and I were sitting on our dorm roof, wondering what the best nerdy science tattoo would be. The double helix down the leg or back was suggested, but we concluded that a chloroplast was a better fit for our scientific interests. As the photon-collecting organelle in plants, it's the source of energy for nearly all plant life and a fas-

cinating biochemical machine. At that point in our careers, we found something that would represent our fascination with plants, no matter what field we chose to pursue. He is in botanical education (and didn't go through with the tattoo). I'm in horticulture."

Fungi are not the only partners on which plants depend for their success. Within their cells, they house tenants that help as well. Like us, they trapped oxygen-consuming bacteria that became mitochondria, which generate energy from sugar. But to get that sugar in the first place, plants forge together water and carbon dioxide, using sunlight to power the process. And all that takes place in lozenge-shaped chloroplasts. Like mitochondria, chloroplasts have wisps of DNA. And that DNA helps expose their true identity: they are former bacteria, captured a billion years ago by algae, and passed on to every plant alive today.

Grass

"KANSAS IS FILLED with open fields full of prairie grass that blows free in the wind," writes Kristina Lewis, a graduate student in environmental studies. "I moved to Kansas to attend school from a small town in upstate New York. I knew I wanted my first tattoo to be of prairie grass after one of my school labs where we spent all day work-

ing in it. To me, my tattoo of prairie grass, Kansas, and attaining my bachelors degree represents a time and experience that has allowed me to be more free in life; just as the prairie grass blows freely."

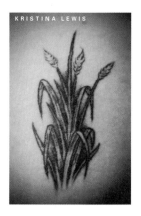

KRISTINA LEWIS

Passionflower

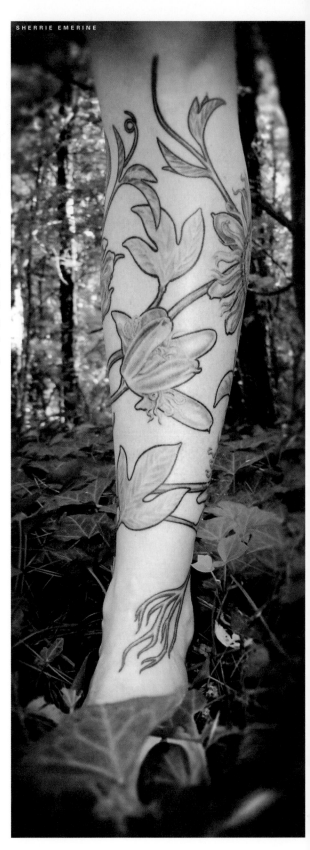

SHERRIE EMERINE is a weed scientist, but her tattoo, the passionflower (*Passiflora incarnata*) is not a weed. At least it's not a plant recently introduced to the United States. Passionflowers have been spreading their vines across North America for many thousands of years. Passionflowers have a rare ability among native plants: it can invade farm fields and become a pest. "I chose it because the plant is really lovely and the flowers are botanically unique, and because it fulfills many of the requirements for ornamental plants, but has the benefits of native species, such as providing food for insects, birds, and other wildlife, which is very important to me," writes Emerine.

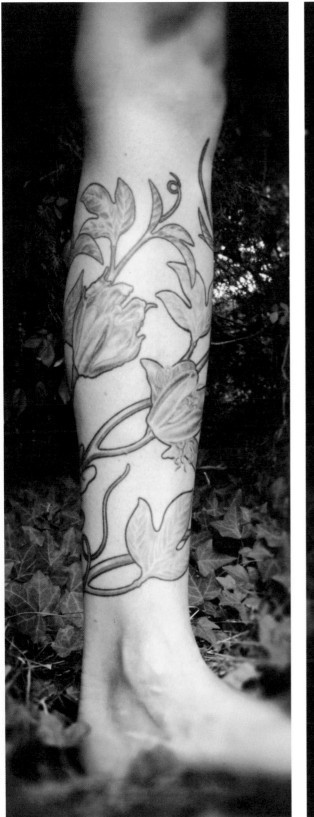
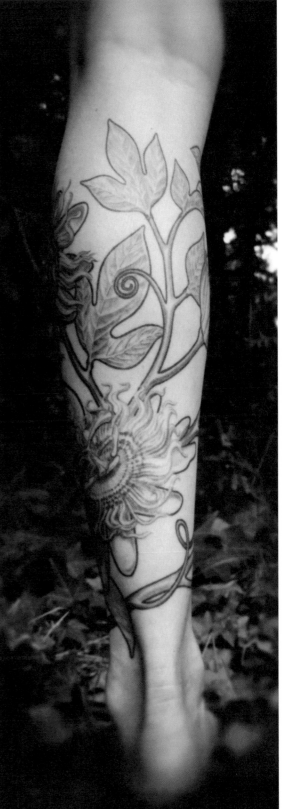

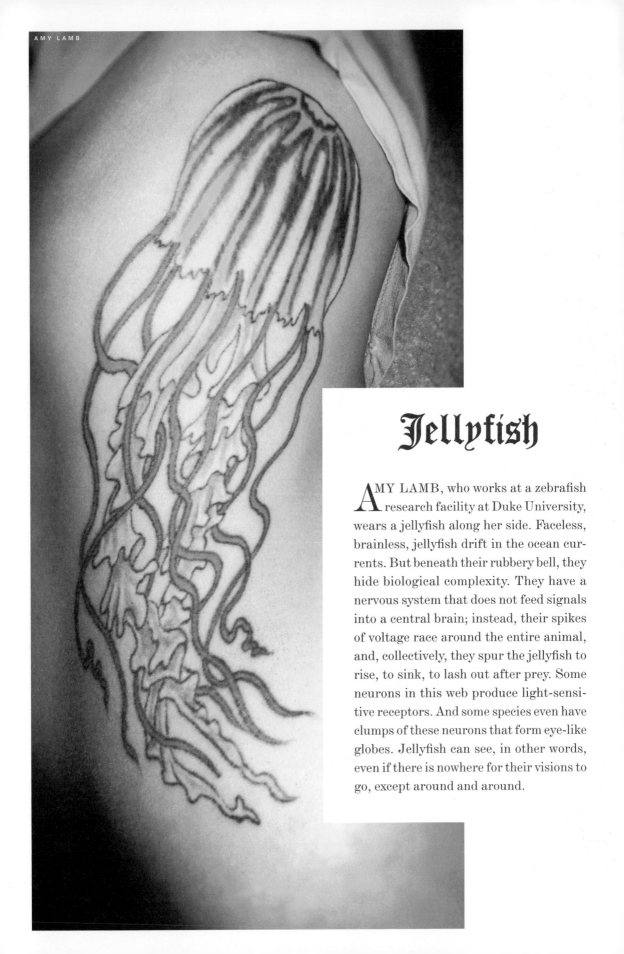

Jellyfish

AMY LAMB, who works at a zebrafish research facility at Duke University, wears a jellyfish along her side. Faceless, brainless, jellyfish drift in the ocean currents. But beneath their rubbery bell, they hide biological complexity. They have a nervous system that does not feed signals into a central brain; instead, their spikes of voltage race around the entire animal, and, collectively, they spur the jellyfish to rise, to sink, to lash out after prey. Some neurons in this web produce light-sensitive receptors. And some species even have clumps of these neurons that form eye-like globes. Jellyfish can see, in other words, even if there is nowhere for their visions to go, except around and around.

Tardigrade

KRISTAL MCKELVEY, who now works in the pharmaceutical industry, spent time in college studying microscopic animals known as tardigrades. "I discovered three new species to science, and this tattoo is to represent how much I enjoyed that research. Also, I think tardigrades are some of the coolest organisms on Earth—they're practically indestructible!"

KRISTAL MCKELVEY

Tardigrades make the world their hiding place. They live invisibly in the ground, in the muck of ponds and deep-sea sediments, in dunes, in moss, in stone walls, on the tops of mountains, and deep inside glaciers.

They go unnoticed thanks to their miniature dimensions: the biggest tardigrades don't get bigger than a poppy seed. When the naturalist Johann A.E. Goeze discovered tardigrades in 1773, he dubbed them *kleiner Wasserbär*, meaning little water bear. Their stocky bodies and stumpy legs do give them an ursine cast, but there aren't many bears that have eight legs, or daggers in their mouths that pierce smaller animals or algae cells.

There are also aren't many bears that could be taken aboard a spacecraft, left out in the vacuum of space for ten days, and still be alive when they returned to Earth. But tardigrades have made this journey. Here on Earth, they can survive without water by going into a state of suspended animation. Even after nine years, a splash of water can revive them. No one is quite sure how tardigrades manage all this. Some experiments hint that they can turn their bodies into a liquid that's as hard as a solid. Scientists call it biological glass.

Gastropods

ANDREW THALER, a graduate student in marine biology at Duke University, sports a pair of gastropods, deep-sea relatives of terrestrial snails and slugs. "I call it 'the balance of the deep.' Two hydrothermal vent endemic gastropods to commemorate my first deep-sea cruise. The one on the top is *Alviniconcha hessleri* and the one on the bottom is *Ifremeria nautilei*."

In the cold blackness at the bottom of the ocean, gashes in the Earth release a bath of boiling mineral water. Giant mats of bacteria grow on their flanks, along with giant tube worms, crabs, shrimp, and many other species, isolated in underwater islands.

ANDREW THALER

These gastropods are among this group of bizarre species. They have no algae or plants to feed on. Instead, they play host to bacteria, which live in special organs inside the snails, where they feed on chemicals spewed out of the vents. The snails then feed on the bacteria, like carnivorous houses.

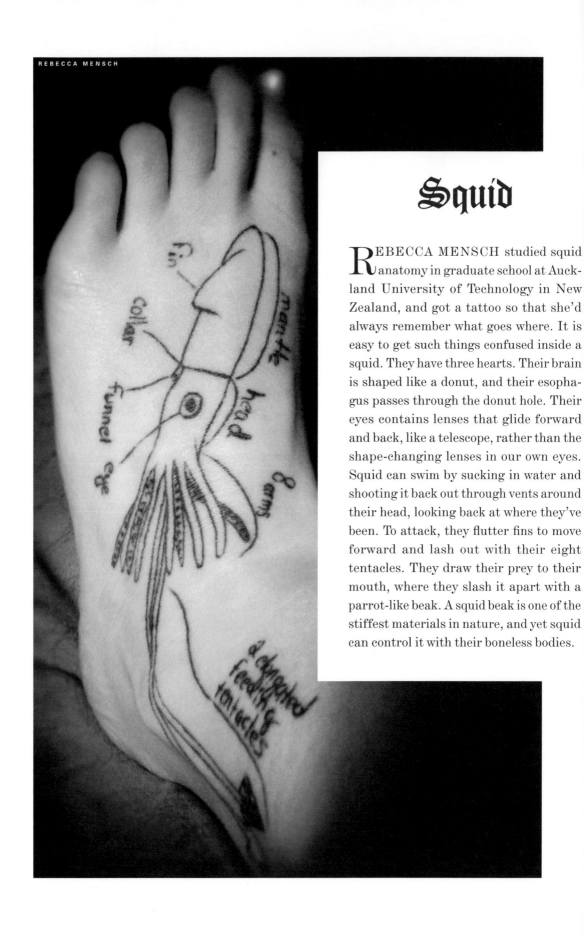

Squid

REBECCA MENSCH studied squid anatomy in graduate school at Auckland University of Technology in New Zealand, and got a tattoo so that she'd always remember what goes where. It is easy to get such things confused inside a squid. They have three hearts. Their brain is shaped like a donut, and their esophagus passes through the donut hole. Their eyes contains lenses that glide forward and back, like a telescope, rather than the shape-changing lenses in our own eyes. Squid can swim by sucking in water and shooting it back out through vents around their head, looking back at where they've been. To attack, they flutter fins to move forward and lash out with their eight tentacles. They draw their prey to their mouth, where they slash it apart with a parrot-like beak. A squid beak is one of the stiffest materials in nature, and yet squid can control it with their boneless bodies.

Bug Lady

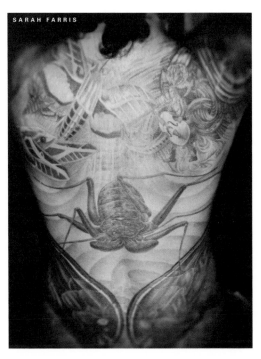

SARAH FARRIS

SARAH FARRIS is an insect neurobiologist at West Virginia University, studying the evolution and structure of bug brains.

"I am obsessed with invertebrates, the subjects of most of my tattoos (OK, the fish are honorary invertebrates due to similarities in diversity and overall aesthetic value). The tattoos started out as a hobby during grad school, as the semi-monthly tattoo appointments were something to look forward to amidst the stresses of completing my dissertation. Since I got the full sleeves, it's pretty hard to hide the tattoos at work, especially during the summer. So I just let them show. No complaints yet."

Ant

"I'VE ALWAYS BEEN passionate about ants," writes Antoine Felden, a biologist at the University of Toulouse in France. "Before I was able to walk, I spent most of my time on all fours to look at them. So it was natural, after high school, to start studying them. So I chose to take biology

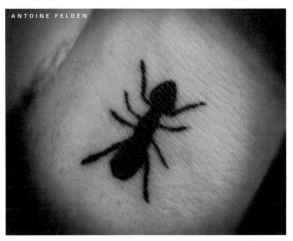

ANTOINE FELDEN

majors in Toulouse (France) and I finally ended up doing a small research project in an ant-specialized lab on the Cal campus. There, my passion for ants met the Californian way of life, and this tattoo is the baby. It's on my wrist, looking to my hand, symbolizing a forward movement to more scientific discoveries."

Fig Wasp

FIG TREES GROW throughout the tropics, looming overhead in many of the world's rain forests. Like most other flowering plants, they have to have sex to reproduce. The female flowers on a tree must be fertilized with the pollen from male flow-

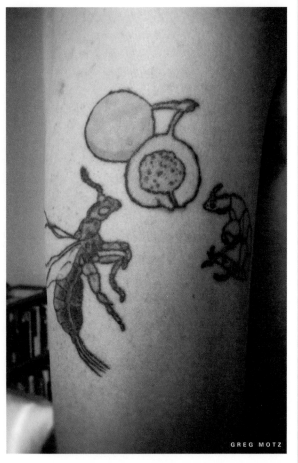

GREG MOTZ

ers of another tree in order to develop into seeds. But it's hard to imagine how this can happen when you look at a fig. This tree's male and female flowers both grow inside the fruit, sealed away from the outside world.

The fig tree's secret is a tiny wasp. A female wasp lands on a fig and digs its way inside, her wings stripping off along the way. She lays eggs inside the fruit and dies. When her eggs hatch, the larvae feed on the fruit and then develop into adults. The wingless male and the winged female wasps mate, after which the males dig a tunnel out of the fruit. The males die not long after they emerge from their fig womb, but the females take flight, covered with pollen from the fruit's male flowers. The females seek out trees of the same species, and when they crawl inside a new fruit, the pollen on their bodies brushes up against the female flowers.

This tattoo of a fig and its wasp belongs to Greg Motz, a postdoctoral researcher at the Ovarian Cancer Research Center at the University of Pennsylvania. "I started out my educational path completely uncertain, and mostly uninterested," writes Motz. "I was seriously going to be German Literature major, but I was also always interested in the sciences and did pretty well in those courses. At some point early in college I was reading a book by Richard Dawkins (I think *Climbing Mount Improbable*), and came upon the story of fig wasp. I was so totally enamored with the story of this tiny wasp, its symbiotic relationship with the fig tree, and the entire complex evolutionary and organismal biology of the wasp and tree. Reading this story was extremely powerful to me, and solidified in my mind that I would be a scientist. So, the tattoo is a constant reminder of why I chose to go down the path I did and maybe even forces me to reflect once in a while about the utter beauty and complexity of the natural world."

White Mariposa

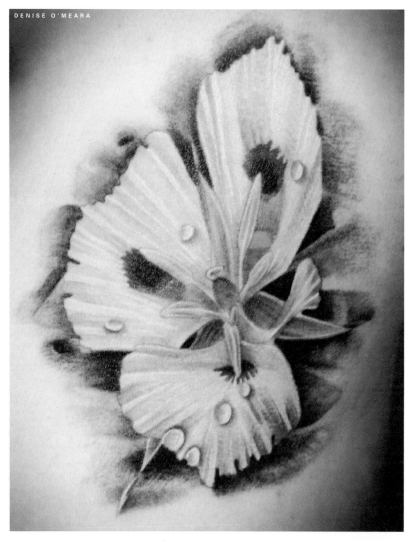

DENISE O'MEARA

"MY TATTOO IS of a flower called White Mariposa lily," writes Denise O'Meara, a graduate student in molecular ecology at Waterford Institute of Technology in Ireland. "It occurs in Idaho, Montana, Nevada, Oregon, Utah, Washington and Wyoming. I first came across the flower as an ecology undergrad when I was fortunate to intern with the Nature Conservancy on the Zumwalt prairie in northeast Oregon. The huge expanse of rolling hills, teeming wildlife and beautiful wild flowers was like nothing I had ever seen or experienced growing up in Ireland. My time there has inspired me to further my education in conservation and I am currently pursuing a postgrad in conservation genetics. The tattoo is a reminder of the root of my passion for conservation and natural beauty."

Frog

"I STARTED COLLEGE as an art major but always found myself drawing bones," writes David Laurice, a grade-school science teacher. "The one structure that continued to come into my work was the skeleton of *Rana pipiens* [northern leopard frog]. I had memorized it from my high school biology textbook and a model my teacher had. The more I thought about it, the more I drew it, and learned about other structures. In any event, the compulsion eventually led me to what I call an 'old school' biology degree, as I became a natural historian and comparative anatomist. I had to forego all the prestige of taking the molecular route, and instead resigned myself to a desk as a teacher. Poor old *Rana*, laying on a tray at my side waiting to inspire another kid to be a biologist."

DAVID LAURICE

Turtle

RICK MACPHERSON, the director of the Coral Reef Alliance, chose a turtle tattoo based on an image of a sea turtle carved into volcanic rock throughout the Hawaiian islands. Honu, as the sea turtle was called, was believed to be created by drawing marks on rocks near the water. Honu swam into the ocean, but because it was part earth, it had to return to land to lay its eggs. "The Honu has a place in Hawaiian myth and legend as a messenger, a monster sent to attack enemies, a living canoe that transports lovers to each other, and even as the foundation of some of the islands," writes Macpherson.

The sea turtles of Hawaii have lost many of their nesting sites to coastal development. Their eggs are devoured by the nonnative rats, dogs, and pigs. And the turtles themselves are killed in fishing nets. The most commonly sighted species around Hawaii, the green sea turtle, has been designated as threatened, and thanks to conservation and education, its numbers have been recovering in recent years.

"However, a relatively new mystery and threat has proven more challenging to solve," writes Macpherson. "Over the past two decades, many Hawaiian sea turtle individuals have been plagued with a papilloma virus that causes disfiguring tumors on any soft portion of the turtle's body." The source of the outbreak is still a mystery, but several studies suggest that pollution is suppressing the turtles' immune systems. "So the ancient Hawaiians may have been correct in seeing the Honu as messenger," writes Machperhson. "Perhaps fibropapilloma-afflicted sea turtles are trying to tell us that contamination of our coastal waters has reached a tipping point."

Boa

"I AM A COMPUTER programmer and amateur herpetologist," writes Maggie Owens. "On my leg is Henry, a North Brazilian boa constrictor. This photo is so special, since he's posed very much the way he came out on my leg, tongue and all. It's not like I could give him instructions on what to do."

This picture led me to do some research on the North Brazilian boa constrictor. The one paper I discovered was from, of all places, *The Archives of Ophthalmology*. It is worth quoting at length:

"An 18-year-old man was bathing his pet snake, a 6-ft-long North Brazilian boa constrictor (*Boa constrictor*), when it attacked him and bit him on the right eye. The snake had infectious stomatitis, a bacterial infection in the mouth. When the snake struck, the patient partially blocked the attack with his right hand; however, the snake was able to engage the patient's right eye with its lower teeth, and his hand with its upper teeth. It would not release its bite and tried to wrap around the patient's neck. The patient managed to telephone a neighbor, who dialed 911, and the police arrived. The policeman who answered the call, however, was ophidiophobic (fear of snakes) and was unable to lend assistance. The fire department arrived shortly thereafter, and a fireman, using a large knife, cut the snake's head from its body. The multiple small recurved teeth could not be disengaged, so the patient was transferred to a nearby emergency department with the snake's head attached to his eye."

After getting the hole in his eye sewn up and taking some antibiotics, the man recovered. Let that be a lesson: take care when you give your snake a bath.

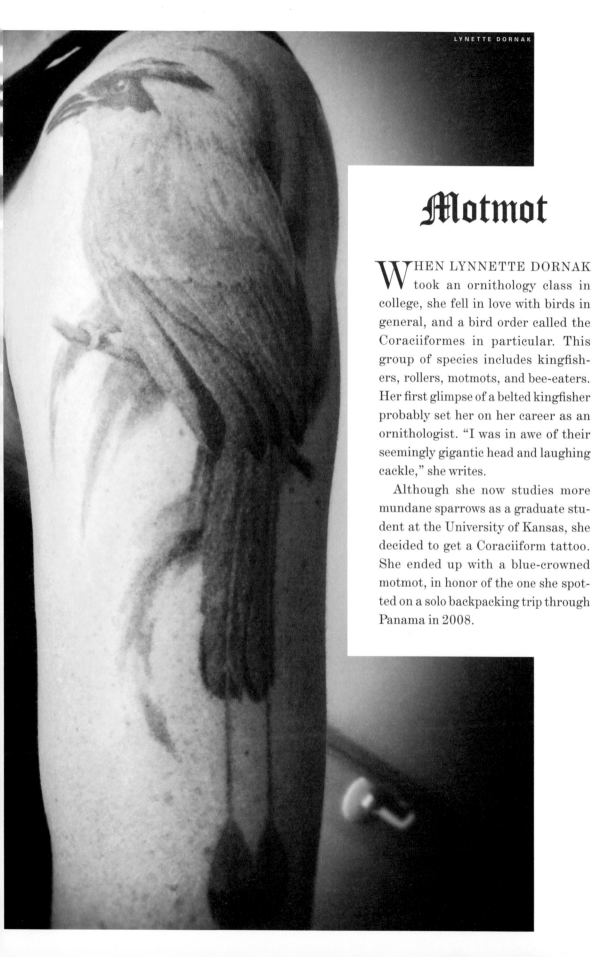

Motmot

WHEN LYNNETTE DORNAK took an ornithology class in college, she fell in love with birds in general, and a bird order called the Coraciiformes in particular. This group of species includes kingfishers, rollers, motmots, and bee-eaters. Her first glimpse of a belted kingfisher probably set her on her career as an ornithologist. "I was in awe of their seemingly gigantic head and laughing cackle," she writes.

Although she now studies more mundane sparrows as a graduate student at the University of Kansas, she decided to get a Coraciiform tattoo. She ended up with a blue-crowned motmot, in honor of the one she spotted on a solo backpacking trip through Panama in 2008.

Swamp

MAUREEN DRINKARD has spent years mucking through Ohio bogs as she earned a Ph.D. at Kent State University, and so she decided to document the experience. "The extended exposure to methane gases and gallons of blood donated to mosquitoes, ticks and leeches inspired my tattoo," she writes.

Her tattoo is an ecological allegory. Each species is both a resident of Ohio bogs and a personal symbol. The *Sphagnum* moss in her tattoo helps to establish bogs by creating a vast, water-logged carpet of vegetation in which trees and other large plants cannot grow. "I consider the *Sphagnum* moss the world around me," Drikard writes.

Among the plants that do manage to thrive in this ecosystem is the cardinal flower. Its bright red flowers bloom in clusters along riverbanks, where they find just the right balance of conditions. "The cardinal flower is a symbol for my family," Drinkard writes. "All of them being Ohioans, my roots are here. My little group of 10 or 20 people are living in the same conditions I am. We all have the same needs and we are always found together."

Below the cardinal flower grows a skunk cabbage. The skunk cabbage emerges early in the spring in Ohio bogs, sending up its dark broad leaves. As it grows, its metabolism casts off so much heat that it can melt the surrounding snow and warm insects living on it so that they can fly off to pollinate other plants. "The skunk cabbage is able to be an important part of the lives of many organisms just by 'doing what it does,'" writes Drinkard. "I want to lead a life that is beneficial to those around me just by 'doing what I do.' I consider the skunk cabbage my job."

Drinkard also sports a rat-tailed maggot. It lives in stagnant water, covered in a slimy coat. If you pick one up and hold it in the sunlight, the slime gives off a rainbow sheen. The rat-tailed maggot develops into a fly that looks and acts just like a bee, eating nectar and pollinating flowers. Because few other animals will attack a bee, the fly goes unmolested as well. For Drinkard, this transformation gives her hope for herself. "I consider the rat-tailed maggot my future."

The dragonfly in her tattoo is the green darner (*Anax junus*). "But don't confuse their beauty for daintiness," Drinkard warns. "They are the most forceful fliers of any insects. They are voracious predators. They will eat anything else that moves near them (including small fish and amphibians). I chose the image of the dragonfly so that I remember I can be strong and ferocious while maintaining my sense of identity."

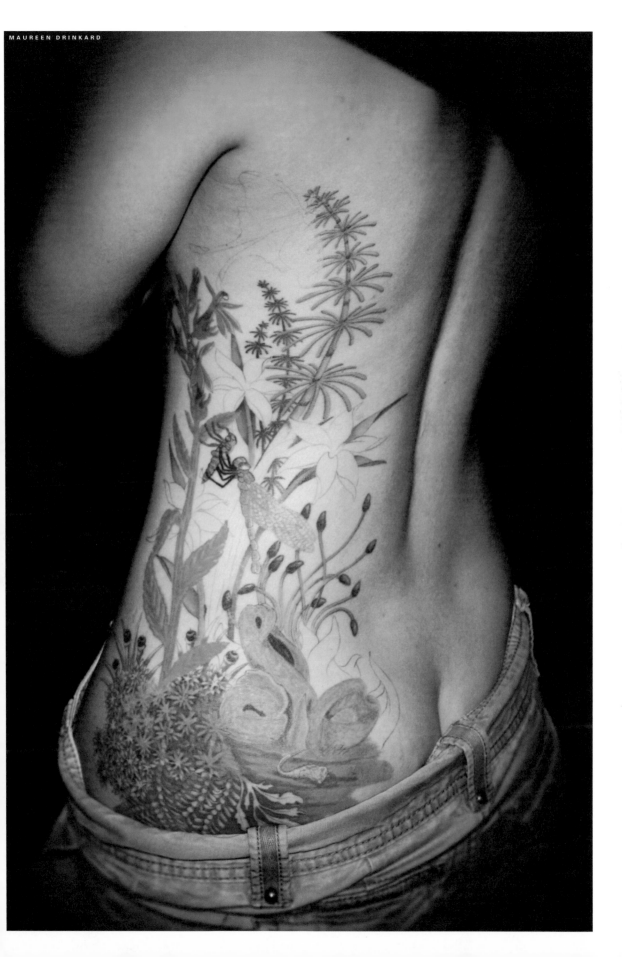

Nitrogen Cycle

"MY TATTOO IS taken from a 1950s biology textbook," writes Matthew Beer, a Philadelphia political organizer. "The reason it means so much to me is because of the relevance of the nitrogen cycle to the cycle of life. The horse dies, which feeds the plant, which feeds the horse. Its really quite beautiful."

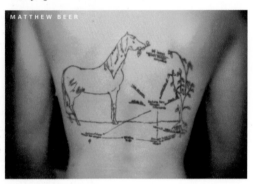

MATTHEW BEER

We are each fleeting intersections of the Earth's biogeochemical cycles, the paths of nitrogen, carbon, oxygen, and the other elements. The carbon cycle is the most familiar of those cycles today, because we are adjusting its knobs so that more carbon is shooting into the atmosphere, trapping heat from the Sun. If we were to shut the knob off, atmospheric carbon would slowly subside over hundreds of thousands of years as it flowed further on through the carbon cycle, to the bottom of the ocean and ultimately into the bowels of the Earth.

The nitrogen cycle is important as well, and we are also adjusting its knobs. Today the nitrogen entering the world's soil is moving at twice its natural rate, thanks to our production of fertilizers and burning of fossil fuels. The nitrogen that gets into streams flows out to the oceans where it triggers runaway explosions of microbes, leading to oxygen-free "dead zones" in places like the Baltic Sea and the Gulf of Mexico. These dead zones would be far bigger if not for the help we get from a hidden part of the nitrogren cycle—bacteria in the soil and banks of streams and rivers. Some of these microbes have the biochemical wherewithal to pull nitrogen out of the water and turn it into molecular nitrogen or nitrous oxide, which diffuses into the air. But these bacteria cannot turn the knobs all the way back; the more nitrogen they are given, the less efficient they get at converting it. As the world's population grows and releases more nitrogen, the hidden parts of its cycle may come painfully to light.

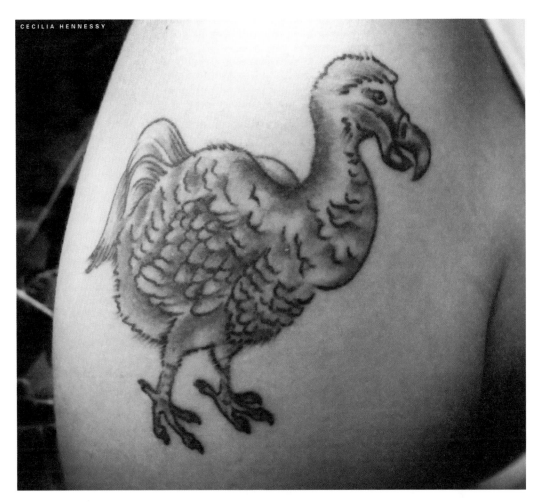

CECILIA HENNESSY

Dodo

"I AM WORKING on my Ph.D. in wild-life population genetics," writes Cecilia Hennsessy of Purdue University, "and I can trace my passion for my research to a moment when I was in the third grade and we learned about the extinct dodo bird from Mauritius Island. At first, I could not understand what *extinct* meant, but as the concept sunk in that I would never see this bird, and no one else would ever see it again, I felt a deep sadness and sense of loss.

"Recently, as I was slogging through field and lab work and my ambition started sag-ging, I decided to get a dodo tattoo to remind myself why I chose this path. Extinction is forever, and we never know what we've lost until it's gone. Recently, ecologists on Mauritius Island discovered that the dodo was the prime seed disperser for the tambala-coque tree that may now go extinct because there hasn't been a dodo around for over 300 years to abrade the seeds. In this manner, extinctions reverberate through ecosystems. I hope that my work will help prevent future extinctions of wildlife."

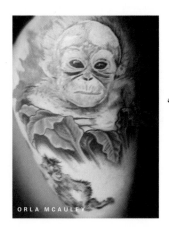

ORLA MCAULEY

Orangutan

"I'M A ZOOLOGY undergrad in Dublin, Ireland," writes Orla McAuley. "I got this tattoo of an orangutan to ensure that, even if they die out in the wild, which seems to be quite likely, they'll still be remembered. The noblest of the apes sits on my lap forever."

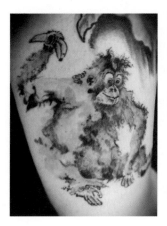

Endangered Species

IN 2009, A CO-OP of artists in Manchester called Ultimate Holding Company celebrated Darwin's 200th birthday with a three-day tattoo marathon they called "Extinked." Working with conservation groups, the artists created 100 drawings of endangered animals, plants, and fungi. Over the course of three days, volunteers were tattooed in public with the images by tattoo artists from Ink vs Steel.

Hannah Rosa, a science teacher in London, got a tattoo of the narrow-bordered bee hawk moth, an insect that lives only in the damp grasslands of Britain. "I decided to sign up for the project as I have worked closely with endangered species in the field as part of my degree studies and understand the importance of closely monitoring and preventing the extinction of these species," she writes. "I wanted to become a life long ambassador so that I can educate others about the impacts of climate change and other human activities, which are threatening hundreds of species in the UK alone."

Along with the bee, her tattoo includes the closing words of *The Origin of Species*: "Endless forms most beautiful and most wonderful have been, and are being, evolved."

Among the other ambassadors are Rachel Holmes (adder, *Vipera berus*), Sally McGee (rampion bellflower, *Campanula rapunculoides*), Nicola Steffen (short snouted seahorse, *Hippocampus hippocampus*), Tim Graham (mole cricket, *Gryllotalpa gryllotalpa*).

RACHEL HOLMES

SALLY MCGEE

HANNAH ROSA

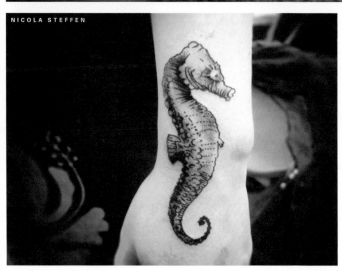

NICOLA STEFFEN

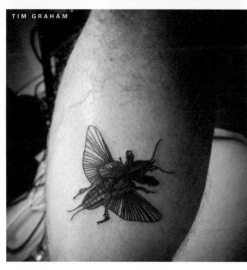

TIM GRAHAM

PRIMATES
Dentes primores fuperiores IV paralleli
Mamma pectorales y binae.

PRIMATES.

Dentes primores fuperiores IV paralleli.
Mammæ pectorales, binæ.

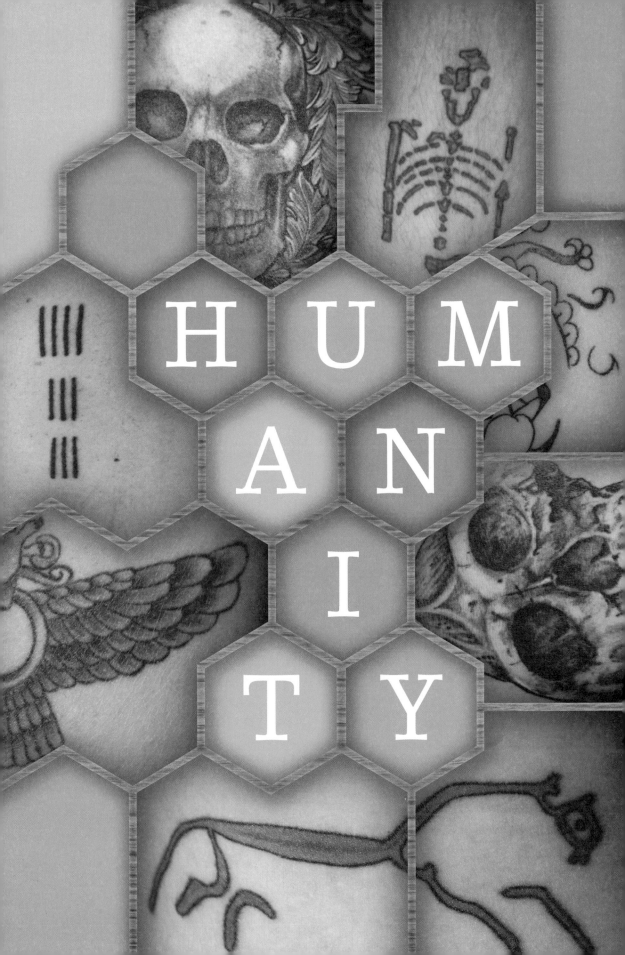

Primates

TODD DISOTELL, a professor of anthropology at New York University, wears two ways to think about human beings. On one arm is Darwin's tree of life. And on the other is an older view of nature, courtesy of Carl Linnaeus.

Linnaeus was the first great cataloguer of life. Born in 1707, he proved to be a genius at botany. At age as 23 he was giving lectures about botany at Uppsala. At 25, he journeyed to Lapland in northern Sweden, walking a thousand miles to the Arctic Ocean and back. When he got back home, he went through the plants he collected and wrote a book called *Flora Lapponica*. But writing a book about plants posed a profound puzzle—and in solving it, Linnaeus would become the most famous naturalist of his day.

The puzzle was this: How was Linnaeus supposed to name his plants? There was no standard way to do this in the early 1700s. People gave all sorts of names to the same animals and plants, and if you read about a plant in a book from England, you had no idea if they were talking about the same plant you were looking at in Sweden. And the names people did use could be hideously complicated. For example, when some naturalists referred to the wild geranium, they'd call it *Geranium pedunculis bifloris caule dichotomo erecto foliis quinquepartitis incises summis sessilibus*.

Linnaeus realized that the puzzle of names actually hid a much more profound mystery. Eighteenth century naturalists could put species in groups, and they generally believed that these groups were a glimpse at the divine order. If they could discover a way to classify all species, they would, in effect, be reading the "Book of Nature," written by god. But it was very hard to come up with a system that was consistent and that was also easy to use. How was a naturalist supposed to classify a whale, for instance? You couldn't just look at all its traits to decide, because some traits would put it with fish, and others would put it with mammals.

It was Linnaeus's great achievement to figure out the first good system. He started out with plants, which he knew best. Since reproduction was central to life, Linnaeus used the number and size of the sexual organs on plants to organize species into larger groups, called genera. The genera would go into orders, and the orders into classes, and the classes would all go into the plant kingdom.

And once Linnaeus had a system for plants, he started expanding it to organize all nature. In 1735, when he was just 28, he published a pamphlet called *Systema Naturae*. He mapped out the animal kingdom, the plant kingdom, and even the mineral kingdom. Linnaeus spent the rest of his life expanding that little pamphlet into bigger and bigger tomes. And in his tenth edition, published in 1758, Linnaeus established the rules for naming species. The names were short, sweet, and easy to remember. Names like *Homo sapiens*.

In Linnaeus's time, there were 20,000 named species. Today there are something like 1.8 million. But each of them still carries a Linnean name, and has a place in a genus, a class, and so on. Linneaus gave taxonomists a common language, and we still speak it today.

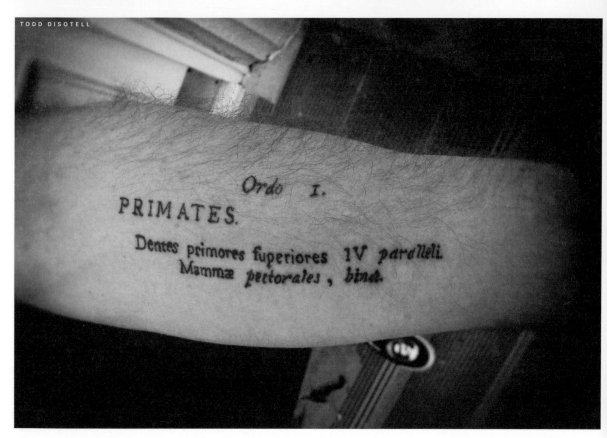

But Linnaeus has another legacy. In its rigid divisions, it fostered the belief that there are unbreachable barriers between species. Each species has its own essence, and breaching its boundaries would go against nature or against god's will. Linnaeus was actually more open-minded about nature than his rigid system would suggest. He was willing to entertain conclusions that were shocking in his day.

For example, Linnaeus changed his mind about whales. He first thought they were fish, but then decided they were mammals. This was a scandalous idea, and even in the early 1800s, the United States fought in court to keep whales classified as fish, because they could charge a tax on fish but not mammals. Linnaeus recognized that whales nursed their young, and for him, that was the key trait for mammals.

Linnaeus really riled people up, however, with his treatment of *Homo sapiens*. He placed humans in the same order as monkeys and apes, a group he eventually dubbed primates.

He knew that wouldn't make theologians happy. In a letter to a friend he wrote:

> "It is not pleasing that I placed humans among the primates, but man knows himself. Let us get the words out of the way. It will be equal to me by whatever name they are treated. But I ask you and the whole world a generic difference between men and simians in accordance with the principles of Natural History. I certainly know none."

And so the classification stood. It still does today. Disotell's tattoo has yet to go out of date, over 250 years since its model was first typeset.

Skull

KARI MULLEN, a graduate student in evolutionary anthropology at Duke University, wears a picture of a skull of an ancient relative of humans, known as the Taung Child.

When Charles Darwin proposed that humans had evolved from ape-like ancestors in 1871, he had no fossils to document that history. In 1924, workers in a South African limestone quarry discovered just the sort of skull Darwin predicted was waiting to be found. Dating back 2.5 million years, it had all the hallmarks of humans, with a few exceptions. Its braincase was tiny, for example, and its jaws were unusually large. Raymond Dart, the anatomist who first published a description of the Taung Child, declared it "an extinct race of apes intermediate between living anthropoids and man."

At the time, such a suggestion was scandalous. A reader of the London *Times* responded to an article about the Taung Child with an angry letter. "Man, stop and think," he warned; Dart had, in his words, "become one of the Devil's best arguments in sending souls to grope in the darkness."

Today, scientists know that the Taung Child belonged to a species called *Australopithecus africanus*, which lived in South Africa for a million years. It is one of twenty or so intermediate species, known as hominins, for which paleoanthropologists have found fossils. But even in the growing crowd of hominins, the Taung Child manages to hold a special place in the hearts of scientists like Mullen.

KARI MULLEN

"My tattoo is in the style of traditional Dia de los Muertos iconography," she writes. "Dia de los Muertos (Day of the Dead) is an annual festival to honor and remember relatives and ancestors gone by. When studying for my master's degree in biological anthropology in New Mexico, my colleagues and I were drawn to these local traditions both for their beautiful imagery and their sentiment. I designed this tattoo both as a remembrance of my time spent in New Mexico, and in honor of a distantly lost relative."

Ascent of Man

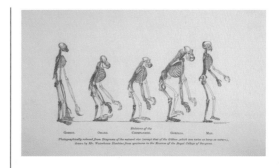

T HIS SERIES OF skeletons wraps around the torso of Chad Tatum, a software systems engineer at Georgia State University. It comes from the 1862 book *Man's Place In Nature*, by the British biologist Thomas Huxley. The image may smack the modern tattoo-viewer as the clichéd march of progress, from lowly troglodyte to hunched caveman to modern human. But it actually meant something different in Huxley's book. To understand why, one must turn back the clock suitably far. In 1862, Darwin's theory of evolution was still a raw new idea, having been unveiled only three years earlier. Darwin himself was leery of delving into what his theory meant for humanity. It was left to others, such as Darwin's great champion Huxley, to start considering humans as evolved.

Huxley had no ancient fossils of inter- mediate forms to tie humans to other animals—those were decades away from discovery. But he did have the anatomy of other primates to consider. And he used the skeletons of gorillas, chimpanzees, and other "man-like apes," as he called them, to drive home a shocking lesson. Humans may be different from other species, but our skeletons are not far outside the range of variation found in other primates. Tatum's tattoo is not a march, but a reunion.

CHAD TATUM

Lucy

JAMES CHAPEL

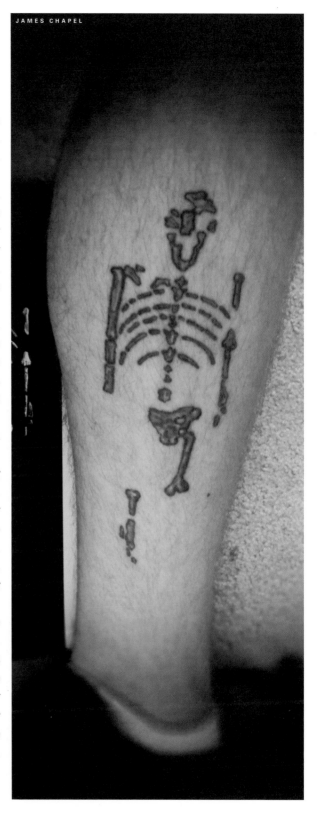

JAMES CHAPEL sports one of the most famous skeletons in the history of human evolution, known as Lucy. "Here she is in all her 3.2 million year old glory," he says.

In 1974, a team of scientists digging in a remote corner of Ethiopia discovered the skeleton of *Australopithecus afarensis*. They nicknamed her Lucy, after the song "Lucy in the Sky with Diamonds," which they had been listening to. Subsequent expeditions have discovered even more *A. afarensis* bones.

Lucy was far older than any hominin fossil found up until then, which made the fact that forty percent of her skeleton was still intact all the more remarkable. Instead of an isolated tooth or toe, the researchers could analyze a sizeable chunk of her body. Subsequent expeditions have discovered even more *A. afarensis* bones.

Lucy had legs and feet suited for walking on the ground, albeit slowly and inefficiently. She still had long hooked hands, which may have been useful for leaping into trees to escape leopards. And her brain was still tiny, measuring about a third our own. In Lucy, we see how our ancestors stood upright long before they had our mental fire power.

For decades, Lucy stood at the outer edge of our understanding of human evolution. But in the 1990s, paleoanthropologists found several fossils of hominins that date back as far as 6.5 million years. Now Lucy stands midway along the journey from our common ancestor with chimpanzees to the six billion people on Earth today, a small, shuffling two-legged ape.

Paranthropus

GABRIELLE RUSSO, an anthropologist at the University of Texas, studies how our ape ancestors lost their tails. Her tattoo is of a hominin called *Paranthropus boisei*, which existed from 2.3 million to 1 million years ago—a good run. It stood upright like us, but had a small brain and powerful jaws for biting tough food like seeds and roots. *P. boisei* is not our ancestor, not even a close cousin. Instead, it belonged to a separate branch of hominid evolution—one that may have been wiped out by a changing climate. Now it is remembered in museums, and on at least one tattooed arm.

GABRIELLE RUSSO

Human Skull

"I AM A BIOLOGICAL anthropologist," says Tracy Prowse of McMaster University in Canada, "and I study human skeletal remains to explore the lives of past populations. I chose to have this tattoo done three years ago to represent my love of the human skeleton and the knowledge we can gain about human history from looking at our own remains. People tend to think of the skull as one complete unit, but it is a wonderfully complex structure made up of 22 bones (plus ear ossicles!), including the delicate ethmoid bone and the strange, bat-like sphenoid bone. The skull houses most of our major senses; it protects one of the most important organs in our body, the brain; it is the architectural framework for the face that represents who we are to the outside world."

Trowel

"GOT THIS AT a biker rally in Hines, Oregon," writes Brandon Berg. "I like to get tattoos of the major professions I have had in my life. But with the trowel everyone thinks I'm a mason. I have to tell them I am an archaeologist."

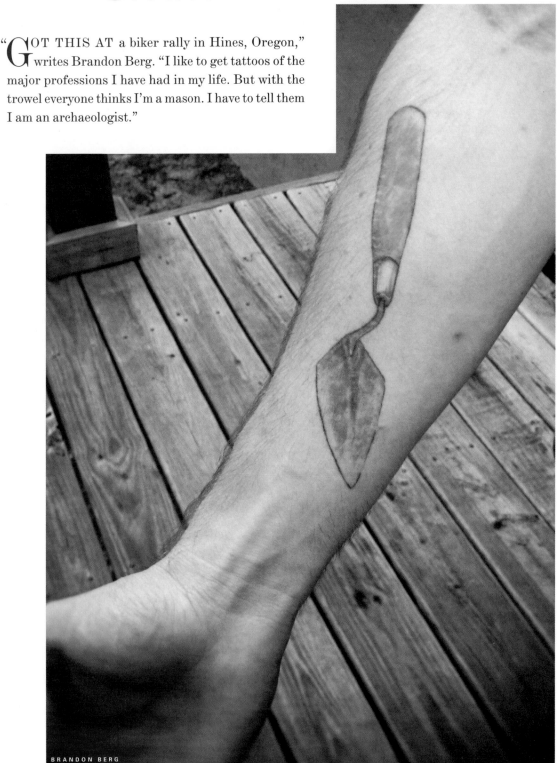

BRANDON BERG

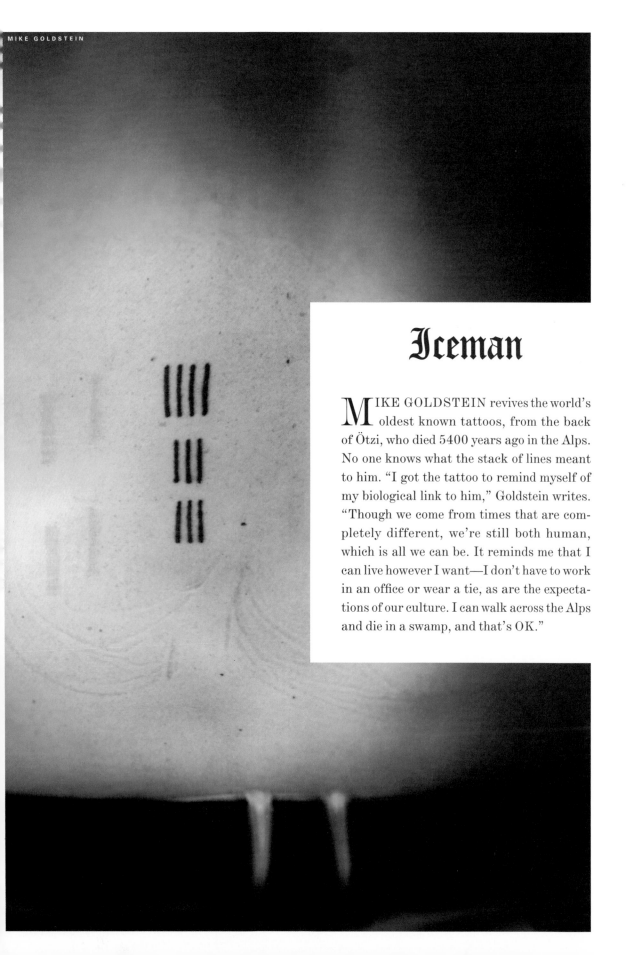

Iceman

MIKE GOLDSTEIN revives the world's oldest known tattoos, from the back of Ötzi, who died 5400 years ago in the Alps. No one knows what the stack of lines meant to him. "I got the tattoo to remind myself of my biological link to him," Goldstein writes. "Though we come from times that are completely different, we're still both human, which is all we can be. It reminds me that I can live however I want—I don't have to work in an office or wear a tie, as are the expectations of our culture. I can walk across the Alps and die in a swamp, and that's OK."

Phonetics

FOR MOST ENGLISH speakers, the language is built from an alphabet of twenty-six letters. For linguists, our ABCs are child's play. Letters may serve well enough for spelling out words, but they fail to represent the swirls and puffs that make up spoken words. To become a linguist, one must learn a shadow alphabet, known as the International Phonetic Chart. It is full of alternative letters with inconceivable meanings: tɕ, the voiceless alveolo-palatal affricate; ɱ, the labiodental nasal.

The chart (opposite, bottom), belongs to dictionary editor Steve Kleinedler and maps the places the tongue goes to make each vowel. Linguist Luzius Thöny (opposite, top) wears the symbol for the glottal stop. "It designates a specific consonant occurring in many languages of the world," says Thöny. "To articulate a glottal stop, you need to stop the airflow by pressing your vocal cords together, build up pressure from the lungs, and then release the vocal cords with an audible burst. Many dialects of English have a glottal stop instead of /t/ in words like /cat/ or /butter/."

LUZIUS THÖNY

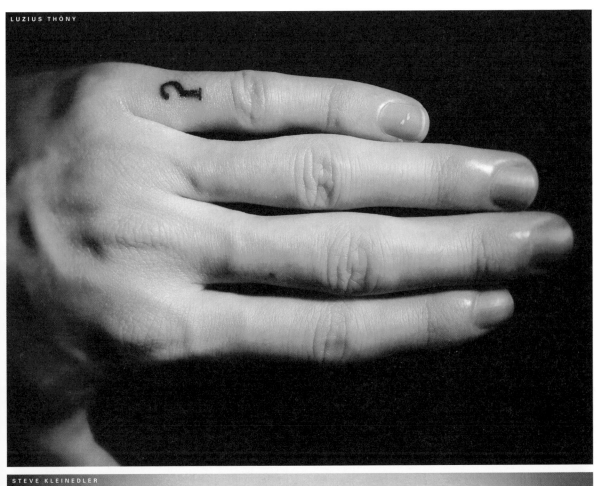

STEVE KLEINEDLER

Uffington Horses

ROZ DEKTETT

SARAH BOYLE

CARVED INTO AN escarpment look-ing over the English countryside is the 360-foot-long outline of a beast known as the Uffington Horse. There was a time when the Uffington Horse was thought to be the dragon slain by Saint George. But it is older than dragons. The Uffington Horse was carved three thousand years ago, we now know, because that is the last time that light struck the buried soil around the figure. Some kinds of soil and sand contain radio-active elements that break down at regular intervals. The energy they release damages the crystal structure of the soil particles, creating traps in which electrons get stuck. Sunlight striking the soil has enough energy to jostle the electrons free, and they release a tiny burst of energy. Once soil gets buried, however, the electrons become trapped again, and the longer it is buried, the more electrons are trapped. Scientists dug up buried soil around the Uffington Horse and shined a light on it. Electrons incarcerated for three thousand years escaped, and in a flash, the horse had an age.

Sun God

THIS TATTOO, WRITES Thaddeus Nelson of the State University of Stony Brook, "was inspired by a relief at Persepolis created under the Persian Emperor Darius II. It depicts a winged sun disk, likely showing the god Ahura Mazda, in this case, but was used as an icon for important deities in Assyria, Egypt, Judah, Urartu, and throughout most of the ancient Near East."

Pazyryk

KATE PARKINSON

THREE THOUSAND YEARS ago, a people known as the Pazyryk roamed across Siberia on horseback. Today, they are known only from the burial mounds that swell the Earth.

In 1993, archaeologists opened up a 2400-year-old Pazyryk mound and discovered the frozen corpses of six sacrificed horses inside. Deeper into the chamber, they found a ceremonial alter with a piece of sacrificed mutton still sitting atop it. And at the bottom of the chamber lay a coffin held shut with four heavy copper nails.

The archaeologists opened the lid and found a glassy slab of ice inside. As they thawed the ice with cups of warm water, pieces of gold emerged. And then a face, its eyes cut out and the sockets stuffed with fur. More melting revealed the entire mummified body of a young woman. She lay alone, adorned in a three-foot-tall headdress made of felt and a necklace of wooden camels. A silk pouch at her knee held a sacred mirror. She wore a dress of Indian silk.

When the archaeologists pulled up the sleeves of her dress they saw tattoos: tattoos of wolves, goats, cats, and this dancing deer. These tattoos may have marked her as a shaman, a story-teller. And her tattoos have now escaped their tomb and copied themselves onto living flesh once more.

Hieroglyphic Brain

TIMOTHY VERSTYNEN

TIMOTHY VERSTYNEN, a post-doctoral cognitive neuroscientist at the University of Pittsburgh, wears Egyptian hieroglyphs on his arm. "The four hieroglyphic characters are the earliest written form of the word 'brain' and are found in the Edwin Smith Surgical Papyrus," he writes. Dating back to seventeenth century B.C. Egypt, the papyrus is perhaps the first neurological case study describing the symptoms of head injuries and the odd fleshy matter that was often visible in the most gruesome of head wounds.

"These symbols and the story of the papyrus are the opening to the classic textbook *Principles of Neuroscience*, which I first came across when taking an undergraduate course in 2000. In honor of starting my graduate research career in studying the brain, I got this tattoo while attending a neuroscience conference in NYC in 2002."

Vesalius Brain

FOR CENTURIES, medieval anatomists thought the best way to understand the brain was to read old books. They would pore through the writings of Greek and Roman scholars, like Aristotle and Galen, to learn the true nature of the human body. In the mid-1500s, an anatomist named Andreas Vesalius realized at last that the doctors of the ancient world had not actually dissected humans. They had dissected animals instead, and extrapolated to our own anatomy. So Vesalius looked for

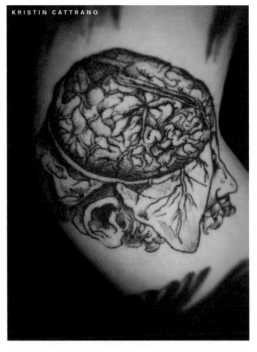
KRISTIN CATTRANO

himself, and drew pictures of the body's interior unlike anything that had come before.

"This is a rendition of Andreas Vesalius' 'The Quivering Brain,'" writes Kristin Cattrano. "I admired many of his anatomy studies in art school, as I spent fifteen years as a painter, but I was always a little more interested in science than art. I even considered a career as a medical illustrator at one point. Using science as artistic reference and researching for a painting was my favorite part of painting. Actually, it was the only thing I really enjoyed. It took me many years to realize this. I got this tattoo right before going back to school to study neuroscience. It couldn't be more perfect."

Pyramidal Cell

MODERN NEUROSCIENCE WAS born when researchers discovered how, in effect, to tattoo a neuron. In the early 1800s, biologists came to recognize that all living things were made up of cells. But when they trained their microscopes on the brain, they could only make out a staggeringly tangled net. Most researchers

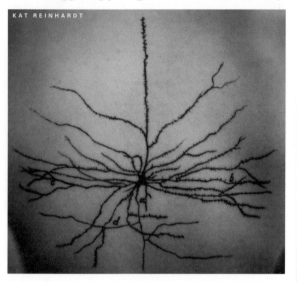

KAT REINHARDT

agreed that the brain must be a continuous fusion of cells. But in the 1880s, a Spanish researcher named Ramon y Cajal began to stain brain cells with potassium dichromate and silver nitrate. Like a developing photograph, a few cells turned black, and Cajal could trace their tree-like structures out to their furthest twigs. "What an unexpected spectacle!" Cajal wrote. "One would have thought that they were designs in Chinese ink on transparent Japanese paper."

"This is a Ramon y Cajal drawing of a human motor cortex pyramidal cell," writes Kat Reinhardt, a graduate student at the University of Oregon studying developmental neurobiology.

Cajal would gaze at his stained neurons in the morning and then draw them from memory all afternoon. He could recognize different kinds of neurons, such as this pyramidal neuron, which is abundant in the neocortex, the outer layers of the brain. Each type of neuron had its own beautiful peculiarities, but they all had some shared anatomy. Their genes resided in a central knot called the soma, which was surrounded by branches, some for receiving signals and some for sending them on to other neurons. But the neurons did not join together in a seamless mesh. A tiny gap lay between the branches of communicating neurons, to be leaped by neurotransmitters. It was with images, such as the 1899 drawing that inspired this tattoo, that Cajal made scientists understand the true anatomy of the nervous system.

"I am a student of neuroscience and greatly admire Ramon y Cajal not only for his scientific contributions but for the artistic and beautiful quality of his images," writes Reinhardt. "This image reminds me of the vast and incredible power of the neocortex, and of the amazing capability of the human body."

Neuron

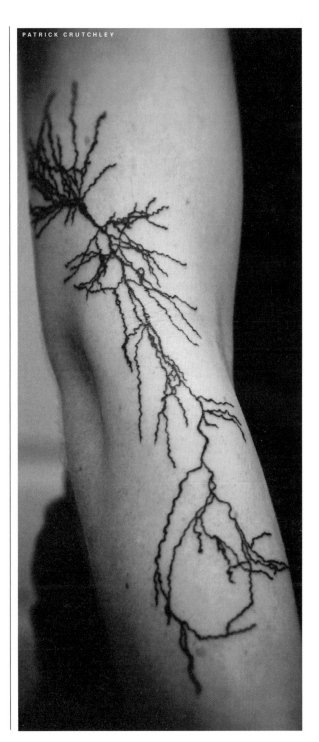

PATRICK CRUTCHLEY

RAMON Y CAJAL recognized what neurons actually look like and began to sort them like an ornithologist classifying crows and robins and toucans. Today, neuroscientists can say what a lot of those different kinds of neurons actually do.

Patrick Crutchley, a research coordinator at a memory lab at the University of Pennsylvania, wears the image of a neuron known as a CA1 pyramidal cell. These neurons are found only in a pair of small patches of tissue located on either side of the brain, called the left and right hippocampus. There, they perform a marvelous trick, first discovered in the early 1970s by James O'Keefe, then at University College London and his colleagues. O'Keefe placed electrodes near CA1 pyramidal cells in the brains of rats and then let them wander around an enclosure. Each cell crackled every time the rat visited a particular spot in O'Keefe's lab. It was as if the animals had drawn a map of the lab inside their brains.

More recent studies have shown that rats are, indeed, mental cartographers—as are we. Each CA1 pyramidal cell receives signals from many different neurons in other regions of the brain. Neuroscientists suspect that some of those signals deliver information about where we are at any moment. Other neurons deliver memories to the CA1 pyramidal cells—essentially, a model of the world as we remember it. Experiments suggest that the CA1 pyramidal cells compare what is to what we remember it to be. The harmony of those signals lets us know where we are; if they clash in discord, our brains can rewire their connections to make a better match.

Neural Net

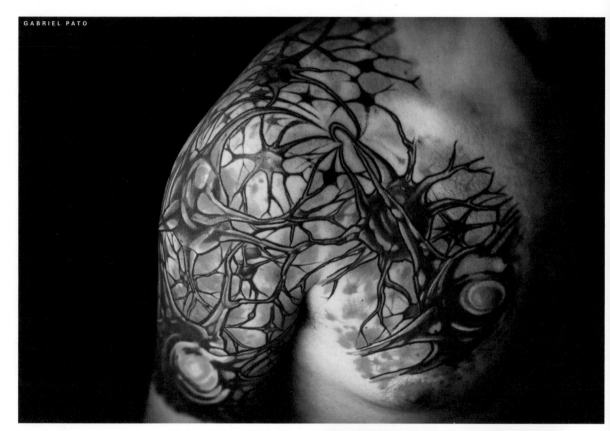

GABRIEL PATO

MARTIN ROTH

GABRIEL PATO, a Brazilian biologist, and Martin Roth, a philosopher at Drake University, both carry the same principle on their body: the brain is a network. Neurons send signals to thousands of other neurons, and it is the number and the strength of those connections from which our thoughts emerge. There is no single homunculus-like neuron in which a person's mind resides. There is not even a single neuron for memories, or for smells, or for joy. Instead, our perceptions flow into layered networks, and out of those network come responses. If you hike too far into the brain, you lose the forest for the trees.

Gestalt

J.C. DWYER

"THE BROKEN TRIANGLE is an illustration of the Gestalt law of closure," writes J.C. Dwyer. "The law of closure demonstrates how the mind creates wholes out of parts—and a world out of sensory information—by filling in the gaps. Although I'm no longer a professional social scientist, the law is a useful one in the realm of public policy, where I'm currently employed. Personally, I use it as a reminder to stay humble, because you never know how much of the world you're making up as you go along."

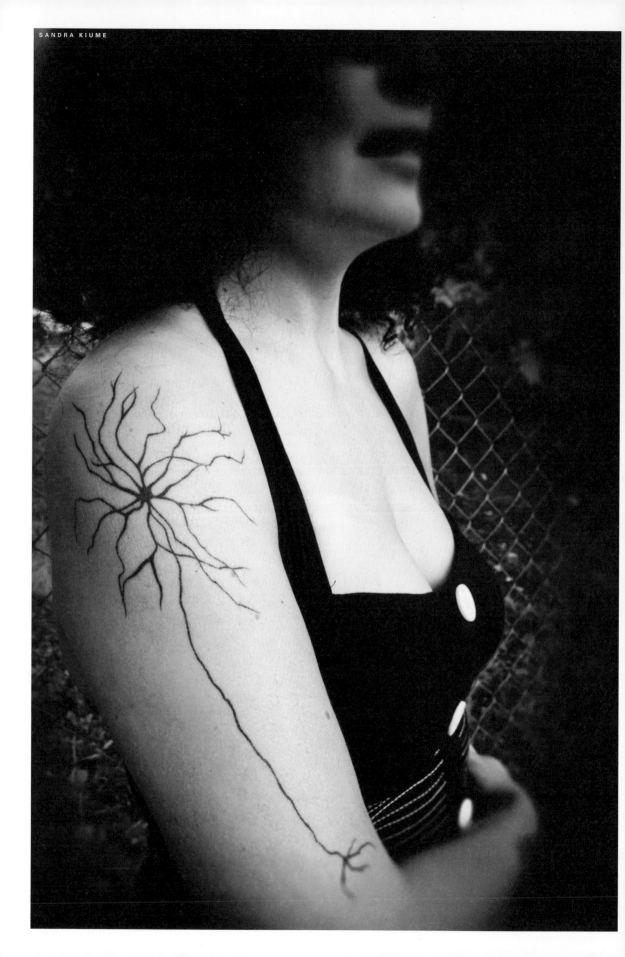

Ganglion Cell

THE BACKS OF our eyes—the rods and cones—are carpeted with neurons. Some types are covered with receptors that can capture different wavelengths of light. These neurons relay signals down the optic nerve, which whisks them to the back of the brain, where we begin to recognize images. But along with those familiar neurons are other light-catchers. Mental health advocate Sandra Kiume wears a tattoo of an intrinsically photosensitive retinal ganglion cell. It is sensitive to blue light, but it does not help paint the blue of a bluebird. Instead, it sends its color elsewhere: to neurons that control the size of the pupil, to regions of the brain that set the body's clock, to other regions that release hormones that make us sleepy and wakeful.

A rare disorder can wipe out all the photoreceptors of the eye, save for the intrinsically photosensitive retinal ganglion cells. It leaves people blind, yet not completely unaware of the lit world. In 2007, Steven Lockley of Harvard Medical School and his colleagues examined a blind 87-year-old woman who had lost all her rods and cones decades before. They would switch on a light for ten seconds and then turn it off; in other trials, they kept it off for ten seconds and then turned it on. The scientists asked the woman to tell them during which interval the light was on. She was perplexed that they wanted her, a blind woman, to tell them about a light she could not see. But she gamely guessed. When they showed her red light, she got the right answer about half the time—no better than chance. The same went for yellow, green, and all the other colors of the rainbow, except blue. If she saw the blue light in her right eye, she guessed right seven out of ten times. And if she saw the blue light in her left eye, she gave the right answer almost every time. The intrinsically photosensitive retinal ganglion cells must tap into the higher regions of the brain, without ever ruffling our consciousness.

Serotonin

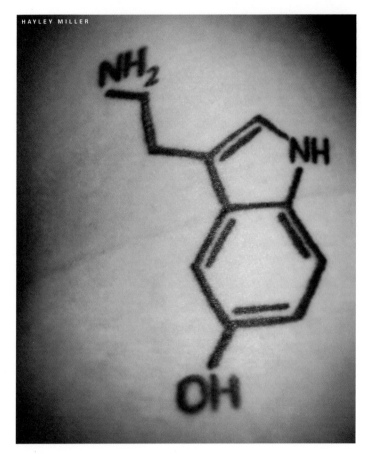

HAYLEY MILLER

"HERE IS A picture of my serotonin tattoo," writes Hayley Suzanne Miller. "I don't know that it needs much more explanation than it's my favorite neurotransmitter."

If you gathered up all the serotonin in our bodies, it would weigh less than a grain of rice. Yet it shapes our experiences during every moment of our lives. Most of it is produced by our guts, where it triggers our intestines to contract in response to food. A barely measurable amount is made by the brain—or rather, a small clump of neurons near its base. This serotonin suffuses through our heads and is taken up by neurons that make a suitably shaped receptor. Those neurons are responsible for our cycle of sleep and waking, for our body temperature, for our hunger, our ability to learn and remember, and, most importantly for drug makers—legal and otherwise—our happiness.

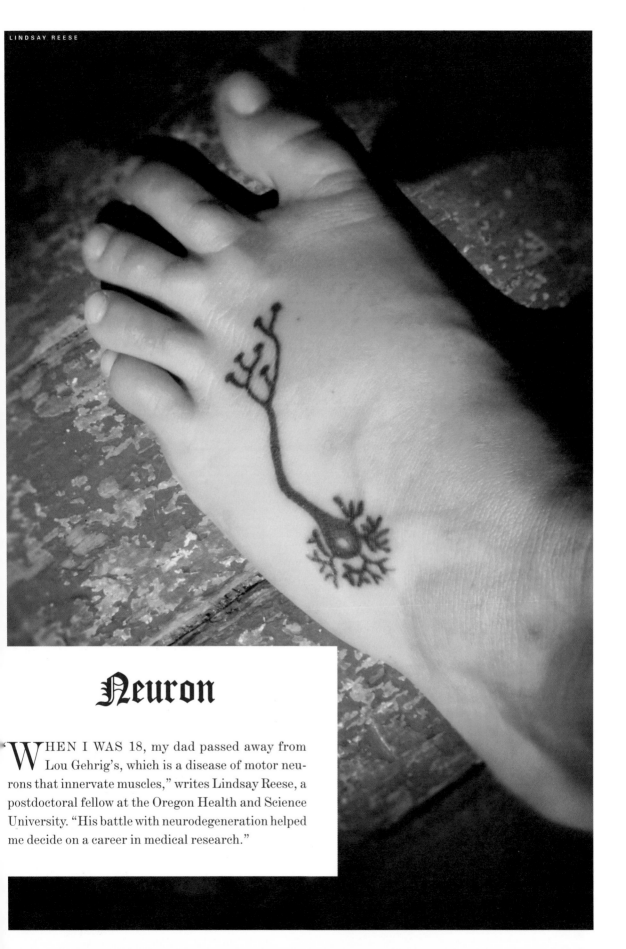

Neuron

WHEN I WAS 18, my dad passed away from Lou Gehrig's, which is a disease of motor neurons that innervate muscles," writes Lindsay Reese, a postdoctoral fellow at the Oregon Health and Science University. "His battle with neurodegeneration helped me decide on a career in medical research."

Sleep of Reason

JOHN OLTHOFF, a graduate student in the Department of Neurobiology & Behavior at Cornell, chose for his tattoo a print made by Francisco de Goya in 1799, "The Sleep of Reason Produces Monsters."

"I wouldn't say my tattoo directly relates to my research in neurobiology, but more to scientific and critical thinking in general," writes Olthoff. "I was a natural scientist and skeptic, always interested in biology and how we know things. So when my AP art history teacher put Goya's 'Sleep of Reason' up on the screen one day in class, it took me less than five seconds to know that it would be my first tattoo. It reminds me of the importance of rational thinking not only in my work as a scientist, but also how the lack of it more broadly can lead to dangerous things."

What the MIND Makes

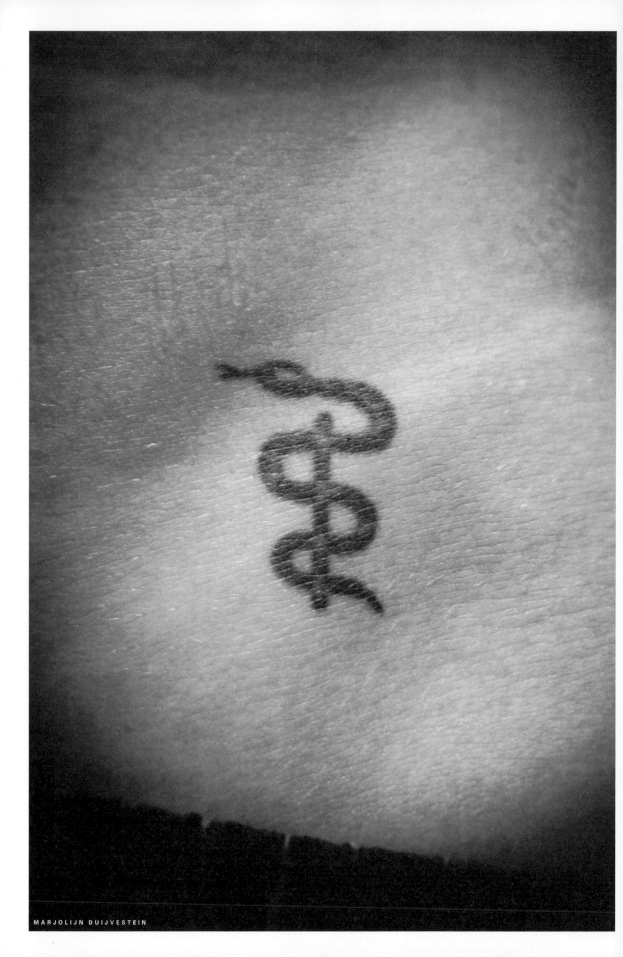

Caduceus

"I GOT THE tattoo when I received my medical degree," writes Marjolijn Duijvestein, a resident at the Leiden University Medical Center in the Netherlands.

On their crisp white coats, doctors carry a badge borne of magic and monsters. Across ancient Greece, temples were built to the god Asclepius, the god of medicine. He may have started out as a real doctor, but as his followers grew, he received a divine make-over. Now he was the son of Apollo—appropriately so, since the sun god was also the doctor of Olympus. The mother of Asclepius was a nymph named Coronis. When Apollo discovered she had another lover, he killed her with his bow and arrow and had her laid on a funeral pyre. At the last minute he was filled with remorse, and opened her belly to save his child. The name Asclepius means "cut-open."

The centaur Chiron raised Asclepius and tutored him in medicine. The snakes of Mount Pelion, Chiron's home, taught Asclepius which herbs could heal the sick. Asclepius himself became the most famous doctor of his time, thanks to the help of the snakes, who accompanied him wherever he went. In statues and on coins, Asclepius was pictured walking to visit his patients with a snake wound around his staff. Eventually Asclepius became so successful that Hades complained to Zeus that the doctor was cutting off the flow of the dead to the underworld. Once Asclepius started actually raising the dead back to life, Zeus decided things had gotten out of hand: he killed Asclepius with a lightning bolt.

After his death, the stories went, the doctor became a god. His priests reared live snakes that swarmed around the grounds of his temples. Generations of Greek doctors, including Hippocrates, claimed to be the direct descendants of Asclepius. Romans believed that he took the form of a snake to come to their rescue during epidemics.

In the Renaissance, European doctors revived the image of Asclepius's staff as a symbol of medicine. Around 1900, American doctors confused this legacy by adopting a symbol of two snakes wrapped around a staff with wings. This is the caduceus, which the winged messenger of the gods, Hermes, carried with him when delivering news to Zeus. Thus, American doctors may have seen the caduceus as a publisher's symbol in some medical books of the time and mixed it up with Asclepius's single snake. In 1902, the two-snake caduceus was adopted by the U.S. Army Medical Corps, and the confusion was frozen in place. But today Asclepius's rod can be found on the logo of the World Health Organization and the American Medical Association. In an age when we can take antibiotics to cure once fatal infections, when organs can be moved from person to person, when robots scour out clogged blood vessels like sink pipes, the symbol should remind us of the original doctor, who incurred the wrath of the gods with his power.

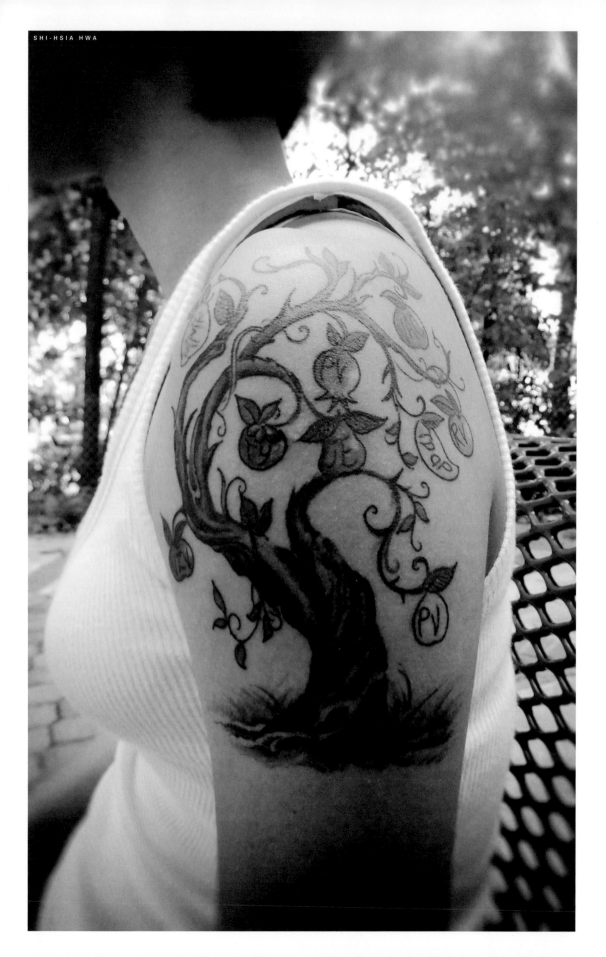

Vaccine Tree

"**I**'M A VIROLOGIST in a biotech company in Singapore," writes Shi-Hsia Hwa. "Here's my story: I've been interested in infectious diseases since I was a kid because my father almost died of TB when he was an infant, and his secretary was an older man with a pronounced limp from polio. I must have been the only kid who looked forward to mass vaccination days in school. For a field trip to the Philippines after my bachelor's and my first job shortly thereafter, I had to be immunized against a lot of other things that the average person doesn't.

"The choice of motif was inspired by a verse from the biblical book of Revelation (a.k.a. Apocalypse): 'On each side of the river stood the tree of life, bearing twelve crops of fruit, yielding its fruit every month. And the leaves of the tree are for the healing of the nations.' The 'tree of life' motif in Western folk art is a tree bearing various different fruits on its branches. I was stupid and didn't check the stencil after the tattooist smudged one part, which is why there are two PVs; one should have been HAV for Hepatitis A. Like everybody else in this part of the world, I've had the BCG but will not add a TBa fruit until a truly effective tuberculosis vaccine is invented."

Target

"**I** DIDN'T TATTOO SCIENCE—science tattooed me!" writes Frank Turnitza. After Turnitza was diagnosed with testicular cancer, his doctors decided to treat the tumor with beams of radiation. To aim one of the beams correctly, they gave him this tiny tattoo on his abdomen. The cancer is gone, but the mark of science remains.

FRANK TURNITZA

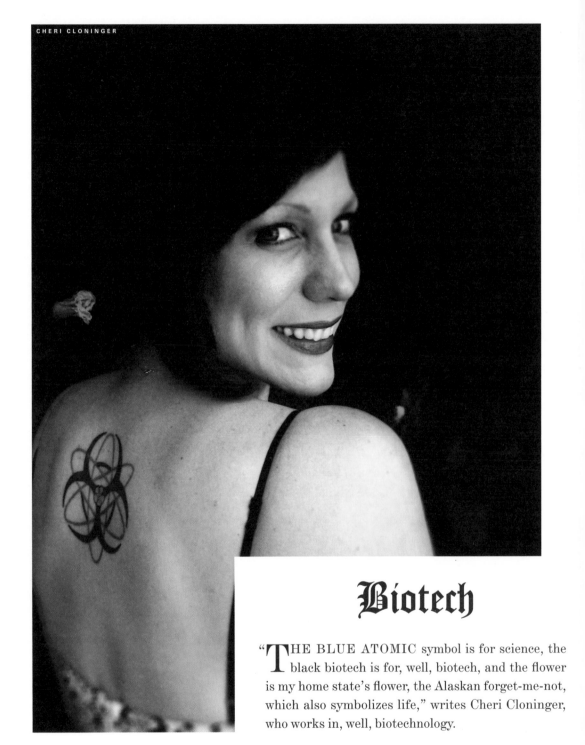

CHERI CLONINGER

Biotech

"THE BLUE ATOMIC symbol is for science, the black biotech is for, well, biotech, and the flower is my home state's flower, the Alaskan forget-me-not, which also symbolizes life," writes Cheri Cloninger, who works in, well, biotechnology.

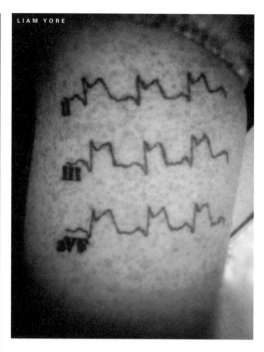

LIAM YORE

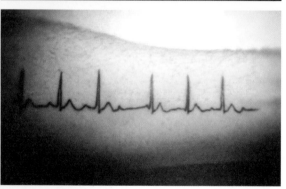

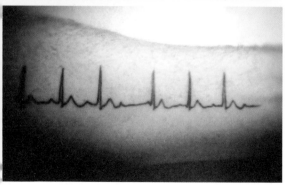

EKG

A CARDIOLOGIST, LIAM YORE, wears two electrocardiogram read-outs. The first, on the inside of his left forearm, shows a wave of electricity during a heartbeat lagging on its way from one chamber of the heart to the next. Called second degree AV block, Mobitz I/Wenckebach, it is actually a benign condition. Such is not the case for the second read-out, on his upper forearm, which shows recordings from three separate EKG leads. It shows an acute inferior myocardial infarction—a heart attack, in other words.

Noise Circuit

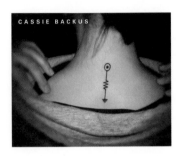

CASSIE BACKUS

"MY COLLEGE EXPERIENCE working towards my electrical engineering degree was a long and difficult one," writes Cassie Backus. "Everyone can admit that their early twenties are a difficult time anyway, what with growing and changing and maturing, but adding engineering school to the mix surely upped the challenge. I nearly dropped out several times during my college career, worried that I was condemning my life to one of solitude doing design at a desk in some dimly-lit cubicle farm. I have since used my degree to secure a role doing application engineering for a technical company that handles human interface solutions, and I couldn't be happier about it. When I eventually finished my degree after five years, I wanted a tattoo to mark my progress in life."

Electrical engineering has its own alphabet: a set of symbols for different elements that can be arranged into circuits. Just as there is no end to the poems a poet can write with the English language, there is no end of devices electrical engineers can invent. And rather than photograph their creations, or try to describe them in words, engineers can simply draw capacitors, transistors, and the other tools of their trade.

Backus chose for her tattoo a schematic diagram of a noise circuit. The current that flows through electronics never perfectly matches its diagram, thanks to random fluctuations. Electrical engineers therefore build in elements that can filter out the noise and strengthen the signal. "To me, this tattoo says 'I am responsible for the creation and the resolution of static in my life,'" writes Backus.

Voltage

"THIS TATTOO IS the schematic for the reference point of electricity," writes Konstantin Avdashchenko, an electrical engineer. "It's really either the point at which you consider voltage to be 0, or, in this picture's case, the physical connection to the earth (hence the lower calf)."

KONSTANTIN AVDASHCHENKO

"Mein Gott im Himmel!"

TYLER ROLLINS, a musician, wears the drawing that accompanied a patent granted to Thomas Edison on February 19, 1878. "I think that this invention goes mostly under-appreciated," writes Rollins. "This was the first phonograph! The first thing that could record and playback sounds, voices, music!"

I usually don't care for exclamation points, but Edison's invention certainly deserves a few. If you put yourself back in 1878, it's hard to imagine how an aria could be engraved on a piece of tinfoil—not the words, but the sounds of the words—captured and forever ready to sing again on command.

The phonograph got its start as a glorified telegraph. Edison experimented with devices that could record the dots and dashes of a telegraph message on a piece of paper. The paper could then be fed back into a telegraph machine to send out the message automatically. When the strip of paper was fed quickly under a contact lever, the lever rattled up and down noisily. That noise made Edison think about the nature of sound—a series of vibrations of different frequencies and amplitudes. He had been trying to improve the telephone, and had discovered that a diaphragm made of a sandwiched layer of carbon trembled with great sensitivity under the onslaught of a voice. Perhaps, he thought, the force of that quivering could drive a sharp point into a piece of paper, deeply or shallowly depending on the sound at the moment. And if he ran another point rigged up to another diaphragm, he could hear the same sound again.

Edison eventually decided that tinfoil wrapped around a spinning cylinder would work best. He had John Kreusi, a German workman in his shop, put the device together. When Kreusi was nearly done, he asked Edison what it was for.

"I told him I was going to record talking, and then have the machine talk back," Edison later wrote. "He thought it absurd."

Edison recited "Mary Had a Little Lamb" into the phonograph, and a moment later, the machine was playing back the rhyme. It must have sounded strange—clouded with static, twisted so that a thirty-year-old inventor sounded like a great-great-grandfather. Nevertheless, it was obviously Edison's own voice. Kreusi muttered, "Mein Gott im Himmel!" And even Edison was impressed. "I was never so taken aback in my life," he wrote.

The waves of shock radiated out of Edison's New Jersey workshop. He went to New York, walked into the office of *Scientific American*, and informed the editor that he had something to show him. He unpacked the phonograph and recorded "Mary Had a Little Lamb" once more. The staff had him record it again, and again. More people came into the office to see it. Finally he had to stop because the editor was worried the floor would collapse from the weight of the astonished.

Edison went back to his lab in Menlo Park, and special trains were run from New York so that crowds could come listen to him play his voice to them. He ended up playing the phonograph for President Rutherford Hayes in the White House until past three in the morning. John Heyl Vincent, a prominent theologian of the day, came one morning to the lab and skeptically asked Edison if he

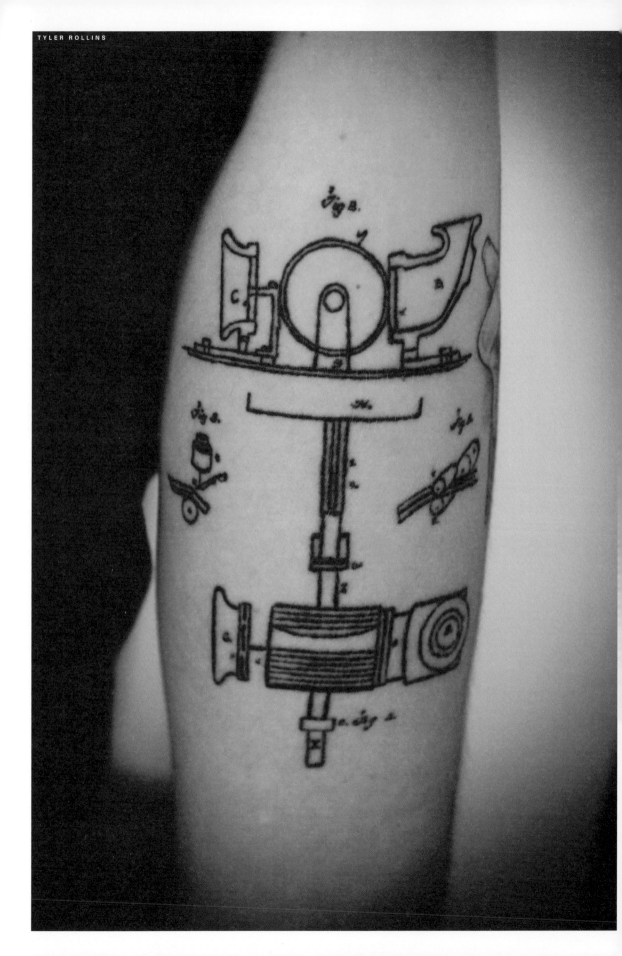

could speak a few words into it. "He commenced to recite biblical names with immense rapidity," Edison later wrote. "On reproducing it, he said: 'I am satisfied, now. There isn't a man in the United States who could recite those names with the same rapidity.'"

Tinfoil gave way to wax and cylinders gave way to disks of resin. Engineers found ways to impress sound onto magnetic tapes, onto films, and then onto plastic compact disks, hard disks, and flash memory. Instead of the rich rise and fall of analog sound, we now listen to the infinitesimal staccato of digital recordings. Telephones have merged into this digital stream, our voices and our music engraved into an abstract ocean of ones and zeroes. We swim in this engraved sound, which flows out of car radios and mobile phones, televisions, digital pianos, and talking dolls. And it all began with the drawing on Rollins's arm.

Tesla Motor

"MY FASCINATION WITH Nikola Tesla started in elementary school, when my science teacher compared Tesla and Edison," writes Abraham Orozco, the science director at Heart of Los Angeles, a community center for children. "I decided to pay my tribute to the wizard with a patent drawing on an electric magnetic motor, submitted by Tesla in the late 1800s."

Edison was a factory of a man, churning out one invention after another with a methodical steadiness. No one ever mistook him for a wizard. But an aura of magic enveloped Edison's great rival, the Croatian-born engineer, Nikola Tesla. Tesla worked briefly for Edison when he came to the United States in 1884, but the two had a falling out over money. Perhaps Edison sensed a threat even then. Edison wanted to power the world on direct current, but instead, Tesla went on to develop motors, lights, and other devices that could run on alternating current. In 1893, President Grover Cleveland came to the Chicago World's Fair, where he pressed a button and switched on a hundred thousand lamps running on Tesla's alternating current.

To a great extent, we now live in Tesla's world. And yet Tesla was never quite of this world. With the money he made from his early inventions, he opened laboratories where he could explore the ragged edges of engineering. He was in love with action at a distance. He invented coils that could pick up faint radio signals and make them loud enough to be heard. He built boats he could control by remote control. He could light up a vacuum tube without a single wire.

Tesla built a tower on Long Island where he hoped to send wireless messages and power homes miles away. He dreamed of a world where a businessman could dictate a memo in New York and have it show up instantly in London. A watch-sized device could let him listen to a sermon, a song, or a speech anywhere on Earth. Most of his dreams ended in bankruptcy, and Tesla ended his life in a two-room apartment in New York. A picture of a Telsa invention is not merely a plan for a motor or a vacuum tube. It's the image of an electrical utopia.

Crystal Radio

THOMAS AREY, a technical writer, wears a schematic diagram for a basic crystal radio. As the nineteenth century came to an end, engineers like Nikola Tesla and Guglielmo Marconi developed the technology that could transmit Morse code not by wires, but through the air, riding atop radio waves. Further developments allowed radio stations to broadcast voices and even music. But initially, listening to radio was a rare luxury, mostly limited to ship-to-shore operators. To pick up a radio transmission, you needed an antenna to catch the signal and convert it into alternating current. Then you needed a way to turn the current in your radio into something you could hear. The machinery required for this transformation was too complex and expensive for the masses.

THOMAS AREY

Radio's first great liberation came in 1906, when an American engineer named Greenleaf Pickard ran radio waves through minerals. He found that the waves could travel in one direction through the crystal structure of some minerals, but not the other. This fussiness, Pickard realized, could allow a mineral crystal to become the heart of a simple radio. An antenna would simply need to capture a signal and deliver it through a fine wire to the crystal. Instead of the peaks and troughs of an alternating current, only the peaks came out the crystal.

These pulses of direct current could rattle the diaphragms in a pair of headphones, creating sound.

Crystal radios were a titanic hit as soon as Pickard started selling them, despite the fact that they quickly became obsolete. They could only pick up radio broadcasts from a couple dozens miles away. Newer radios, with vacuum tubes and other technology, could pick up more distant signals, and they could even produce sound through speakers loud enough to fill a room.

Instead of heading for the dust heap of technological history, however, crystal radios became an underground sensation. Fancier radios needed a supply of electricity, but crystal sets needed nothing. They simply hummed in sympathy with the vibrations of the world. The parts for a crystal set were few and cheap. *Boy's Life* ran ads for crystal set kits. People could use a metal bedpost as a ground. In World War II, American soldiers were often barred from owning regular radios, for fear the enemy would detect the oscillators inside them. So soldiers built "foxhole radios," using mortar fragments, razor blades, pencil points, and other items they could scrounge.

Today, when we get our radios from a complex network of satellites and computers, it's still refreshing to assemble a crystal radio kit. Even the schematic diagram of a crystal radio on a shoulder is bracing in its simplicity. It says: this is all it took for our wireless world to be born.

Microwave

MICROWAVE ENGINEER Chris Sanabria wears an engineering icon, known as the Smith Chart. It is the most useful thing that came out of a magnificent folly that consumed Bell Labs in the late 1920s. Bell Lab engineers were looking for new ways for people in the United States to communicate with Europe. One idea they tried out was using short-wave radio. In Lawrenceville, New Jersey, the engineers went to ludicrous extremes building curtain-shaped antennae that sat atop twenty-six steel towers, stretched out across a mile of countryside.

One of the engineers, Philip Smith, had to make the array actually work. The biggest trouble he encountered lay in the transmission lines from the radio transmitter to the antenna. Because the radio waves had such a high frequency, they could simply radiate away from the cables. And when they encountered a new part of the system, some of the waves were reflected backwards instead of continuing on. To compensate, Smith had to build in circuits that could preserve the signal. He had to make lots of rapid-fire calculations to set the radio waves right again. A longtime fan of the slide rule, Smith realized that he could trace out the different variables that he had to calculate onto a curved grid. He could then move from one intersection to another on the chart until he ended up at a spot that would give

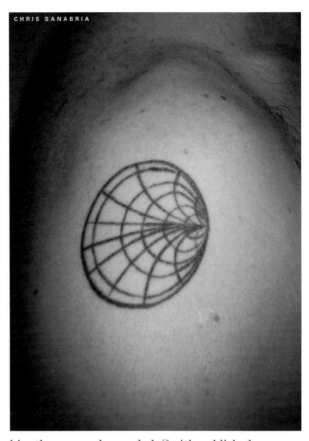

CHRIS SANABRIA

him the answer he needed. Smith published an article describing his chart, and soon it was spreading among engineering circles, bearing his name. Bell Labs abandoned the shortwave project in the early 1930s. Today, engineers can use computers to solve the same kinds of problems. But the Smith Chart survives. For one thing, it's convenient and easy for engineers to use. And for another, it has an inadvertent beauty.

Apple

CHRISTOF KOCH is the chief scientific officer at the Allen Brain Institute, where he oversees an ambitious attempt to map every neuron involved in behaviors, such as seeing and hearing. "The original Apple Macintosh, together with the Boeing B-747 Jumbo Jet and the Golden Gate Bridge in San Francisco, are the three most beautiful and elegant artifacts of the twentieth century," Koch writes. "A perfect marriage of form and function."

RFID

PEOPLE WHO SEE Paul Johanson's tattoo often don't recognize the image. And when he explains that it's an RFID tag, their blank stare does not disappear. Johanson has taken to carrying a real RFID tag in his wallet, which he takes out as he explains what it is. It's ironic that RIFD tags remain so obscure, even as they surround us, silently singing our most intimate details.

RFID is short for radio frequency identification. The basic design of a tag is simple. It contains miniature antenna for picking up a distinctive signal, along with circuits for producing a signal of its own. At their simplest, RFID tags are like crystal radios: they don't even need a power source, because they can harness the energy of the incoming radio waves. Fancier tags have their own batteries, which allow them to do more complicated signal processing and detect more distant signals.

RFID tags are so small and cheap that businesses can slip them into every package they ship to track their whereabouts. Dogs and cats are "chipped" by vets so they can be identified should they become lost. RFID tags sit in millions of cars, allowing people to pay for tolls simply by driving through a toll booth. In many countries, commuters use RFID-tagged cards to board buses and trains. Casinos implant them in high-priced poker chips. They lurk in passports. Police badges contain RFID tags, to foil counterfeiters. Surgeons slip them into sponges, so that if they lose one in a patient's gut, a pass of a wand over the stomach will identify it.

It's also possible—even legal—to implant RFID tags permanently in people. A company called Verichip has designed an RFID tag that can be implanted in diabetics, where it can measure vital statistics and coordinate the various medical devices and catheters. People suffering from dementia could be implanted with a tag so that police who pick them up would know exactly where they belong. And it's possible that society will gradually slide towards ubiquitous chipping—a prospect that terrifies civil liberties watchdogs. But even without surgery, RFID tags are now rife within the body politic. With the right equipment, a thief can snatch all sorts of valuable information from passersby. Their blank stare is no protection.

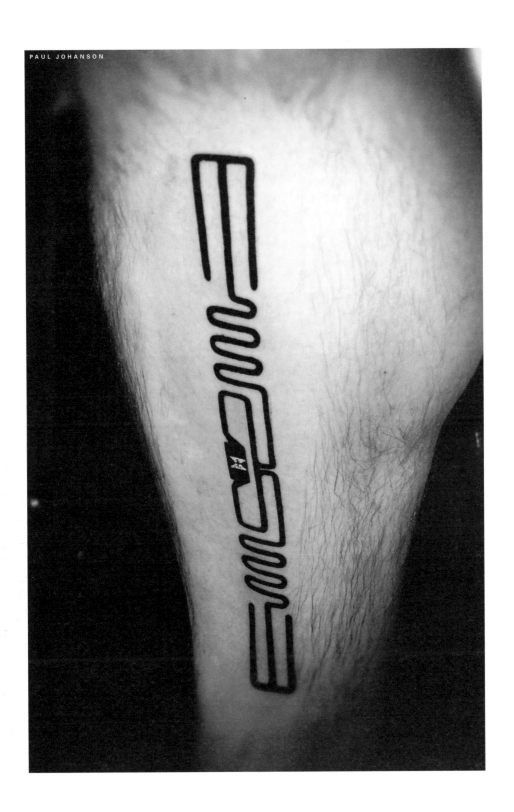

Satellite

"**I** AM AN AEROSPACE engineer who has worked in the field of microsatellites for the last 20 years," writes Terrance Yee. He wears tattoos of some of the satellites he has helped build. His first tattoo was CHIPSat, which the University of California at Berkeley used to scan for faint traces of the cloud from which our solar system formed. The TacSat-2 spacecraft (opposite page), launched in 2006, was built for the Air Force to develop technology for taking battleground images. Next came the DSX spacecraft (right), which travels around the Earth in an oval-like orbit that takes it through belts of intense radiation that surround our planet. The satellite is equipped with devices that can remove radiation, which might be used to protect satellite from nuclear attacks.

"Small satellite missions are very demanding," writes Yee, "requiring total dedication to the mission and getting the job done on a tight budget and short schedule with really challenging new technology. In order to lead teams through this sort of development, you have to be 100% committed and very passionate about your endeavor. It can't be just a job, but a calling, something that you recognize only a handful of people in the world are lucky enough to do. I'm inspired by the work I do and I hope the artwork I have inspires others to be as passionate as I am about space."

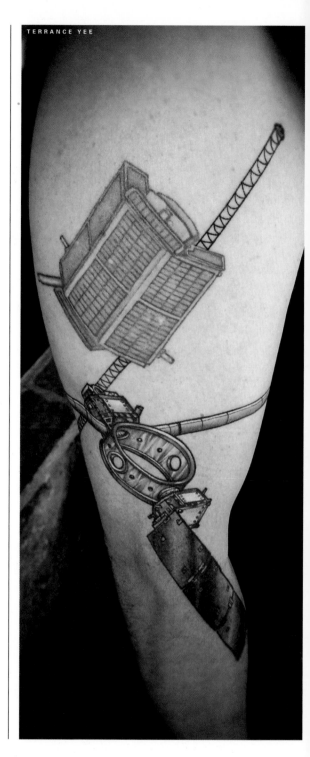

TERRANCE YEE

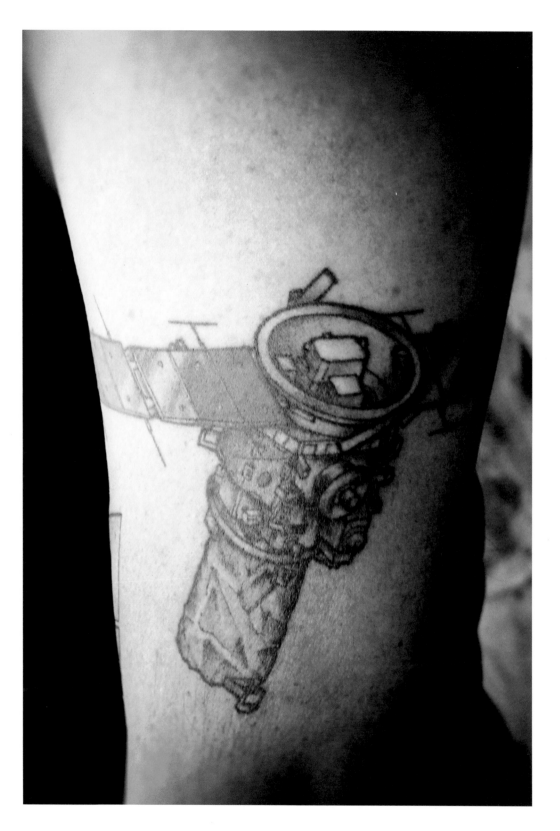

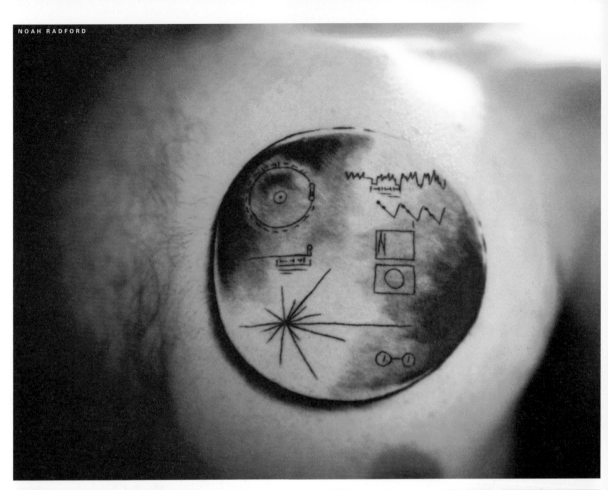

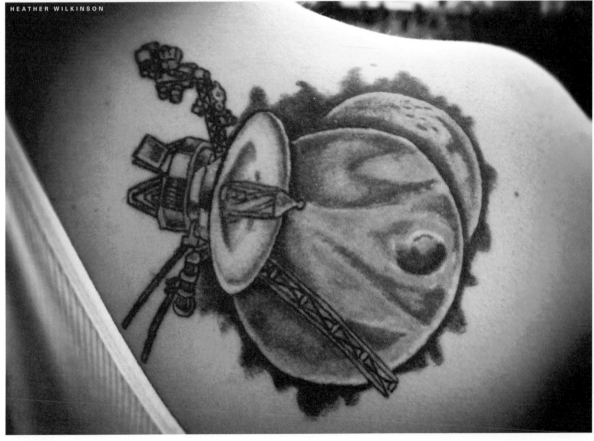

Pioneer & Voyager

IN THE EARLY nineteenth century astronomers and other scholars began to think seriously about communicating with aliens. At the time, many of them were convinced that aliens were close by, living on the Moon. To send a message to the lunarians, some proposed digging trenches across the Sahara, filling them with kerosene, and lighting them ablaze. The great mathematician Karl Friedrich Gauss favored clearing vast tracts of Siberian forests to create a gargantuan piece of geometry—a textbook figure of the Pythagorean theorem, perhaps. By the end of the nineteenth century, lunarians had evaporated into myth, but in 1920, Robert Goddard, the inventor of the rocket, was still arguing for humanity to compose messages for aliens. Instead of the Moon, however, he turned his attention to Mars. He urged that spacecraft should be sent to Mars, engraved with figures that Martians might recognize.

In 1973, the dream of Gauss and Goddard became real. The Pioneer 10 probe (p. 239) was launched into space bearing a message for aliens. A gold plaque depicted a naked man and a woman, along with a celestial map (p. 238, top).

The map shows the location of Earth relative to nearby pulsars, which are rapidly rotating stars that unleash regular pulses of radiation "The intervals are very much like fingerprints and are distinct from pulsar to pulsar," explains Alaina Hunt, an artist and amateur astronomer (p. 238, bottom). "On the map, each pulsar's period is encoded in binary code. To decipher the period in megahertz, one needs to figure out the binary number then multiply it by 1420 MHz to get the period of each of the pulsars. With the knowledge of relative distance and the pulsars' periods, one can triangulate the position of our sun."

Pioneer 11, launched the following year, bore the same plaque. Both space probes have left the solar system and are now hurtling into deep space. Once NASA had finished with the Pioneer probes, they designed a new generation of spacecraft, called Voyager (opposite, bottom). Launched in 1977, it carried a new plaque. It included not only engravings, but was also etched with a phonographic recording of music, natural sounds, and digitally encoded images (opposite, top).

I like to think of these engravings as the ultimate science tattoos. It would be presumptuous to think that aliens will ever see them, though. Voyager has followed Pioneer out of our solar system, where the probes will be spending thousands of years far from another star. We can only hope that an alien civilization will be able to detect tiny spacecraft far from their own planets, adrift in a great void. Even if aliens did scoop up one of our probes, we cannot assume they'd be able to figure out the meaning of their tattoos. It can be hard enough to figure out a science tattoo here on Earth without some help from its owner.

What we do know is that these plaques will escape the fate of every human creation here on Earth. While the pyramids of Egypt and the Empire State Building crumble under the relentless force of wind and rain and rust, the Pioneer and Voyager plaques will last for hundreds of millions of years. They may well become the final traces of our species. They are not a gesture to aliens, then, but to the unimaginable future.

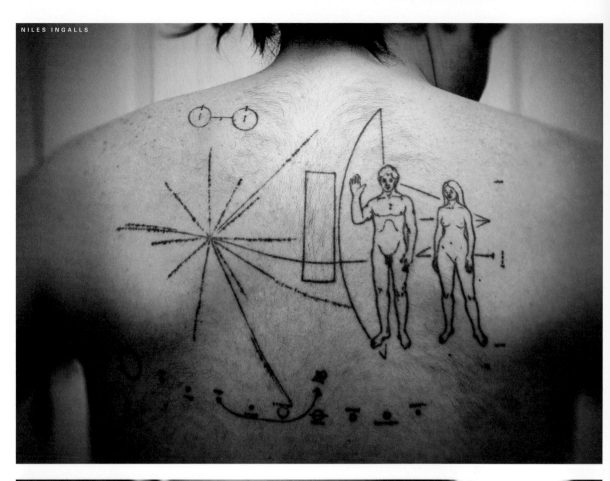

NILES INGALLS

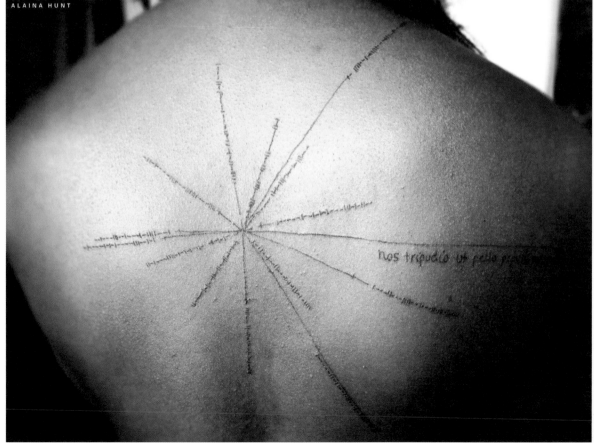

ALAINA HUNT

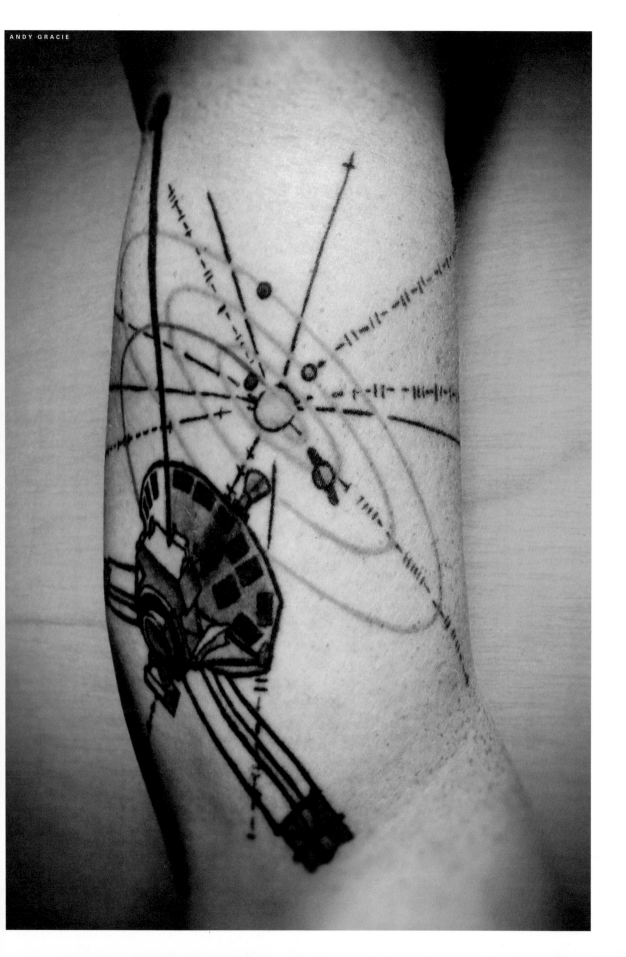

Acknowledgments

M ANY THANKS TO George Scott and Charles Nix for recognizing that a collection of blog images could be a book, and making it into such a wonderful one at that. Thanks also to Russ Galen, who as our agent found a home for *Science Ink*, and to Nathaniel Marunas at Sterling for publishing it. I'm grateful to Sean Carroll, Sam Gerritz, Jennifer Ouellette, Ainissa Ramirez, and Steven Strogatz for checking parts of the book. Deep thanks to my wife Grace for her forbearance, as her husband spent hours on end inspecting tattoos on his computer. And finally, thanks to the hundreds of scientists and lovers of science who shared their skin and their stories with me.

Carl Zimmer

"Carl Zimmer is one of the best science writers
we have today."

—Rebecca Skloot,
author of *The Immortal
Life of Henrietta Lacks*

"As fine a science essayist as we have."

—*The New York Times Book Review*

"It's this simple: Carl Zimmer is one of our very best
science writers. If not the absolute best, bar none."

—*Scienceblogs.com*

"Carl Zimmer is one of my absolute favorite
science writers…"

—Maggie Koerth-Baker,
Boing Boing

Carl Zimmer

CARL ZIMMER is a lecturer at Yale University, where he teaches writing about science and the environment. He is the author of ten books, including *Microcosm*; *Parasite Rex*; *Evolution: The Triumph of an Idea*; *At the Water's Edge*; *Soul Made Flesh*; *A Planet of Viruses*; and *Brain Cuttings*.

His writing has appeared in the pages of the *New York Times*, *Scientific American*, *Discover*, *Time*, *Science*, *Popular Science*, and *National Geographic*. Zimmer's work has been anthologized in both *The Best American Science Writing* and *The Best American Science and Nature Writing* series. He writes a monthly column about the brain at *Discover* and is the author of *The Loom*, a popular blog.

Zimmer is a two-time winner of the American Association for the Advancement of Science's Science Journalism Award and winner of the National Academies Communication Award. He has earned fellowships from John Simon Guggenheim Memorial Foundation and the Alfred P. Sloan Foundation, and in 2011, he was appointed to the board of directors of the Council for the Advancement of Science Writing. He has been a guest on many radio programs, such as "Fresh Air" and "This American Life." He also lectures around the country at universities, medical schools, and museums.

Zimmer lives in Guilford, Connecticut with his wife Grace and their two daughters, Charlotte and Veronica.

www.carlzimmer.com

ALSO AVAILABLE BY CARL ZIMMER

A Planet of Viruses
UNIVERSITY OF CHICAGO PRESS, 2011
ISBN: 978-0226983356

Brain Cuttings
SCOTT & NIX, INC., 2010
AMAZON KINDLE EDITION: B0045U9UFM
EPUB: 978-1935622154

The Tangled Bank:
An Introduction to Evolution
ROBERTS AND COMPANY PUBLISHERS, 2009
ISBN: 978-0981519470

Microcosm:
E. coli and the New Science of Life
PANTHEON, 2008
ISBN: 978-0375424304

Soul Made Flesh: The Discovery
of the Brain and How it Changed the World
FREE PRESS, 2005
ISBN: 978-0743272056

Evolution: The Triumph of an Idea
HARPER PERENNIAL, 2006
ISBN: 978-0061138409

Parasite Rex: Inside the Bizarre World
of Nature's Most Dangerous Creatures
FREE PRESS, 2001
ISBN: 978-0743200110

At the Water's Edge: Fish with Fingers,
Whales with Legs, and How Life
Came Ashore but Then Went Back to Sea
FREE PRESS, 1999
ISBN: 978-0684856230

PRAISE FOR

Mary Roach

"Her 'style' is at its most substantial—and most hilarious—
in the zero-gravity realm that *Packing for Mars* explores…
As startling as it is funny."

—Janet Maslin, *The New York Times*

"Truly funny…. Roach's writing is supremely accessible, but
there's never a moment when you aren't aware of how much
research she's done into unexplored reaches of space travel."

—*Entertainment Weekly*

"Mary Roach is the funniest writer on sex and death since
Sigmund Freud…"

—Peter Sagal, host of NPR's
"Wait Wait… Don't Tell Me!"

"Roach is an original who can enliven any subject with wit,
keen reporting and a sly intelligence."

—*Publishers Weekly*

"Even if there were thousands of science-humor writers,
[Roach] would be the sidesplitting favorite."

—*Booklist*

"Droll, dark, and quite wise, *Stiff* makes being dead funny
and fascinating and weirdly appealling."

—Susan Orlean, author of
The Orchid Thief

𝕸𝖆𝖗𝖞 𝕽𝖔𝖆𝖈𝖍

MARY ROACH is the best-selling author of *Packing for Mars: The Curious Science of Life in the Void*; *Stiff: The Curious Lives of Human Cadavers*; *Spook: Science Tackles the Afterlife*; and *Bonk: The Curious Coupling of Science and Sex*. Her articles have appeared in *Outside*, *National Geographic*, *Wired*, *New Scientist*, and *The New York Times Magazine*. She has appeared on numerous radio and television shows including "The Daily Show with Jon Stewart" and has lectured at the TED Conferences. She lives in Oakland, California.

www.maryroach.net

ALSO AVAILABLE BY MARY ROACH

Packing for Mars: The Curious Science of Life in the Void
W. W. NORTON & COMPANY, 2011
ISBN: 978-0393339918

Stiff: The Curious Lives of Human Cadavers
W. W. NORTON & COMPANY, 2004
ISBN: 978-0393324822

Spook: Science Tackles the Afterlife
W. W. NORTON & COMPANY, 2006
ISBN: 978-0393329124

Bonk: The Curious Coupling of Science and Sex
W. W. NORTON & COMPANY, 2009
ISBN: 978-0393334791

Donors Choose

A DONATION FROM THE proceeds of *Science Ink* will be made to Donors Choose, an online charity that makes it easy for anyone to help students in need. Donors Choose grew out of a Bronx high school where teachers experienced first-hand the scarcity of learning materials in our public schools. Charles Best, then a social studies teacher, sensed that many people would like to help distressed public schools, but were frustrated by a lack of influence over their donations. He created DonorsChoose.org in 2000 so that individuals could connect directly with classrooms in need. Donors Choose works in public schools by giving people a simple, accountable and personal way to address educational inequity.

www.donorschoose.org

Visual Index

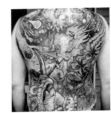

ACEVEDO, ALDEMAR, 112

ACEVES, RICHARD, 53

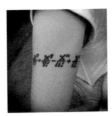

ACKERMAN, NICOLE, 9

ADAMS, JIM, 137

AKOB, DENISE, 29

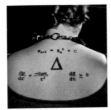

ALISON, EARNHART, 40

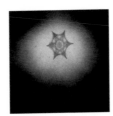

ANAPOLSKY, ABRAHAM, 64

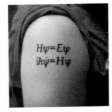

ANZEL, PAUL, 34

APPLEWHITE, ASHTON, 106

ANONYMOUS, 42, 43

ANONYMOUS, 50

ANONYMOUS, 68

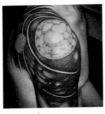

ANONYMOUS, 89

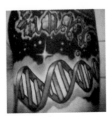

ANONYMOUS, 103

ARBOGAST, BRIAN, 138

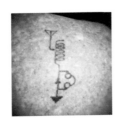

AREY, THOMAS, 230

AVDASHCHENKO, KONSTANTIN, 226

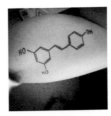

AZIOS, NICO, 54

BACKUS, CASSIE, 226

BAIN, EMILY, 100

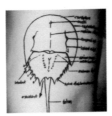

BALLANTI, LOREN, 145

BARTHOLOMAUS, CRAIG, 114

BARTLETT, REX, 168

BEER, MATTHEW, 184

BERG, ALEX, 36

BERCOVICI, ANTIONE, 134, 135

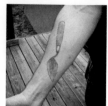
BERG, BRANDON, 198

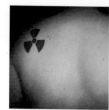
BIGELOW, STEVEN, 56

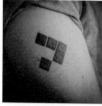
BIMM, JORDAN, 21

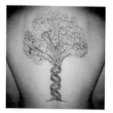
BONHAM, KEVIN, 101

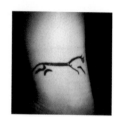
BOYLE, SARAH, 202

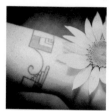
BRAYBROOK, SIOBHAN, 7

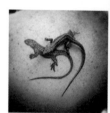
BURKE, RUSSELL, 153

C

CALDWELL, LAUREN, 70

CARLSON, ROSE, 151

CATTRANO, KRISTIN, 207

CHAN, EMILY, 77

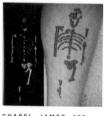
CHAPEL, JAMES, 195

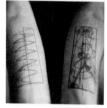
CHEEK, DARREN, 39

CHERKO, AMY, 134

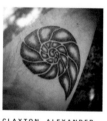
CLAXTON, ALEXANDER, 125

CLEMMENSEN, SHARON, 151

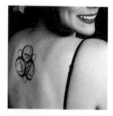
CLONINGER, CHERI, 224

COLLINS, ALLEN, 167

CREWS, RACHEL, 115

CRUTCHLEY, PATRICK, 209

D

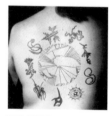
D'ALBERTO, CLARE, 142

DATTA, SANDEEP ROBERT, X

DAVIS, BRANDON, 7

DAVIS, MARCUS, 127

DECOSMO, KATE, 163

DEKTETT, ROZ, 202

DELWICHE, CHARLES, 166

DEVITT, KATE, 69

DICKENSON, PAX, 76

DISOTELL, TODD, 192

DNA ART, 103

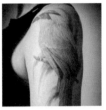

DORNAK, LYNETTE, 181

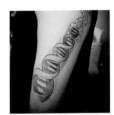

DREW, JOSHUA, 107

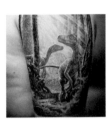

DREWEL, JEREMY, 132

DRINKARD, MAUREEN, 183

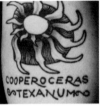

DRYMALA, SUSAN, 130

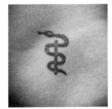

DUIJVESTEIN, MARJOLIJN, 220

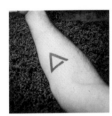

DWYER, J.C., 211

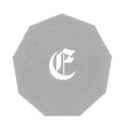

EMERINE, SHERRIE, 170, 171

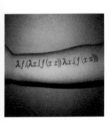

ERET, TURING, 15

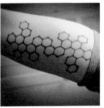

ESKELSEN, JESSICA, 65

EWEN-CAMPEN, BEN, 105

FARNSWORTH, CHRIS, 74

FARNSWORTH, CHRIS, 114

FARRIS, SARAH, 175

FELDEN, ANTOINE, 175

FIRULLI, ANTHONY, 148, 149

FISH, MARGARET, 120

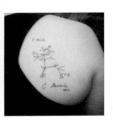

FISHER-REID, CAITLIN, 116

FRALLER, MITCHELL, 51

FRISCIA, ANTHONY, 138

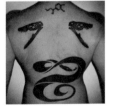

FRY, BRYAN GRIEG, 150

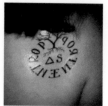

GARCIA, ABIGAIL, 27

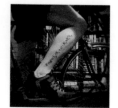

GATES, ANDY, 25

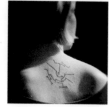

GEMMEL, MARLEA, 154

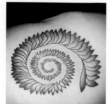

GODBOUT, MEG, 130

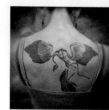

GOLD, MARIA, 134

GOLDSTEIN, MIKE, 199

GONCHAR, ANASTASIA, 32

GRACIE, ANDY, 239

GRAHAM, TIM, 187

GRANT, ANDREA, 11

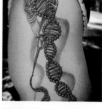

GRUENWALD, BRANDI, 99

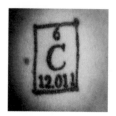

HANDLE, KIMBERLY, 122

HANN, TRISHA, 30

HEATHCOTE, JULIA, 131

HEATHCOTE, JULIA, 147

HENNESSY, CECILIA, 185

HILBUN, ERIN, 46

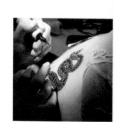

HOFFMAN, ZACHARIA, 20

HOLMES, RACHEL, 187

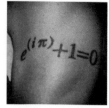

HUDSON, BILLY, 8

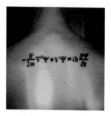

HUGHES, BRITTANY, 35

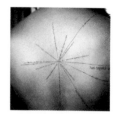

HUNT, ALAINA, 238

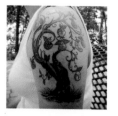

HWA, SHI-HSIA, 222

HYDE, HELEN, 20

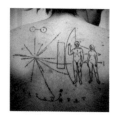

IKEDA, JEFFREY, 48

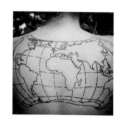

INGALLS, NILES, 238

ISLAS, MARINA, 90, 91

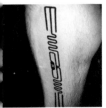

JOHANSON, PAUL, 233

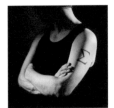

JOHANSSON, ROBERT, 4

JOHNSON, STEVENS, 33

JURD, ANTHONY, 166

KANE, JAMES, 122

KELLEY, NEIL, 121

KELLEY, NEIL, 129

KHONGAR, MILAD, 6

KIUME, SANDRA, 212

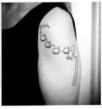

KLEINEDLER, STEVE, 201

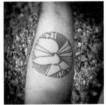

KLINEPETER, JOEL, 144

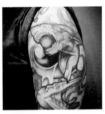

KLOTZKO, IRA, 78

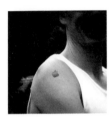

KNEE, WAYNE, 128

KOCH, CHRISTOF, 232

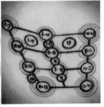

KRAKOW, JESSICA, 51

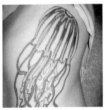

LAMB, AMY, 172

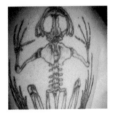

LAURICE, DAVID, 178

LEASMAN, MICHAEL, 79

LEWIS, KRISTINA, 169

LOONEY, CARRIE, 102

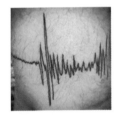

LOZOS, JULIAN, 86

LUCAS, DREW, 25

LUCE, PETER, 75

MACDONALD, ERIN, 29

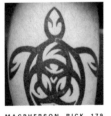

MACLEAN, ALASDAIR, 113

MACPHERSON, RICK, 179

MALENDA, HELEN, 88

MARINOS, RICHARD, 166

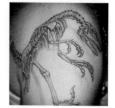

MATTIACCIO, ELYSE, 133

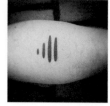

MAY, DAMON, 63

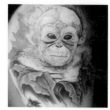

MCAULEY, ORLA, 186

MCGEE, SALLY, 187

MCKELVEY, KRISTAL, 173

MELLOW, GLENDON, 123

MENSCH, REBECCA, 174

MERTZ, DAVID, 55

MICHEL, MATT, 160

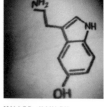

MILLER, HAYLEY SUZANNE, 214

MITCHELL, NATASHA, 165

MITCHELL, SARA, 81

MORENCY, MARC, 72

MOTZ, GREG, 159

MOTZ, GREG, 176

MULLEN, KARL, 193

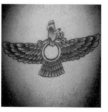

NELSON, THADDEUS, 203

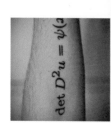

NESSI, GREGORY VON, 19

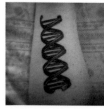

NEUMANN, ANNA, 99

O'DUSHLAINE, COLM, 97

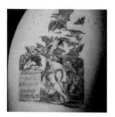

OLTHOFF, JOHN, 216

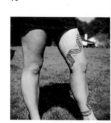

O'MALLEY, KRISTIN, 96

O'MEARA, DENISE, 177

O'ROURKE, JERRY, 57

OROZCO, ABRAHAM, 229

OU, JIMMY, 2

OWENS, MAGGIE, 180

ÖZPOLAT, DUYGU, 115

PARK-GEHRKE, LISA, 49

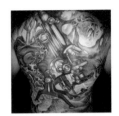

PARKINSON, KATE, 204

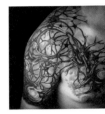

PATO, GABRIEL, 210

PERALES, DARA, 31

PETERSON, ELYSE, 123

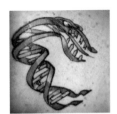

PHELAN, JAY, 102

PIGNO, VINCENT, 158

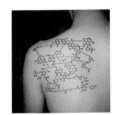

PIKUL, JESSICA, 58

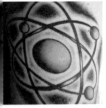

PINGS, AMANDA, 123

PITNICK, SCOTT, 155

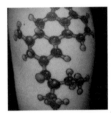

PRASAD, ABHISHEK, 59

PROWSE, TRACY, 197

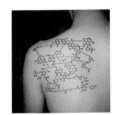

PTAK, COREY, 59

QUAST, MONICA, 143

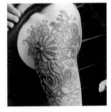

RAASCH, MICHAEL, 99

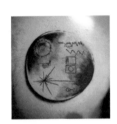

RADFORD, NOAH, 236

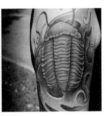

RANDALL, LEA, 124

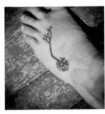

REESE, LINDSAY, 215

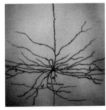

REINHARDT, KAY, 208

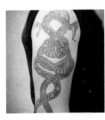

RICE, BRONWEN, 163

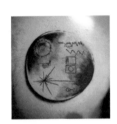

RICHARDS, GARY, 136

RODRIGUES, DÔNOVAN
FERREIRA, 24

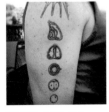

ROEPKE, TROY, 160

ROGERSON, JESSE, 73

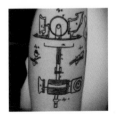

ROLLINS, TYLER, 228

ROSA, HANNAH, 187

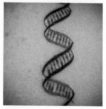

ROSENTHAL, JACYLYNN, 109

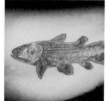

ROSENZWEIG, VICKI, 145

ROTH, MARTIN, 210

ROWHER, CHARLIE, 169

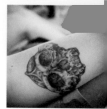

RUSSO, GABRIELLE, 196

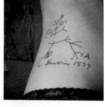

RUTHERFORD, JULIENNE, 117

SANABRIA, CHRIS, 231

SAUNDERS, ARPIAR, 104

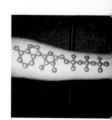

SCHMOLLER, DANIEL, 50

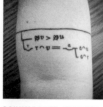

SCHUMACHER, MELISSA, 13

SCHUMACHER, RENATE, 88

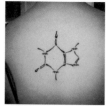

SCICURIOUS, PH.D., 60

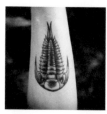

SEGALL, JUDITH, 123

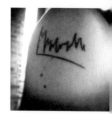

SEPKOSKI, DAVID, 139

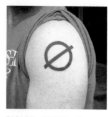

SIGLER, SCOTT, 17

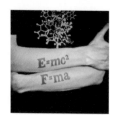

SIMPSON, ADAM, 28

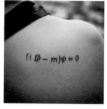

SOARES, MELINDA, 38

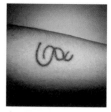

SOUSA LOPES, SUSANA CHUVA DE, 102

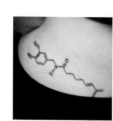

STARR, MADELINE, 61

STEFFEN, NICOLA, 187

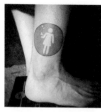

STEMWEDEL, JANET, 61

STROUP, DAVE, 7

TARNOWSKI, HEATHER, 98

TATUM, CHAD, 194

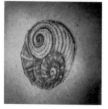

THALER, ANDREW, 173

THÔNY, LUZIUS, 201

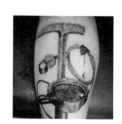

TODD, JASON, 92

TURNITZA, FRANK, 223

URSELL, TRISTAN, 8

VALLE, TREVOR, 139

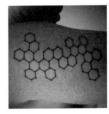

VAN DER MERWE, IVANKA, 26

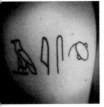

WEINSTOCK, MAIA, 83

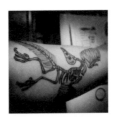

WELCH, MEGHAN, 134

WESEL, ROBERT, 65

VERSTYNEN, TIMOTHY, 206

WILKINSON, HEATHER, 236

WINDSOR, AMANDA, 114

WOLFENDEN, DAVE, 164

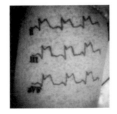

WRIGHT, APRIL, 117

YEE, TERRANCE, 234, 235

YORE, LIAM, 225

YTURRALDE, MARK, 77

ZELANKO, PAULA, 62

Index

PAGE NUMBERS IN ITALIC INDICATE AN ILLUSTRATION.

Colophon

The text of this book is set in *De Vinne*, designed in 1890
by Gustav F. Schroeder.

The main heads are set in *Cloister Black* designed in 1904
by Morris Fuller Benton and Joseph W. Phinney.

All files for production were prepared
on Macintosh computers.

It was printed and bound in China by PrintPlus Limited.

The paper is 120 gsm Golden Sun White Woodfree.

Production was managed by Pip Tannenbaum.

It was edited by George Scott.

The cover was designed by Charles Nix and
Alexandra Zsigmond.

The book was designed by Charles Nix.

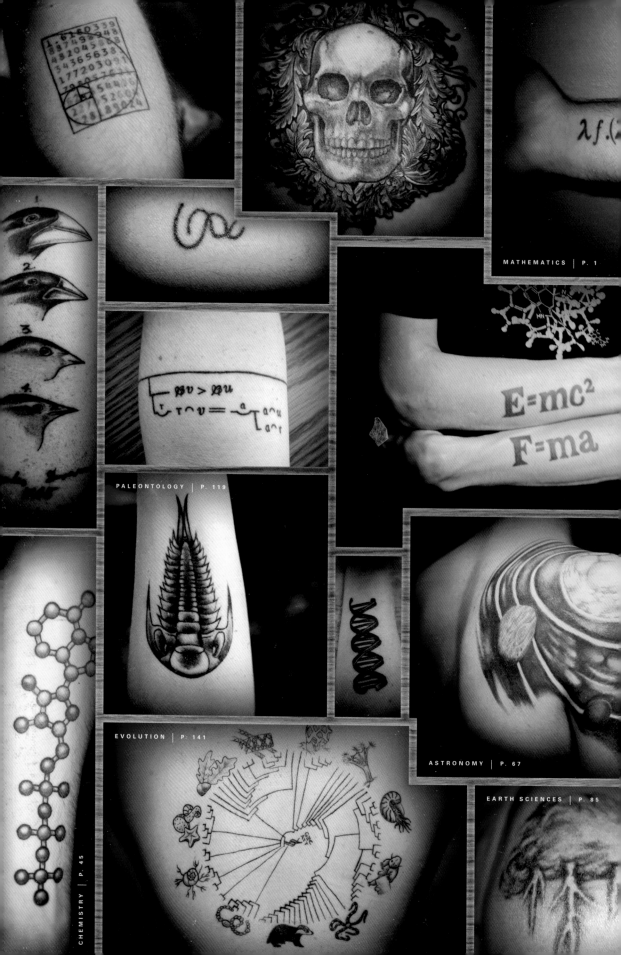

MATHEMATICS | P. 1

PALEONTOLOGY | P. 119

CHEMISTRY | P. 45

EVOLUTION | P. 141

ASTRONOMY | P. 67

EARTH SCIENCES | P. 85